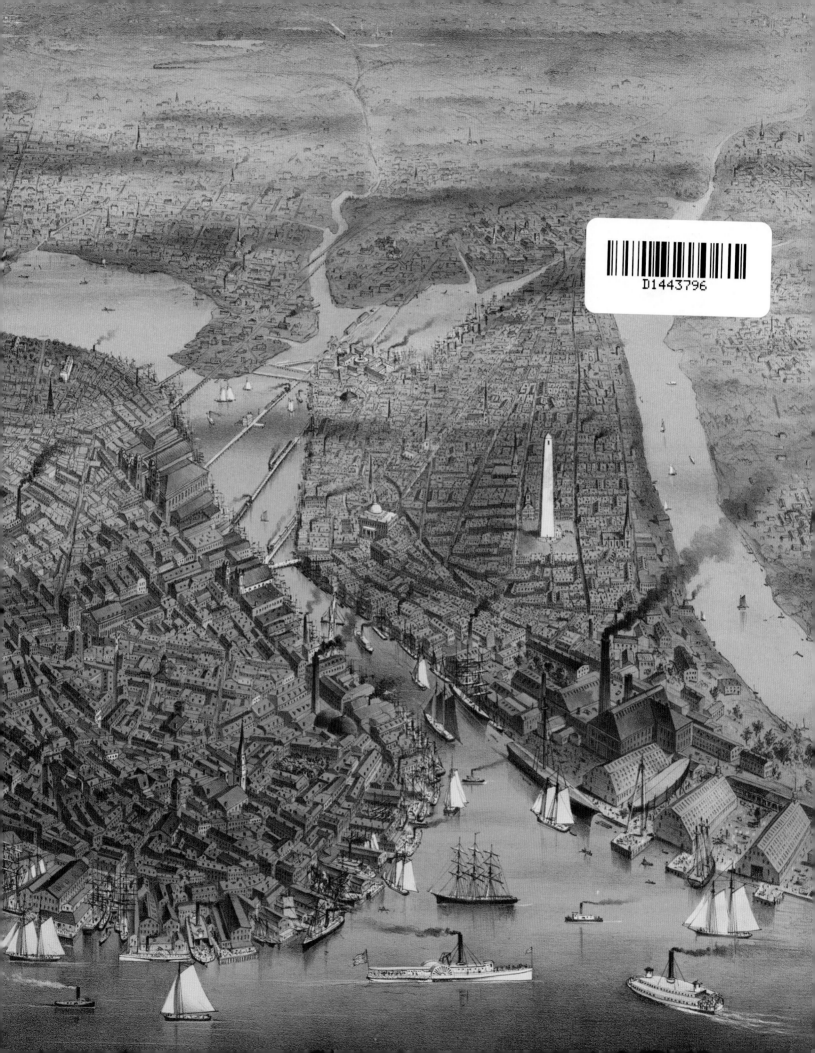

# Boston
## A Visual History

✦✦✦✦✦✦✦✦✦✦✦✦✦✦✦✦✦✦✦✦✦✦✦✦✦✦✦✦✦✦✦✦✦✦✦✦

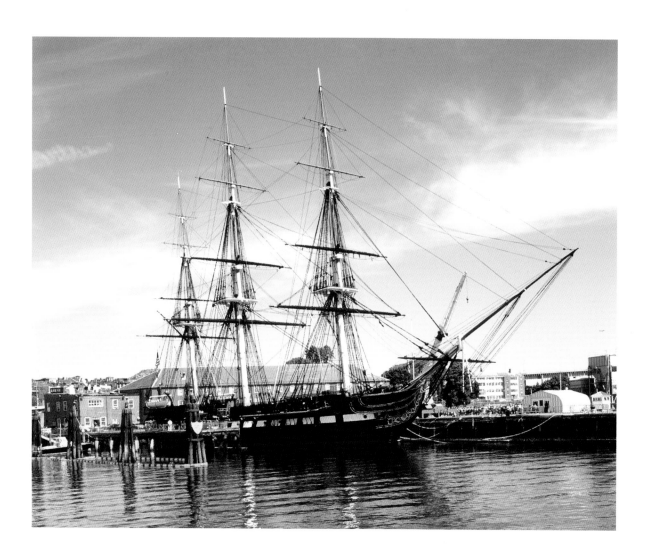

Jonathan M. Beagle, Ph.D.
Foreword by Michael S. Dukakis

imagine!
Publishing

An Imagine Book
Published by Charlesbridge
85 Main Street, Watertown, MA 02472
617-926-0329
www.charlesbridge.com

Created by Penn Publishing Ltd.
1 Yehuda Halevi Street, Tel Aviv, Israel 6513501
www.penn.co.il

Editor-in-Chief: Rachel Penn
Design and layout by Ariane Rybski

Library of Congress Cataloging-in-Publication Data

Beagle, Jonathan.
 Boston : a visual history / Jonathan M. Beagle, Ph.D.
    pages cm
 "An Imagine Book."
 Includes index.
 ISBN 978-1-62354-000-5
 1.  Boston (Mass.)--History--Pictorial works. 2.  Historic
sites--Massachusetts--Boston. 3.  Historic buildings--Massachusetts--Boston.
I. Title.
 F73.37.B3633 2014
 974.4'61--dc23
                        2012044171

2 4 6 8 10 9 7 5 3 1

Printed in China, February 2013

For information about custom editions, special sales, premium and corporate purchases,
please contact Charlesbridge Publishing at specialsales@charlesbridge.com

*Endpapers: Bird's-eye view of Boston, by Parsons & Atwater, published by Currier & Ives, circa 1873.
Library of Congress Prints and Photographs Division*

*Opposite: View of Boston across the Charles River.*

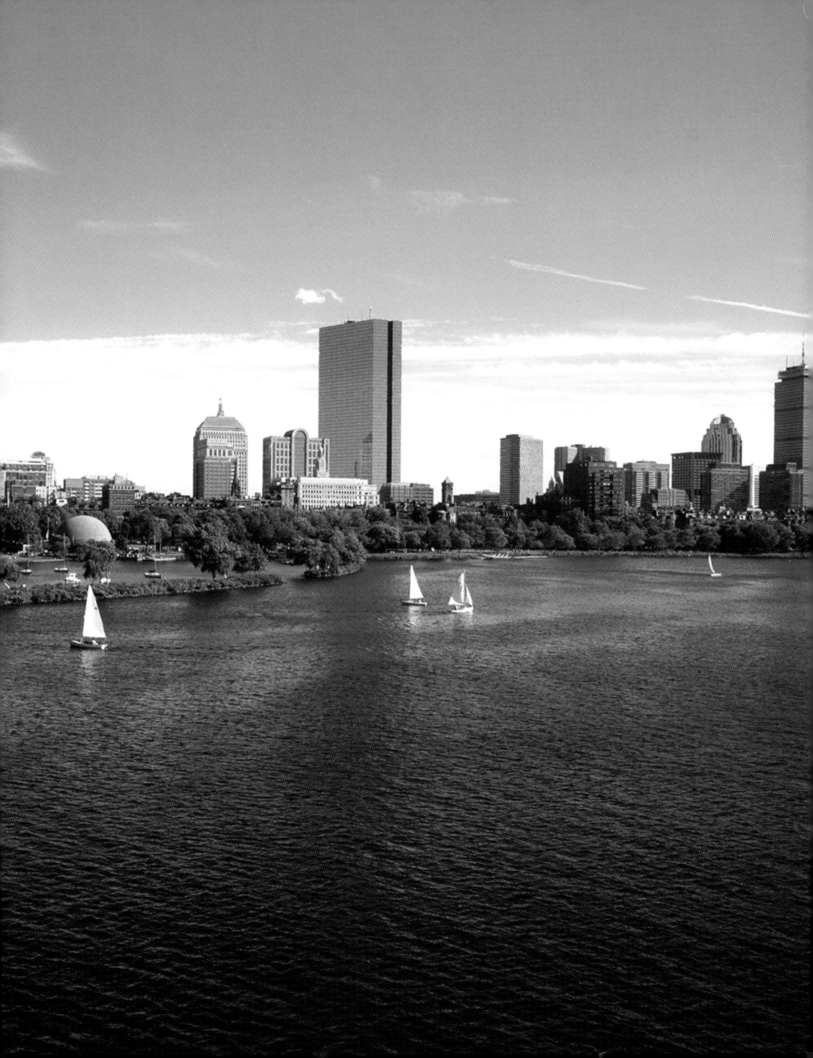

# Contents

***********************************************************

## Waterfront    *108*

## Fenway    *132*

## Around the Hub    *150*

## The Freedom Trail – Official Sites on the Trail    *175*

## Acknowledgments    *175*

## Index    *175*

*Official sites on the Freedom Trail.*

# Foreword

by Michael S. Dukakis

I was born in Boston nearly eighty years ago, and with time out for college in Pennsylvania and military service in Korea, I have been a Bostonian and a citizen of Massachusetts my entire life. True, I tried mightily to become eligible for public housing in Washington, D.C. by running unsuccessfully for the presidency, but Boston gave birth to me, shaped my ideas and philosophy, was responsible for my love of history and has given me the rare opportunity to serve in public life for over thirty years. During the past twenty of these years, I've had the chance to teach what I love—public policy and public service—to hundreds of students at Boston's Northeastern University.

In point of fact, I grew up in the town of Brookline, and it was there that I was first educated and ran and won my first political campaigns. Those of us who grew up in the nearby suburbs never considered ourselves anything but Bostonians. When my buddies in my unit in Korea wanted to know where I came from, I told them proudly that I came from Boston and from the Commonwealth—not the state—of Massachusetts.

The Boston where I was born and nurtured, however, was very different from the Boston of today. It was a tough city, heavily ethnic and often angry and intolerant. It was racist. It was anti-Semitic. Many of its neighborhoods from the 1930s through the 1950s were poor, in decline, and being abandoned by residents who began moving out to the near and far suburbs. Some of these neighborhoods became the destination for African-Americans from America's South and Latinos from Latin America. Immigrants in Boston faced the same kind of discrimination that they faced in virtually every area of the country.

In fact, people of color simply couldn't live in my town, and they couldn't live in many other Boston neighborhoods either. The famous school desegregation battle that tore the city apart in the mid-1970s revealed an ugly side of the city that many Bostonians had refused to acknowledge for years.

Today's Boston, fortunately, is a very different place. For one thing, we stopped tearing it down to try to turn it into something that it wasn't. When post World War II solutions to the problems of traffic and congestion threatened to destroy the Boston that this book so beautifully describes, we caught ourselves in the nick of time and killed the so-called Master Highway Plan that would have turned Boston's transportation system into a Los Angeles cousin. We took the billions in federal highway funds that we had refused to use and invested them in what is arguably the best public transportation system in the country. The city began preserving and restoring our historic treasures that we had been systematically destroying and created a new, lovingly preserved and historic Boston that is today one of the nation's—and the world's—greatest and most beautiful cities.

And we have done it while bringing people together, celebrating our racial and ethnic diversity, restoring so much of what makes Boston so very special, and by taking full advantage of one of our greatest assets—the Commonwealth's 120 colleges and universities, many of them located in Boston or Cambridge. We built one of the most modern and innovative economies in the world, while making sure our political and cultural history remains very much a part of Boston's present and future.

Speaking of our political history, it is one of our greatest

strengths, as most students of American history know. It is not an accident that Massachusetts regularly produces some of the nation's best political operatives and flocks of candidates for the presidency. We haven't won all those presidential campaigns (not by a long shot). Candidates named Dukakis, Tsongas, Ted Kennedy, Kerry, and Romney have all gone down to defeat, but there is no other state in the nation that has fielded as many candidates in recent history for the nation's highest office, or claimed not one but three Speakers of the U.S. House of Representatives during my lifetime, or sent the first African-American to the United States Senate since Reconstruction. In fact, some have argued that every child born in Boston is immediately infected with two diseases— politics and the Red Sox—and this is pretty close to the truth.

Ah, the Red Sox. Our fierce dedication to the city's professional sports teams is another unique feature. Our baseball team claims a particularly special place in all of us. When the powers that be tried to tear down Fenway Park and replace it with a phony version of the real thing at a cost of $850 million, a small but dedicated band of opponents named "Save Fenway" launched the battle that ultimately stopped Fenway's destruction, restored the historic 1912 ball field into what is now an absolute jewel, and set the stage for what has been nearly 700 consecutive sold-out crowds in that wonderful stadium.

And it wasn't an accident that I and one of my cross-country running buddies at Brookline High School ran and finished the Boston Marathon in 1951when we were high school seniors. That historic race—another Boston tradition—draws more than a million spectators along the route every Patriot's Day in April and comes right through our town as the runners head for the finish line. We grew up out there, watching that race from the age of three.

Those of us who participated in some way in Boston's renaissance are extraordinarily proud of what has happened to the Boston of our youth. It is truly a beautiful city today in so many ways—physically, culturally, as a meeting ground for an extraordinarily diverse community—and it just gets better and better. But we built on the foundation of those who came before us, and nobody who grows up in or moves to Boston can possibly be unaware of the rich history that surrounds us and has shaped our capital city.

That is why this book is so special and such a valuable contribution to our understanding of the forces that shaped present-day Boston and Massachusetts. It is beautifully written and exquisitely illustrated. It tells it like it is (and was) and minces no words about the city's triumphs *and* defeats. It is a must read for those of us who have lived all our lives here and for those who are merely visitors or recent arrivals. For it is this combination of all of us that has made it the stunningly attractive and vibrant city that it is today.

**Michael S. Dukakis**
Former Governor of Massachusetts
Distinguished Professor
Department of Political Science
Northeastern University
June, 2013

# Boston:
# The City Upon a Hill

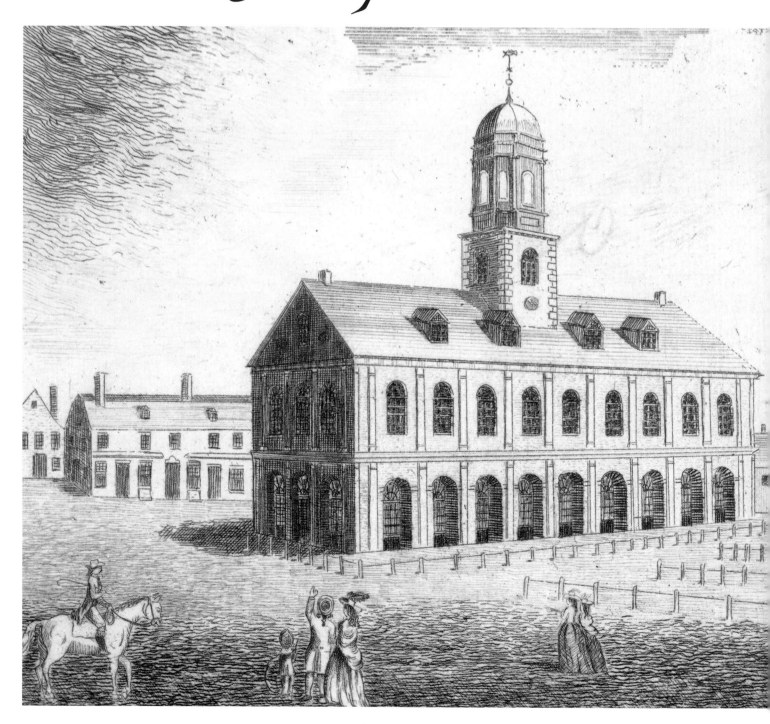

Its Indian name was Shawmut, but the English would call it Boston. Arriving at the hilly little peninsula in the fall of 1630, the first "Bostonians" did not expect to stay long. Their religious consciences had compelled them, albeit reluctantly, to leave an England that had seemingly strayed from the path of righteousness. Though others may have scoffed at the idea, these so-called Puritans were determined to save their beloved homeland through an inspiring display of Christian living in the American wilderness—a "City upon a Hill," as Governor John Winthrop famously described it. They would return triumphantly once England had seen the error of its ways and reformed. It was an admirably idealistic plan, the failure of which would ironically produce one of the great American cities.

What brought the Puritans specifically to Boston has been variously described as fate, fortune, or mere happenstance. After enduring storms and sickness on the high seas, the Winthrop fleet reached Cape Ann and the tiny fishing village of Salem in June of 1630. The sudden influx of nearly 1,000 settlers overwhelmed Salem's meager resources, however, and prompted a removal further down the Massachusetts coastline to Charlestown, Boston's "Mother City" as it would be known. The lure of fresh spring water subsequently carried some, including Governor Winthrop, across the Charles River to Shawmut Peninsula. Connected to the mainland by a thin strip of land that flooded during storms and high tides, the peninsula was a mere two miles long and one mile wide, hardly the sort of place one would expect to find what quickly became the largest city in seventeenth-century America.

The rapid success of Boston surprised even its founders. Clustered around the East Cove, with Beacon Hill at their backs, they carved out a living mostly from the sea. Merchants joined ministers as community leaders, financing the construction of wharves and market houses that soon made Boston the commercial hub of New England. John Josselyn was reminded of London as he walked Boston's cobblestone streets and marveled at its many shops and ships in 1663. Such prosperity seemed a sign of God's favor, although some residents worried that it would also prove the town's undoing. Not only was the seaport attracting some unsavory characters, from rowdy sailors to licentious strumpets, but also seemed dangerously close to replacing God with Mammon. "[T]ho' they wear in their Faces the Innocence of Doves, you will find them in their Dealings, as Subtile as Serpents," complained one visitor. "Interest is their Faith, Money their God, and Large Possessions the only Heaven they covet."

Royal officials also cast a suspicious eye upon Bostonians, whom they long considered disloyal for leaving England and criticizing both the Crown and its Anglican Church. In the 1680s, they took the bold step of stripping the Massachusetts Bay Colony of its self-governing charter and installed a new regime headed by an English aristocrat. Boston would never be quite the same

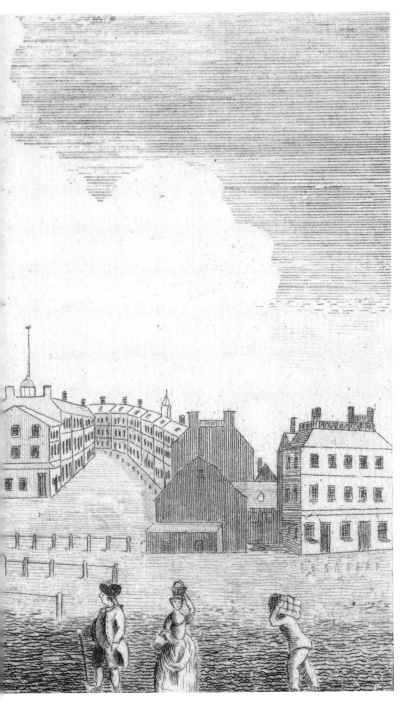

*Faneuil Hall in 1775, 1888 facsimile etching of original engraving from the Massachusetts Magazine of 1789.*

again. Its inhabitants learned to jealously guard their liberty, for although England's Glorious Revolution of 1688 would win them back many former privileges, they lost the right to elect their own governor. They were also forced to tolerate non-Puritans in their community. For some, it felt like the end of the world. To others, it was a new beginning.

The political, economic, and religious changes that transformed Boston in the eighteenth century were also reflected in its evolving architecture. Plain, wooden meetinghouses gave way to brick and stone churches capped with towering steeples, the skyscrapers of their day. Puritan Congregational churches still dominated the religious landscape, but Anglican (Church of England), Quaker, Baptist, and Huguenot houses of worship were now visible as well. The monarch's authority over the community was evident in the royal emblems that covered the State House on recently renamed King Street. And while fine Georgian mansions and English gardens bespoke the wealth of the merchant class, a two-story workhouse told a different story about growing problems with poverty and unemployment. The colonial population even temporarily ebbed from its high water mark of around 16,000 in the 1740s, as high taxes, price inflation, and currency shortages drove some inhabitants to seek greener pastures elsewhere.

By the time of the American Revolution, Boston was no longer the largest or most urbane of Britain's colonial cities, an honor that belonged to Philadelphia. Yet it was more identifiably English than arguably any other part of His Majesty's North American Empire. "This is more like an English Old Town than any in America," noted Lord Adam Gordon, "the Language and manner of the people very much resemble the old Country." As such, Bostonians believed they shared the same political rights as those living in London itself. When Parliament suggested otherwise, they launched a revolution to protect ancient liberties handed down from their Puritan ancestors.

Even after the colonists broke from Britain and assumed a new identity as Americans, Bostonians remained deeply attached to their English roots. Some simply refused to leave the Empire and in 1776 fled to Canada, where many of their ancestors remain today. Those who stayed in Boston were later reluctant to go to war against Britain again in 1812, and a few even suggested New England's secession from the United States as a possible alternative. Visiting Boston in 1837, the Englishman Francis Marryat was pleased to learn that the inhabitants "consider themselves, and pride themselves, as being peculiarly English, while, on the contrary, the majority of Americans deny that they are English."

Twenty years later another observer similarly concluded, "A Bostonian… is still an Englishman in America."

Although England was historically the barometer by which Bostonians measured their civility, they also saw themselves competing with rival American cities for cultural authority over the new nation. They staked their claim through urban improvements, education, and cultivation of the arts, all of which were funded with new sources of wealth. Boston merchants were among the first to open up the lucrative China trade and to invest in domestic manufacturing after the Revolution. Their civic pride was evident not only in the institutions they founded, but also in the nicknames Bostonians gave their city: "The Athens of America," "The Venice of America," and "The Hub of the Universe."

## Beacon Hill

\*\*\*\*\*\*\*\*\*\*\*\*\*\*\*\*\*\*\*\*\*\*\*\*\*\*\*\*\*\*\*\*\*\*\*\*\*\*\*

No section of the city better reflects the values of Proper Boston than Beacon Hill. As the address of the Massachusetts State House, its name has become synonymous with wealth and power, but it originally referred to a wooden beacon placed there to alert the community of danger. The largest prominence on Shawmut Peninsula, Beacon Hill was also part of a ridge known as the "Trimountain," from which nearby Tremont Street derives its name. The area experienced little development beyond John Hancock's mansion until after the Revolution, when its south face was chosen as the site for the new State House. Although the building signified Massachusetts's political independence from Britain, its design also reflected Boston's English cultural inheritance. Such a building, concluded one foreign observer, "could have entered into the head of none but an English architect to conceive." In actuality, the architect was a native Bostonian, Charles Bulfinch, who was determined to refashion Boston in the mold of a great European city.

Bulfinch's State House transformed Beacon Hill into a stylish neighborhood and placed him in great demand among the local elite. He would build many of the beautiful brick homes that still line its streets. Over the years, some of the city's most famous residents have called Beacon Hill home, especially its politicians. In November of 2004, for instance, Democratic presidential candidate John Kerry anxiously awaited election results at his townhouse in Louisburg Square, only to learn of his narrow defeat at the hands

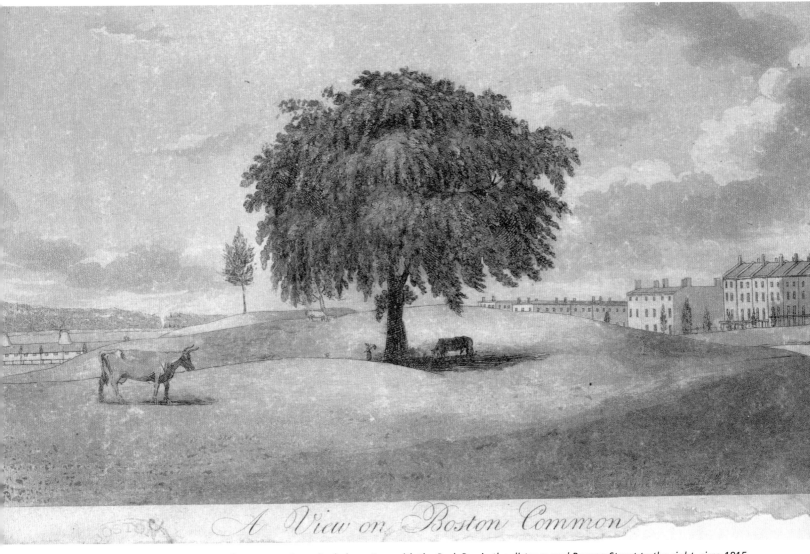

*Cows grazing on Boston Common under a single large tree with the Back Bay in the distance and Beacon Street to the right, circa 1815.*

of incumbent George W. Bush. Even Charles Bulfinch himself had a home on the Hill.

Bulfinch also designed the original Massachusetts General Hospital, one of several prestigious institutions to gravitate toward Beacon Hill in the early nineteenth century. The Boston Athenaeum was another. It had once been located next to King's Chapel before moving in 1849 to its current location at 10½ Beacon Street. With one of the largest book collections in the country, the Athenaeum helped establish Boston's reputation as the literary capital of the United States and was patronized by such celebrated authors as Nathaniel Hawthorne and Louisa May Alcott.

Just a stone's throw away from the Athenaeum, in Old Granary Burying Ground, lies the grave of Crispus Attucks, victim of the Boston Massacre and the first black martyr to the cause of American liberty. His tragic death became an inspiration to generations of African Americans, including members of the all-black 54th Massachusetts Infantry Regiment, who marched off to glory during the Civil War. Massachusetts may have abolished slavery after the Revolution, but racism was still very much alive in Boston. Blacks had difficulty procuring anything but the most menial of work and were often segregated in schools and churches, resulting in what some described as an "aristocracy of skin." Many African American families huddled in tenements on the northern slope of Beacon Hill, seemingly a world away from the wealth and splendor of Bulfinch's Boston. At the African Meeting House on Joy Street, however, they could sing, dance, worship, and learn together without being harassed. The building became the cornerstone of Boston's black community in the nineteenth century and remains a cultural institution today.

# Back Bay

✦✦✦✦✦✦✦✦✦✦✦✦✦✦✦✦✦✦✦✦✦✦✦✦✦✦✦✦✦✦✦✦

Paris replaced London as the model for Boston's urban development in the mid-nineteenth century. Though evident elsewhere in the city, the French connection is most dramatically displayed in the Back Bay district. The Commonwealth Avenue Mall, patterned after Parisian boulevards of the period, features a tree-lined promenade, grassy expanses, and wide streets with elegant brownstones set back from the roadway. Mansard roofs on many of the homes add to the cosmopolitan character of the neighborhood, though modern traffic congestion does ruin its romantic air a bit. Those seeking an amorous retreat often head instead to the Public Garden, where paddleboats and fragrant flowers are sure to stir the passions. Some visitors even see stars in their eyes, not of the celestial kind but rather the Hollywood type. Actors Grace Kelly, Shirley Temple, Bette Davis, Ted Danson, Matt Damon, and director Rob Reiner are among the many celebrities to have enjoyed the Garden's famed Swan Boats since their inception in the 1870s. Indeed, the Swan Boats have achieved a certain celebrity of their own as one of the city's most beloved attractions. They have appeared in everything from movies such as 2012's *Ted*, starring Boston native Mark Wahlberg, to Robert McCloskey's classic 1941 children's book *Make Way for Ducklings*, in which a family of mallard ducks takes up residence in the Public Garden.

The fresh flowery scent of the Public Garden replaced the foul stench that had formerly characterized the Back Bay, a muddy tidal basin that doubled as a garbage disposal. A westerly breeze on a warm afternoon often sent people scurrying off Boston Common to avoid the odor. Everyone agreed after the Revolution that the bay should be filled, but for what purpose? Some saw the economic utility of the new land for a growing populace and pushed for residential development. Others, reacting against the noise and congestion of the city, argued for the creation of a new public space to complement the Common.

In the 1850s, with the city's population over 160,000, both visions were implemented as Boston embarked on one of the most ambitious urban development plans of its day, to fill Back Bay with dirt and gravel hauled in by rail from Needham, Massachusetts. (A similar, though smaller, project had already leveled much of the Trimountain earlier in the century to provide new land for various West End and Beacon Hill neighborhoods.) The massive undertaking created some 400 acres and took decades to complete, but resulted in a fashionable new residential district for the city's

upper classes and cultural elite, the so-called Boston Brahmins.

The Gibson House museum on Beacon Street chronicles the Brahmin experience through the eyes of the colorful Charles Gibson, a long-time Back Bay resident. While Gibson wanted to share his privileged lifestyle with the public, members of the exclusive St. Botolph Club prefer to keep theirs private. Described by some as a "last bastion" of elitism, the century-old club once met on Newbury Street, known more recently for its pricey boutiques and cozy restaurants. Early members included the architect H.H. Richardson and The Reverend Phillips Brooks, who together were responsible for one of Boston's architectural marvels, Trinity Church.

Together with Old South Church and the Boston Public Library, Trinity Church illustrates the tendency of many institutions to follow the population into the Back Bay during the 1870s and 1880s. The move allowed them to escape the confines of the old city and expand their roles within the community. With over six million volumes in its possession, the Boston Public Library now ranks among the largest lending libraries in the country, and its collection of rare books and documents draws scholars from all over the world. Trinity Church, located across from the library on scenic Copley Square, has become renowned for more than its world-class choir; it also provides valuable assistance to the disadvantaged and the ill.

# North End and Charlestown

✦✦✦✦✦✦✦✦✦✦✦✦✦✦✦✦✦✦✦✦✦✦✦✦✦✦✦✦✦✦✦✦✦

Back Bay's gain was, in certain respects, the North End's loss. As the deepest part of Boston Harbor, the North End had developed a distinctly maritime character in the colonial era. Its busy shipyards employed a wide variety of local craftsmen and laborers who lived in the area, including blacks from the "New Guinea" neighborhood near Copp's Hill. The famed U.S.S. *Constitution*, now on display at the Charlestown Navy Yard, was one of many vessels constructed in Boston's North End. Sailors were also a common sight on its narrow, crowded streets, which were lined with slop-shops and taverns catering to jack tars. The

*Hancock House, Beacon Street, 1860.*

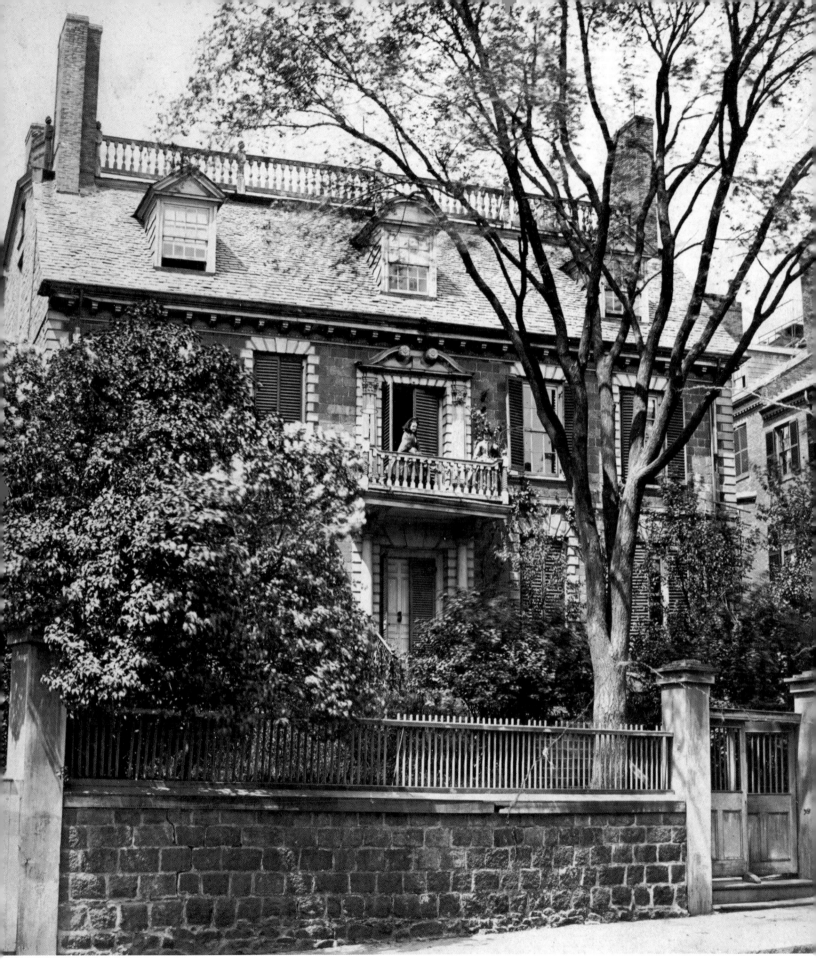

notoriously rough-and-tumble character of the neighborhood gave some pious Puritans pause. The Reverend Cotton Mather, who lived and ministered in the North End, went so far as to make trips down to its dockyards, distributing religious readings amongst the sailors in the hope that they might become good Christians. Whether or not they found God, many mariners did find a final resting place alongside Mather at Copp's Hill Burying Ground.

Despite the North End's rather sordid reputation, a number of wealthy merchants made it their home in order to be near their wharves and warehouses. An early example survives in the form of the Paul Revere House, originally built for the merchant Robert Howard in the 1680s. By the eighteenth century, their luxurious Georgian mansions lent the North End a respectable air, as did the growing numbers of churches their money helped construct. Such riches were occasionally ill gotten, however. Boston was an infamous haven for smugglers and pirates, and some locals were willing to look the other way in dealing with them. Decorative angels on display at Christ Church, now known as Old North, were taken from a French ship bound for Canada and donated by Captain Thomas Gruchy in 1746.

The Revolutionary War hit Boston's North End especially hard. The British occupation and blockade of Boston Harbor severely disrupted commercial trade, putting sailors and mechanics out of work. In turn, the American siege of the seaport prompted undersupplied British soldiers to tear down Cotton Mather's old church and other structures for firewood. Several affluent North End merchants fled Boston with the King's troops in the spring of 1776, taking much of their wealth with them. Afterwards, a smallpox epidemic ravaged the town and spread rapidly through the compact quarters of the North End. "I can't describe the alteration and the gloomy appearance of this Town," James Warren told John Adams. "No Business, no Busy Faces but those of the Physicians. Ruins of buildings, wharfs, etc. etc., wherever you go, and the streets covered with grass."

Boston recovered from the Revolution, and before long the North End wharves were bustling with maritime traffic again. One observer likened the scene to a forest of ship masts floating in the harbor. But the residential development of Beacon Hill and later Back Bay drew wealthy families away from the North End, which grew increasingly working-class and commercial in character. The

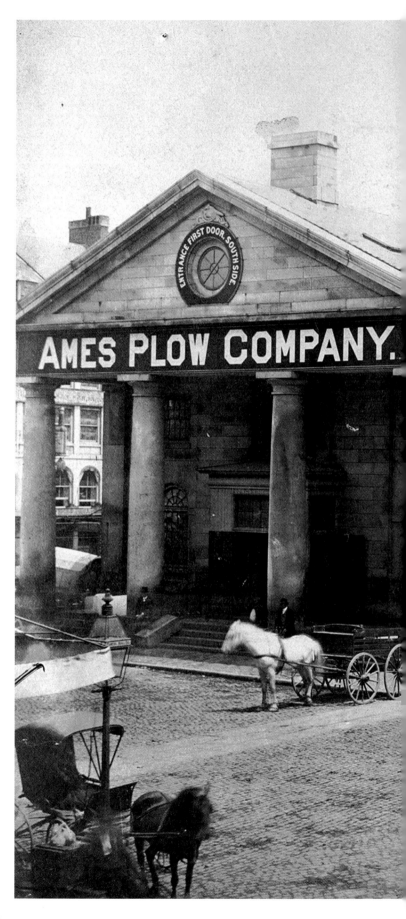

*Faneuil Hall Marketplace building showing famous Ames Plow Company sign, 1870.*

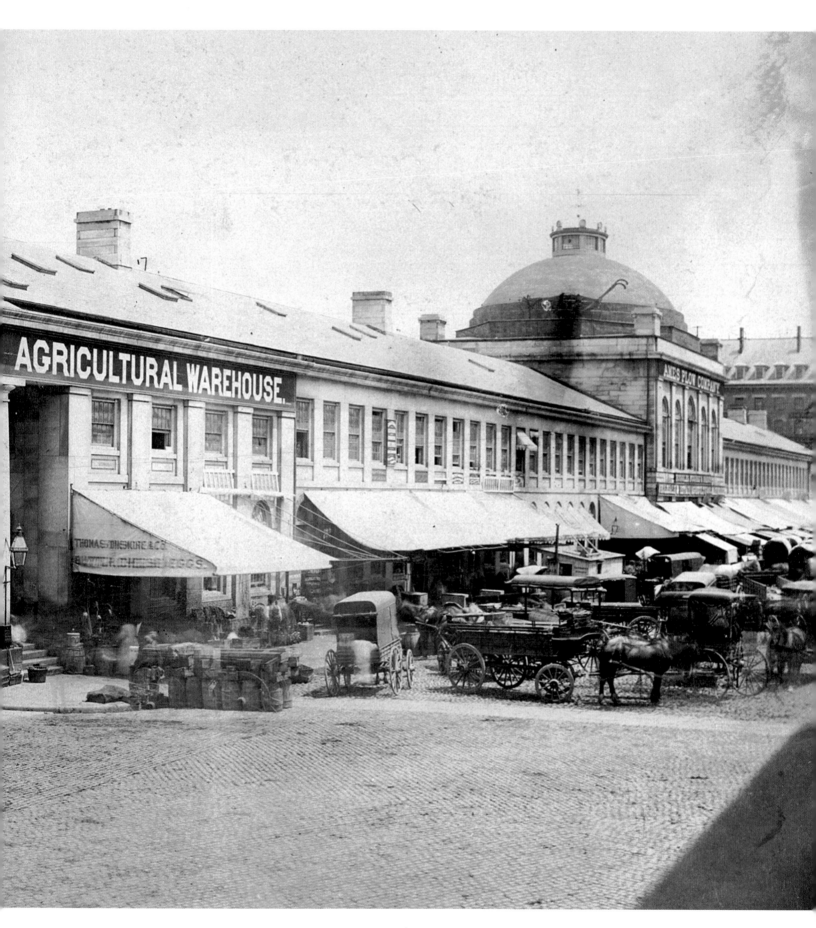

arrival of packet lines and the advent of the Irish potato famine brought thousands of poor Irish Catholic immigrants to the North End in the 1840s and 1850s, largely turning it into a tenement district. Some 50,000 Irish inhabited Boston by 1855.

There were definite patterns of settlement among the North End Irish, with immigrants from Cork County concentrating around North Square near the Revere House while those from Donegal gravitated toward the area around Endicott Street. "Cork Hill" and "Galway City" were the nicknames given to different parts of the rapidly changing North End. The Irish moved in as native Bostonians moved out, taking over the buildings they left behind. Hence did the Bulfinch-designed New North Unitarian Church become Saint Stephen's Roman Catholic Church in the 1860s.

Toward the end of the nineteenth century, the North End underwent another transformation as Italian immigrants began to displace the Irish. Cultural differences and competition for work canceled out any religious affinity between the two Catholic groups, resulting in significant tension. They generally lived separate lives, with the Italians worshipping at their own churches such as Sacred Heart, but their paths inevitably crossed on the narrow North End streets. "The Irish had gangs on the street corners," recalled one Italian immigrant. "They would stop you and ask for a drink. If you give them a drink, you don't have no beer left, and maybe you get beaten up anyway. If you don't let them have a drink, they take it away from you, drink all the beer, and throw the empty can at you." Needless to say, the North End was not a place Boston police enjoyed patrolling in the nineteenth century.

Native Bostonians were initially no more enamored with Italian immigrants than they had been with the Irish decades earlier. "The atmosphere is actually thick with the vile odors of garlic and onions- of macaroni and lazzaroni," they complained. Rather than drive people out, however, such smells have instead attracted them to a gentrified North End in recent years. The neighborhood's Italian restaurants offer some of the best cuisine in Boston, and a North Ender, Guiseppe Parziale, is even credited with introducing pizza to Americans.

## Financial District
★★★★★★★★★★★★★★★★★★★★★★★★★★★★★★★★★★★★★★★★★

Behind the gentrification of Boston's North End lies the revival of its Financial District. Located along State Street, the Financial District has served as the heart of Boston's business community for generations. The Puritan founders first established an open-air provisions market at the site of the Old State House in the 1630s, after which a number of artisans set up their shops in the area. A controversial proposal to move the adjacent town meetinghouse away from the marketplace met with furious resistance from shopkeepers and craftsmen who feared their businesses would suffer. The debate grew so heated that Puritan leaders worried it might tear the community apart in 1639. In the end, the meetinghouse was simply relocated to the opposite side of the market, and trade continued unabated.

The construction of the first Town House atop the marketplace in the 1650s transformed it into a fashionable place for gentleman-merchants to meet and discuss business. According to Joseph Bennett, who visited Boston in 1740, "they meet every day at one o'clock, in imitation of the Exchange at London, which they call by the name of Royal Exchange too." Country traders were consequently forced out into the streets to hawk their provisions door-to-door, leaving Boston without a marketplace. While some preferred this system, others complained that it clogged the streets, contributed to growing crime in the community, and generally gave Boston a bad reputation. Theirs was the only city in the British Empire not to possess a market house, a source of embarrassment to proud Bostonians.

When Peter Faneuil remedied the situation in 1740 by personally financing an elegant brick market named in his honor, he was treated like a hero. Admirers declared Faneuil Hall "a noble building" and praised its patron as "the most public-spirited man ... that ever yet appeared on the Northern Continent of *America*." Over eighty years later, Mayor Josiah Quincy also gained everlasting fame for expanding and modernizing the marketplace. Along with Ammi Young's 1838 customhouse, the Greek-Revival-style Quincy Market represented the economic vitality and democratic optimism of antebellum Boston. The Financial District flourished, and banks and insurance companies were incorporated at an unprecedented rate.

Yet some became disillusioned by what they saw as the corruptive influence of State Street business values on American democracy and civilization. "The lesson of these days is the vulgarity of wealth," grumbled Ralph Waldo Emerson. "We know that wealth will vote for the same thing which the worst and meanest of the people vote for." The Panic of 1857 and onset of the Civil War in 1861 further shook the city's confidence in its capitalist leaders, as investigations uncovered greed and graft that jeopardized the war effort. Historian Howard Mumford Jones

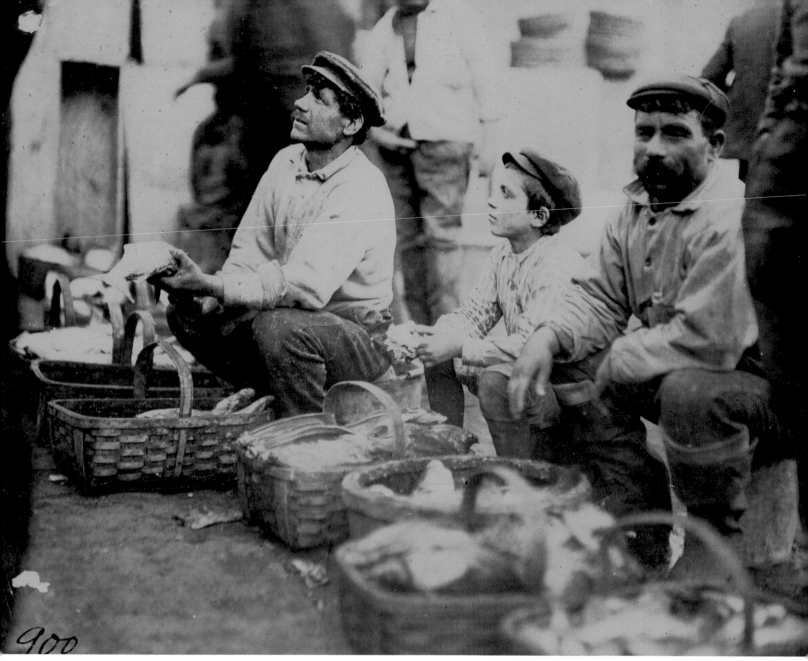

900

tells the story of indignant soldiers dumping inferior overcoats onto State Street as they marched by. A disappointed Charles Francis Adams believed that conservative Boston businessmen had surrendered the enterprising initiative to rival New York.

As if to prove Adams's point, the design of Boston's Custom House Tower, built in 1915, was curiously imitative of the Metropolitan Life Insurance Building in New York. The landmark tower nonetheless became a symbol of the Financial District's prosperous new heights and stood for decades as Boston's tallest structure. That it now houses luxury time-share suites says as much about the changing nature of Boston's waterfront as it does the renewed affluence of the Financial District.

## Waterfront

It was rather hard to escape the waterfront in Boston's early days. With its lone land entrance prone to flooding, Shawmut Peninsula was nearly an island, and most people traveled to and from the seaport by ship. But it was no easy trip. Boston Harbor had only a single, narrow shipping channel with plenty of rocks and shoals to ensnare the unwary sailor. Captains relied on landmarks such as the Boston lighthouse and Fort William on Castle Island to guide them safely into the town, which cut an impressive figure against the ocean tide. As Abbé Robin's vessel sailed past the islands that

dotted the harbor, he spied "a magnificent prospect of houses, built on a curved line, and extending afterwards in a semicircle above half a league." "This was Boston," he wrote excitedly in his 1781 journal. "These edifices, which were lofty and regular, with spires and cupolas intermixt at proper distances, did not seem to us a modern settlement so much as an ancient city, enjoying all the embellishments and population, that never fail to attend on commerce and the arts."

The largest ships headed toward Long Wharf, which stretched nearly 2,000 feet into the harbor to welcome them. It was a major engineering feat for eighteenth-century New England and invariably impressed visitors. Many of the smaller wharves

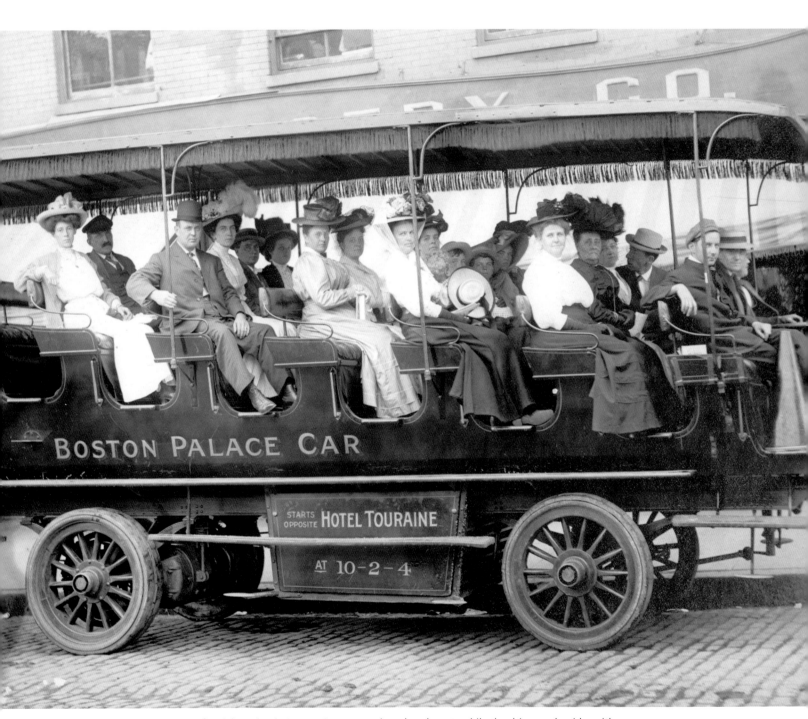

*Boston Palace Car, Open car for sightseeing in Boston. Passengers sit on bench seats while the driver and guide, with bullhorn, sit in the front. Sign on car indicates that the car "starts opposite Hotel Touraine at 10-2-4", circa 1910.*

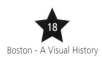

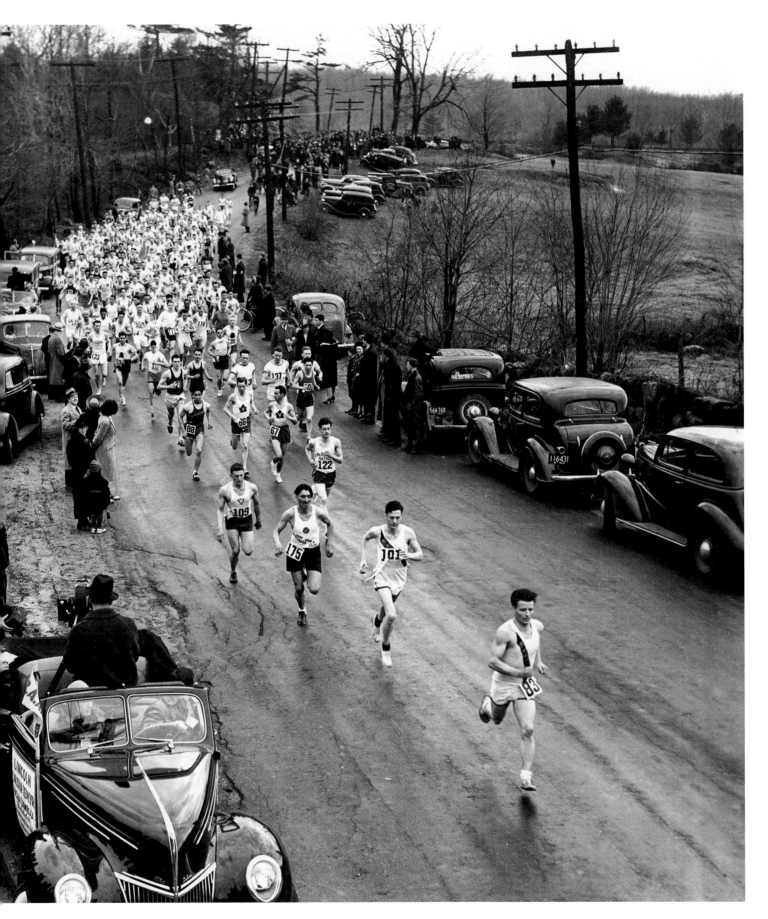

Boston: The City Upon A Hill

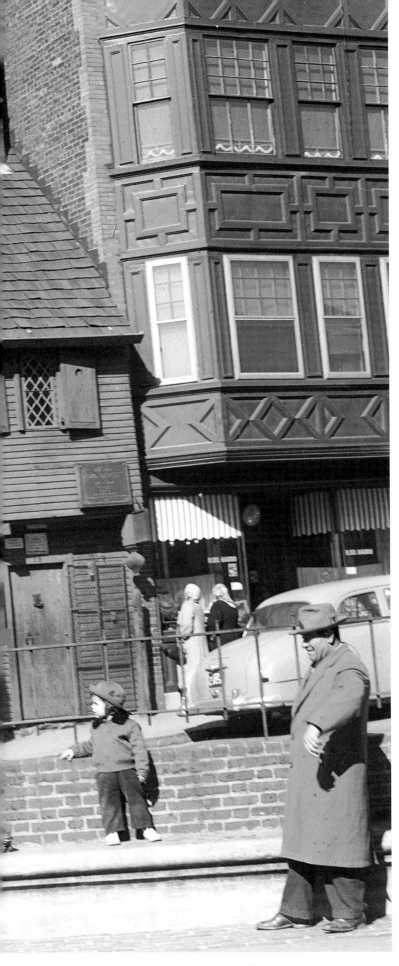

of Massachusetts as "a kind of Highlands with us for Incivility and Irreligion, Licentiousness and Ignorance." Colman was not alone in such sentiments. Visitors to the countryside often mocked the efforts of rural families to be as urbane as the Bostonians. It would seem that the city's sense of its self-importance began long before the nineteenth-century notion of Boston as "the hub of the solar system."

Yet Boston's star has never shone so brightly as to obscure its satellites, which sparkle with their own light. As early as 1636, Harvard University marked Cambridge, Massachusetts as an educational center that has even drawn Boston into its orbit. The Weeks Memorial Footbridge enables students to shuttle between areas of the campus, which now spans both sides of the Charles River. Harvard has also exerted a gravitational pull on such schools as the Massachusetts Institute of Technology, founded in Boston but moved to Cambridge in 1916. And in 1936 it attracted Brookline native John F. Kennedy, who graduated from Harvard in 1940 before enlisting in the Navy during World War II. Twenty years later, Kennedy took strength from the Puritan founders as he prepared to assume the Presidency during the height of the Cold War, convinced that the nation was "setting out upon a voyage in 1961 no less hazardous than that undertaken by the *Arbella* in 1630."

It was to the *Mayflower* Pilgrims of 1620 that Massachusetts patriots turned for inspiration during the crisis with Great Britain in the 1770s, creating and celebrating Forefathers' Day as an act of prideful defiance and a precursor to the modern Thanksgiving holiday. When the clouds of war and revolution enveloped Boston in those dark days, other towns began to emerge from its shadow. Salem and other Essex County seaports experienced a golden age of privateering and commerce as vessels such as the *Friendship* boldly sailed where few New Englanders had gone before, Asia. And as the sun began to set on Britain's American empire at Concord's North Bridge on April 19, 1775, a new dawn emerged there as well. "From the plains of Concord will henceforth be dated a change in human affairs, an alteration in the balance of human power, and a new direction to the course of human improvement," predicted Timothy Dwight in 1796. Like the golden dome of Boston's State House, Massachusetts' brilliant past continues to shine like a beacon, lighting the way toward a brighter future.

*Group of children pose in front of the Paul Revere House, by Leslie Jones, circa 1954.*

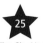

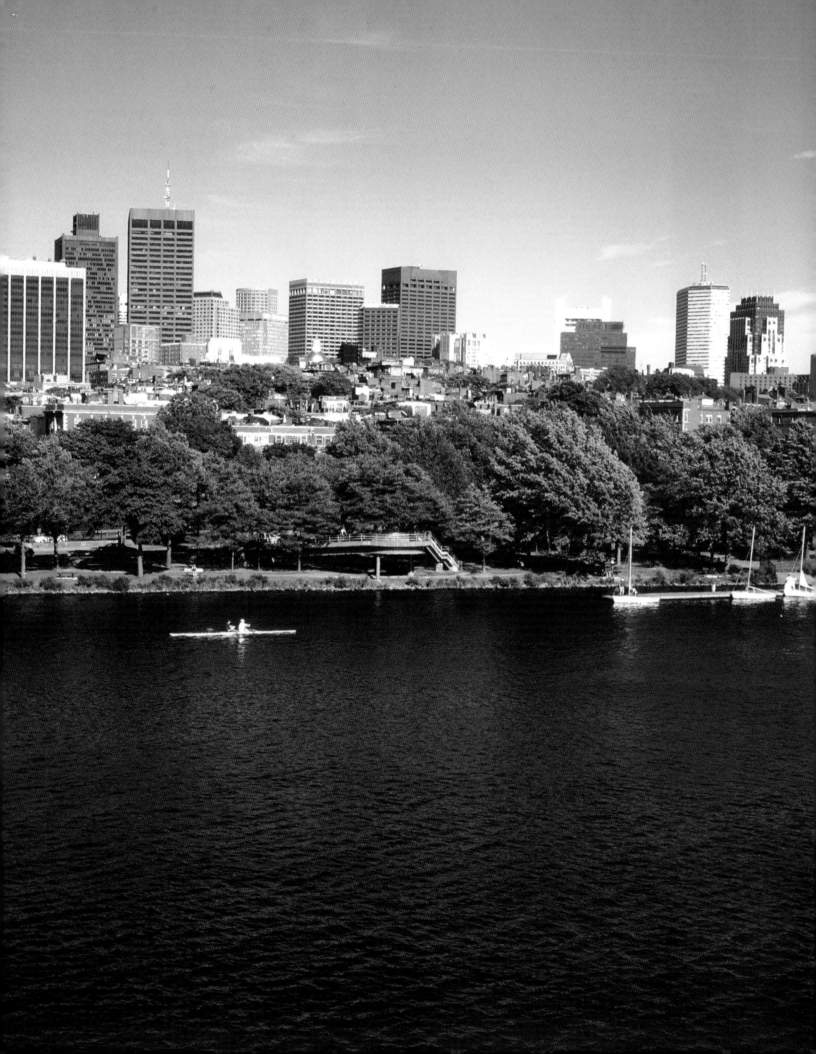

# Beacon Hill

\* \* \* \* \* \* \* \* \* \* \* \* \* \* \* \* \* \* \* \* \* \* \* \* \* \* \* \* \* \* \* \* \* \* \* \* \* \* \* \* \* \* \* \* \* \* \*

*Beacon Hill viewed across the Charles River.*

# Massachusetts State House

Although it represents the entire Commonwealth, the golden-domed Massachusetts State House has been one of Boston's most recognizable landmarks for centuries. Independence from Great Britain had rendered the Old State House on State Street obsolete, prompting a movement in the 1780s to build a larger, more fitting structure somewhere else. But where? Some argued that Boston itself was too reminiscent of the old colonial order to act as the new state capital and suggested that a state house be constructed in another town, perhaps Worcester, where a number of Bostonians had fled during the British occupation. The town of Plymouth, which predated Boston by some ten years, also expressed serious interest in becoming the state capital.

Realizing that it was in danger of losing its traditional pre-eminence, Boston bought a plot of land once owned by John Hancock and offered it to the Commonwealth in 1795 as a site for the new state house. The 1.7 acre-Beacon Hill location, which overlooked Boston Common, had several advantages, not the least of which was aesthetic. It was also in a relatively undeveloped section of the city. This provided plenty of space to build and avoided the crowded conditions that had dogged the Old State House downtown. Officials agreed that it would be an ideal place for a capitol building.

The choice of an architect to design the new state house was simple. Boston native Charles Bulfinch had already made a reputation for himself as a professional architect after building the Hartford State House in Connecticut and the beautiful Boston Theater locally. He was eager to make his hometown the architectural equal of Europe's greatest cities, which he had visited during an extensive tour in 1785 and 1786. According to historian Harold Kirker, Bulfinch's design for the Massachusetts State House was a modified version of the Somerset House of government in London.

Governor Samuel Adams and Paul Revere laid the building's cornerstone on July 4, 1795 in an elaborate ceremony featuring fifteen white horses, one for every state in the Union at the time. During work on the building in 1855, this famed cornerstone and its encapsulated contents underneath, which included early Massachusetts coins and an inscribed silver plate, were found to be in rough shape. They were refurbished and reinserted under a new cornerstone.

Twice during the antebellum era, first in 1831 and then as part of the 1855 construction, new additions were made to the north side of the State House, away from the Common. The interior of the original building was remodeled after the Civil War, and the so-called "Brigham extension" was added to the northern part of the property in the 1890s. These additions and alterations were necessary to keep pace with the state's expanding government and to ensure that the building could continue to function as the capitol. None were allowed to overshadow the architectural elegance of the original structure. The East and West wings of the State House, added between 1914 and 1917, provide a good example, as their simple marble and granite facades stand subordinate to Bulfinch's rich, redbrick design.

The State House's distinctive red bricks were not always so admired, however. They were painted yellow for much of the nineteenth century and only returned to their natural color in 1928. The celebrated golden dome has also undergone several facelifts over the years. In fact, the original Bulfinch dome was made of wood that quickly deteriorated and was sheathed in protective copper provided by Paul Revere's mill in 1802. The dome first became gilded during America's Gilded Age, when twenty-three carat gold leaf was added in 1874. But fear of German air raids during World War II forced the Commonwealth to paint it an unflattering battleship gray for a time. Restoration of its preferred golden hue has become increasingly expensive over the years. The last such project in 1997 cost taxpayers a whopping $300,000.

The Massachusetts State House isn't just for public officials to enjoy. Indeed, it has long been a popular tourist attraction. Nineteenth-century travelers to Boston invariably visited the building, and many dared climb to the top of the dome for a spectacular view of the city. The grounds are ornamented with statues of influential Massachusetts citizens such as Civil War general Joseph Hooker and President John F. Kennedy. Sculptures of Anne Hutchinson and Mary Dyer, both of whom were persecuted by Puritan authorities, remind passersby of the importance of religious liberty.

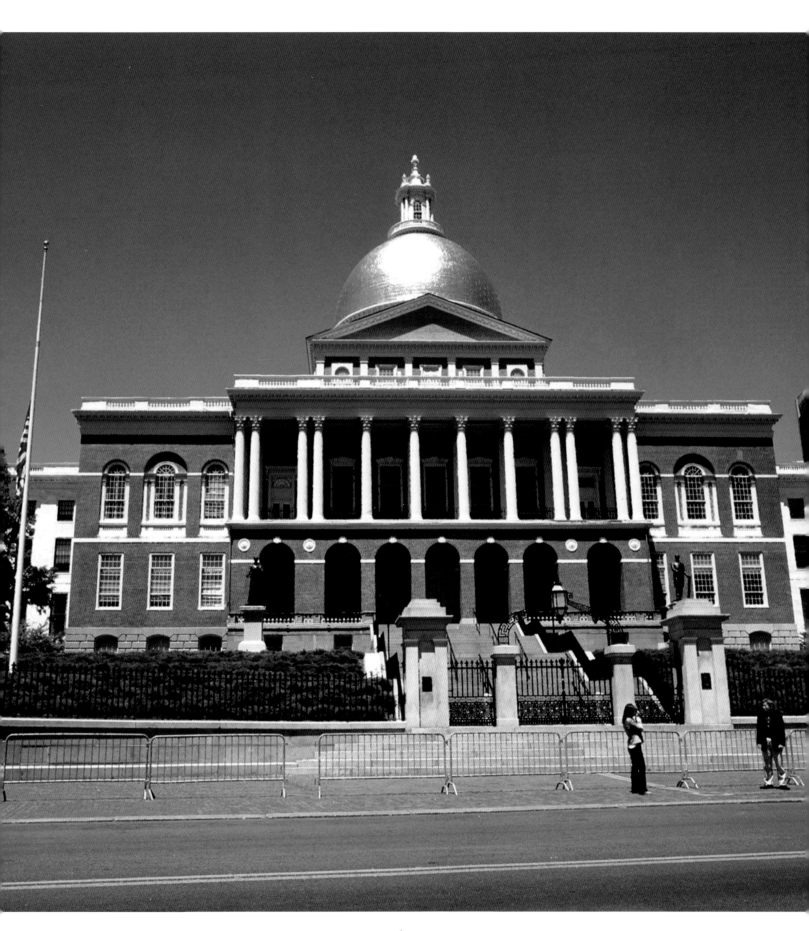

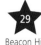

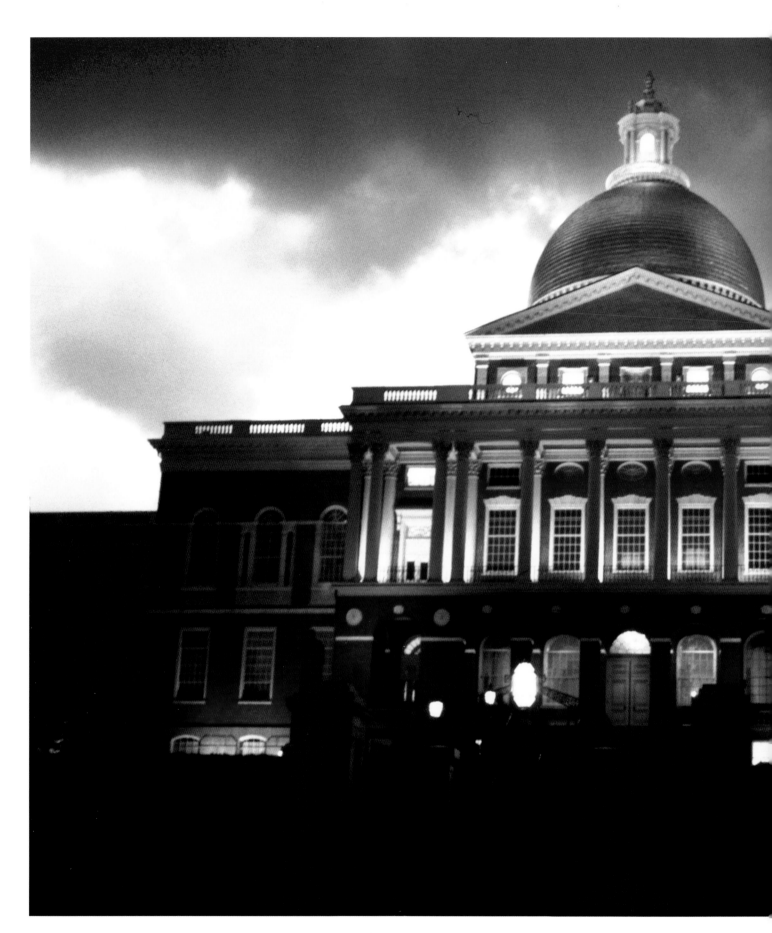

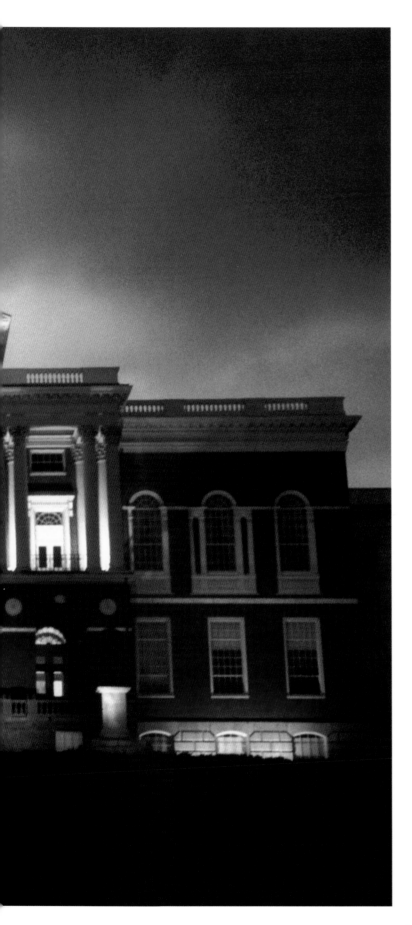

The interior of the State House has become as much a museum as working office space over the years. Memorial Hall, more commonly called the Hall of Flags, once displayed original flags carried by Massachusetts troops into battle, but the stress placed on them prompted their removal in favor of remarkably realistic transparencies in 1987. Included in the collection are hundreds of Civil War flags, but also many flown during the Spanish-American War and each of the major wars of the twentieth century.

The legendary Sacred Cod, which honors the fish's economic importance to the Commonwealth, is a rather unusual specimen that hangs within the House of Representatives' chamber. Originally attached to the Old State House, the wooden cod was removed in 1798 and taken to Bulfinch's newly completed building at the suggestion of merchant John Rowe. It has since become a Massachusetts icon and a prized catch for pranksters.

# Robert Gould Shaw / 54Th Regiment Memorial

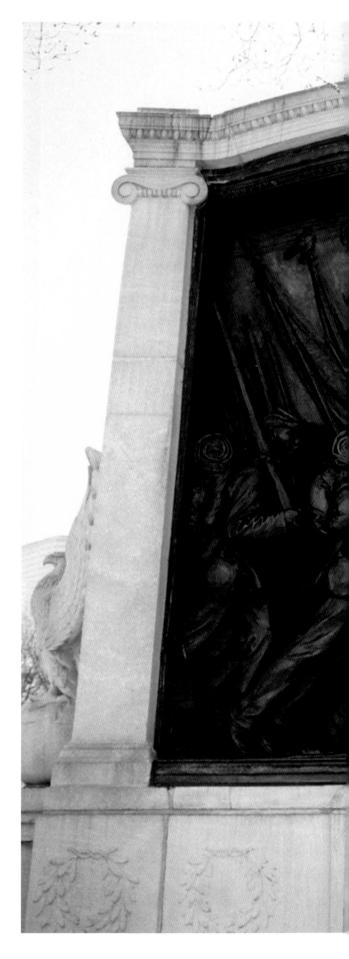

Among the most storied monuments in Boston, the Shaw/54th Regiment memorial honors the courage and sacrifice of the first black volunteer regiment recruited in the North during the Civil War. Enlistees included two sons of the famed abolitionist Frederick Douglass, for whom the regiment represented an opportunity to showcase the skills of black soldiers and destroy Southern slavery in "[o]ne gallant rush."  The white officer chosen to command the celebrated regiment was Colonel Robert Gould Shaw, a relatively undistinguished soldier from a distinguished Boston family. Shaw was no abolitionist and worried about the capacity of his men for battle, yet he understood the political importance of the 54th Regiment to both the abolitionist cause and the state of Massachusetts. This significance was reinforced on May 28, 1863, when the city of Boston gave the regiment a grand send-off as it prepared for deployment in South Carolina. Anxious excitement filled the air as Governor John Andrew reviewed the troops and cheering crowds lined the streets and filled Boston Common to watch the spectacle. The memorial's location across from the State House on Beacon Street marks the parade route taken by the regiment that day. Just two months later, Shaw and over 250 of his soldiers would lose their lives in a failed attempt to capture Fort Wagner, one of several Confederate strongholds guarding the entrance to Charleston Harbor.

Although many members of the 54th regiment performed bravely against superior numbers at Fort Wagner, it was Shaw who garnered most of the attention back in Boston after news of his death reached the city. Governor Andrew created a committee to consider erecting a memorial to the fallen colonel, but his own death in 1867 left the project languishing until the 1880s. Finally, twenty years after Shaw's death, the committee selected Augustus Saint Gaudens, an Irish-born sculptor from New Hampshire, to build the memorial, which went through several incarnations before its official dedication in 1897. By the mid-twentieth century, the memorial was all but forgotten until the Civil Rights movement revived some interest in the site, which served as a meeting place for a 1979 rally. Hollywood paid tribute to the 54th Massachusetts in 1989 with *Glory*, a stirring feature-length film starring Matthew Broderick, Morgan Freeman, and Denzel Washington. Since then, the Shaw/54th Regiment memorial has become one of the more popular sites on several city tours, including the Freedom Trail, the Black Heritage Trail, and the Irish Heritage Trail.

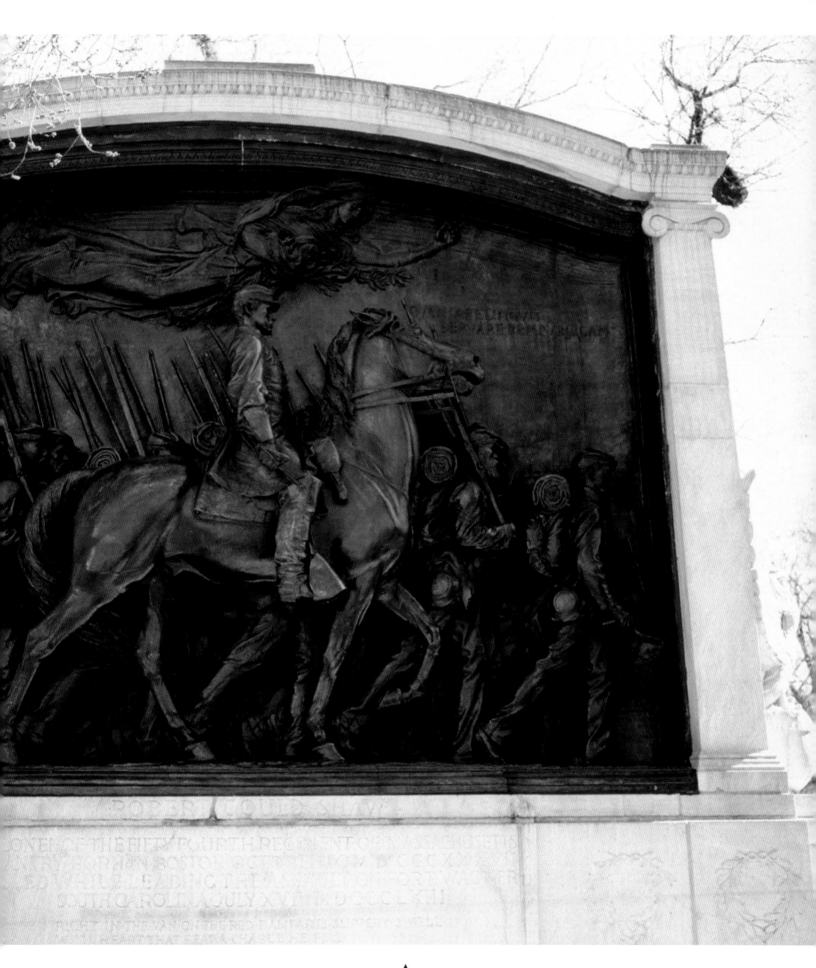

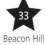

Boston has no shortage of memorials honoring the military service of its citizens, yet few match the grandeur of the Soldiers and Sailors Monument. Perched atop Flagstaff Hill, the Civil War-era monument features a 72-foot column with the statue "Genius of America" overlooking Boston Common, an appropriate site given its importance to the city's military traditions. When

news of the Confederate attack on Fort Sumter reached Boston in April of 1861, state militia regiments were immediately ordered to muster on the Common, which had served such a function since the seventeenth century. The Common served as a parade ground for various regiments throughout the war, including the famed 54th Massachusetts, while the community used it to celebrate signal

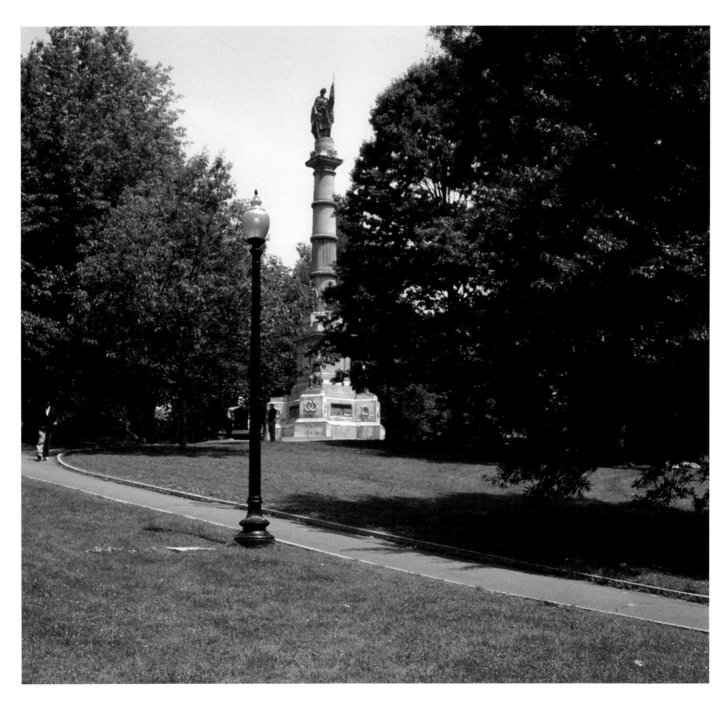

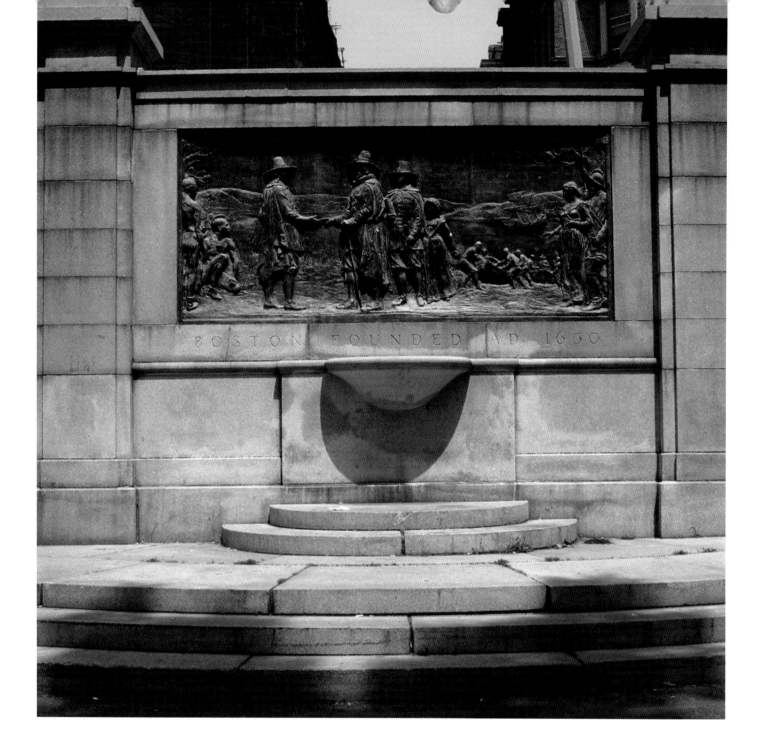

Union victories, such as the fall of Richmond on April 3, 1865. Later that same month, Bostonians gathered together on the Common to mourn the death of President Abraham Lincoln.

After the guns fell silent and the scars of war started to heal, local leaders began planning a memorial to recognize victims of the conflict. Instrumental in this process were members of the so-called Union Club, which had been formed in 1863 to support Abraham Lincoln's war aims. From its headquarters on Park Street across from the Common, the Club gathered public support and helped plan its official dedication, held on September 17, 1877

to mark the anniversary of the Battle of Antietam as well as Boston's founding.

Since its dedication, the Soldiers and Sailors Monument has been included in many of the city's military celebrations and has acquired meaning for veterans of modern wars as well.

Another important monument on Boston Common pays tribute to the founders of the city who arrived after a long sea voyage to the Shawmut Peninsula, as it was known by the Native Americans (below). The Puritans renamed it Boston shortly after establishing their religious colony in 1630.

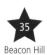

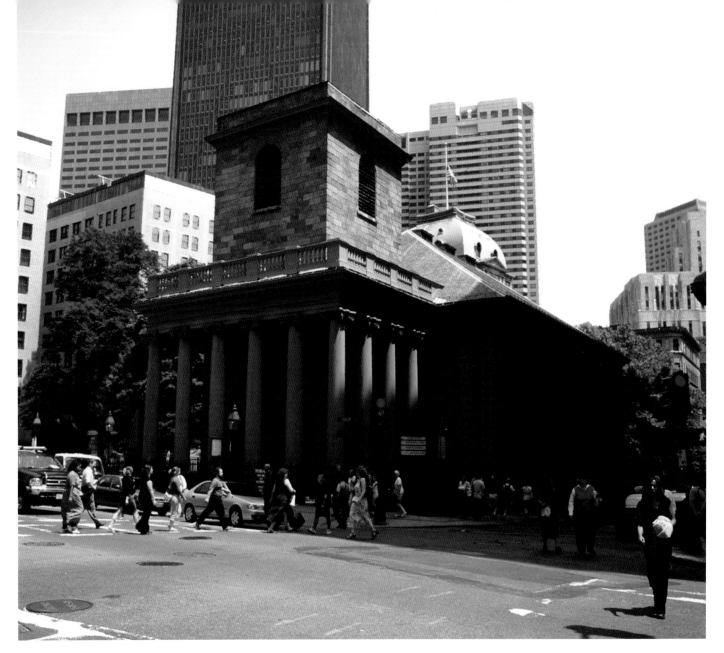

# King's Chapel

Looking upon King's Chapel today, with its solid granite design, the casual observer would hardly believe that Boston's first Anglican church held a very precarious position in the community after its establishment in 1686. But if one recalls that the city's Puritan founders had left England in 1630 partly to escape persecution from the Church of England, its presence becomes curious and its controversial origins clearer. Decades of mistrust between the Stuart monarchs and the Massachusetts Puritans led the King to revoke the colony's original charter of self-governance in 1684 and personally appoint a governor, Sir Edmund Andros, to rule in his name. Already upset by the political changes, Bostonians

were further dismayed to learn that Andros was an Anglican who insisted that Church of England religious services be offered in the town, something that had been previously banned. The location where Andros decided to build his church, on the corner of Tremont and School Street, also proved controversial, since it was the site of the Puritan community's oldest burying ground and final resting place for John Winthrop, the colony's first governor.

Originally a wooden structure, King's Chapel underwent expansion between 1749 and 1754, employing the designs of Newport, Rhode Island architect Peter Harrison. Due to cost overruns and the outbreak of the American Revolution, however,

its steeple was never completed. During the Revolutionary War, British officers worshipped at the church and spared it the destruction they visited upon several Congregational churches in town. In fact, following the British evacuation of Boston in 1776, the building was shared with members of the Old South Meetinghouse until repairs to their church were completed. Since it was politically incorrect after Independence to refer to the structure as "King's" Chapel, locals began calling it the "Stone Chapel" instead. President George Washington sat in the old royal governor's pew for a 1789 concert in his honor, a symbolic act whose meaning was lost on no one. Although today a Unitarian church, King's Chapel serves as a tangible reminder of Boston's estrangement from and eventual reconciliation with its English ancestry.

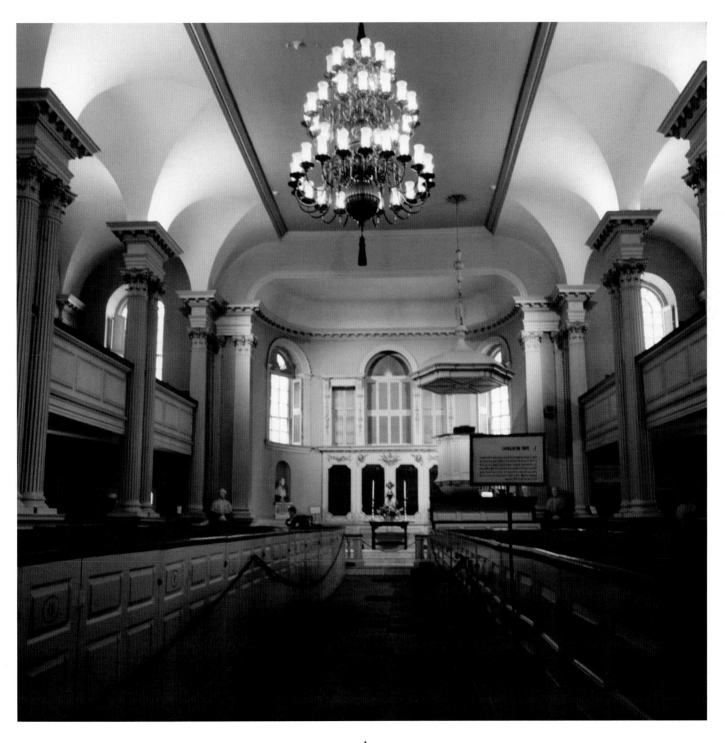

# Old Granary Burying Ground

In Old Granary Burying Ground, the dead do tell tales. Samuel Adams, John Hancock, and Crispus Attucks all speak of war and revolution; Peter Faneuil and Paul Revere call attention to ethnic identity, while the Franklin family attests to enduring parental devotion. Many of the headstones chronicle New England's evolving religious values.

The first story Old Granary tells is of Boston's growing population and its struggles against disease in the seventeenth century. Thirty years after the town's founding in 1630, its original burying ground (located next to King's Chapel today) filled up quickly as the first generation of Puritans aged and passed away. To serve those in the central and southerly end of town, local officials in 1660 created the Old Granary Burying Ground on what was then the northeast corner of Boston Common. Many of the earliest burial markers were made of wood and have long since disappeared, leaving John Wakefield's 1667 tombstone as the oldest in the yard.

The curious name for the burying ground originated in the early eighteenth century when the town erected a public granary, hoping that it would prevent the sorts of food shortages and rioting that had plagued the community during Queen Anne's War. The site is now occupied by the beautiful Park Street Church, built in 1809 and mistakenly assumed by visitors to be connected to the graveyard. Another common misconception about the burying ground is that Benjamin Franklin, a Boston native, is buried within its walls. The source of this fallacy is a twenty-one foot obelisk erected to honor his parents, who are interred there.

A number of Franklin's fellow revolutionaries have found their way into Old Granary, however. John Hancock and Samuel Adams, both of whom joined Franklin in signing the Declaration of Independence, are perhaps the best-known patriots buried there, but Robert Treat Paine, James Bowdoin, and Paul Revere are also present. Both Bowdoin and Revere descended from French Huguenot families, Protestants who fled Catholic France in the seventeenth century. Several such families found success in Boston, including the Faneuils, whose money financed construction of Faneuil Hall in the 1740s. A far corner of Old Granary contains the remains of Peter Faneuil and numerous French Huguenot immigrants.

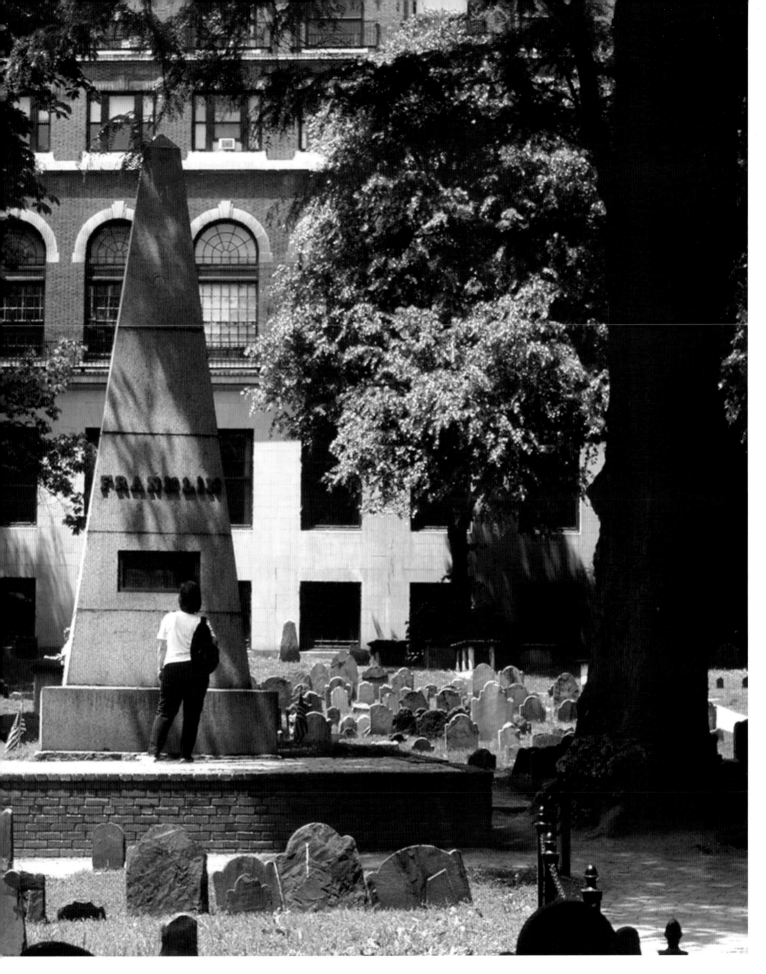

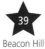

# Boston Athenaeum

Lovers of learning have called 10½ Beacon Street home for over 150 years. Through its doors can be found one of the largest and most prestigious private libraries in the United States, the Boston Athenaeum. Education and literary pursuits had been hallmarks of the community long before the Anthology Society, a gentlemen's social and literary club, opened the Athenaeum on Court Street in 1807. However, there was growing concern that Boston was losing status to other cultural centers in the new nation and that the democratic politics of the era were undermining a classical education. The Athenaeum was designed to remedy this situation by offering its members exclusive access to the finest works of history, literature, and philosophy then available.

New England's finest scholars and writers were invariably attracted to the Athenaeum's vast collection. Indeed, the Athenaeum contributed in no small measure to Boston's reputation as the "Athens of America" for its commitment to learning in the nineteenth century.

# Nichols House

Jonathan Mason commissioned architect Charles Bulfinch to design the row house at 55 Mount Vernon Street as a future home for one of his five daughters in 1804. Mason had once been a law clerk for John Adams, who advised him to stick to his studies rather than rush off to battle in 1776: "We cannot be all Soldiers, and there will probably be in a very few years a greater Scarcity of Lawyers & Statesmen than of Warriors." It was sage advice, for Mason would soon move on to serve in the Massachusetts legislature and later the United States Senate.

In 1795, Mason joined with Harrison Gray Otis and several other wealthy Federalist gentlemen to form the Mount Vernon Proprietors, a syndicate that sought to develop the land around Beacon Hill. Plans were then underway to build a new State House nearby, and property values in the area were sure to rise as a result. The Proprietors negotiated the purchase of unimproved land owned by the portrait artist John Singleton Copley, who spent most of his time in England and was largely unaware of Boston's growth. After his agent signed the deed, however, Copley realized his mistake in selling such valuable land and unsuccessfully tried to void the transaction.

Having completed the largest land transfer in Boston's history to that point, the Mount Vernon Proprietors set to work laying out streets and building homes. The original plan called for Mount Vernon Street to feature mansion-houses set back thirty feet from the roadway, and Mason himself was the first to construct such a stately edifice in 1800. But Stephen Higginson, Jr. broke the mold in 1803 when he hired Bulfinch to build him a series of row houses that he sold off the next year. Mason quickly followed suit with the houses for his daughters, 51-57 Mount Vernon Street. Of the four buildings, only Number 55 retains much of its original appearance.

Several well-known figures have resided in the brick townhouses over the years. Number 57 was the home of Daniel Webster for a few years in the 1810s, while the famed landscape designer Rose Standish Nichols lived at Number 55 until her death in 1960. Nichols, who never married, inherited the four-story residence from her affluent parents and maintained it with earnings from her landscaping and published works on the subject. She also actively campaigned for women's rights and international peace, working alongside such reformers as Jane Addams. When she died, Nichols requested that her house and its furnishings become a museum, which it remains to this day.

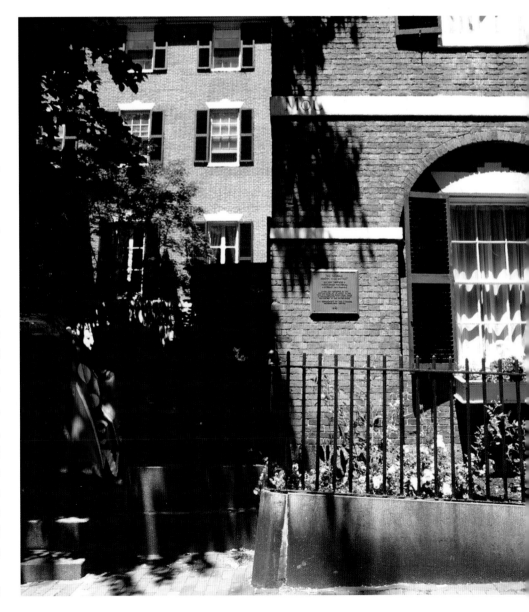

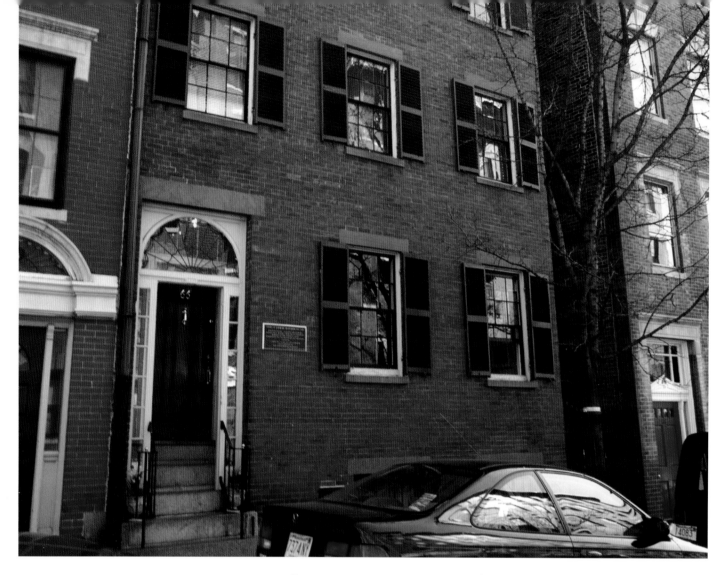

# Lewis and Harriet Hayden House

**B**ehind the unassuming brick walls of their home on 66 Phillips Street, abolitionists Lewis and Harriet Hayden operated Boston's main depot on the Underground Railroad, earning it affectionate nicknames such as "citadel of liberty" and "temple of refuge." It is difficult to know the precise number of fugitive slaves who were secreted through its doors or into its narrow, subterranean passageway during the 1850s, but by all accounts it was considerable. Having escaped bondage in Kentucky, Lewis Hayden empathized with the enslaved and was determined to do everything in his power to liberate them. Twice in the early 1850s, he was arrested and released for his role in plots to free captured fugitives awaiting deportation to the South.

The vitality and leadership of Boston's black community in the fight against slavery had attracted the Haydens to the city in the 1840s. The couple took up residence in the largely African-American neighborhood on the north slope of Beacon Hill. While Lewis opened up a successful used clothing shop on Cambridge Street, Harriet took in tenants at their home— two of the few means of income available to blacks in the seaport. They also began hosting abolitionist meetings, and before long their address was closely identified with the antislavery movement. Wendell Phillips, William Lloyd Garrison, Charles Sumner and other leading abolitionists were regular visitors to the home. John Brown of Harper's Ferry fame also regarded the Haydens as close friends and confidantes.

Once the Civil War broke out in 1861, Lewis Hayden joined Frederick Douglass in calling for the use of black soldiers and sailors in the military, and he helped recruit elements of the 54th Massachusetts regiment. Hayden believed that the historic sacrifices of African-Americans entitled them to the rights of citizenship.

# Edward Hatch Memorial Shell

Warm summer evenings in Boston often bring with them the sounds of outdoor concerts wafting across the waters of the Charles River from the nearby Hatch Memorial Shell. Erected in 1940 as a gift from the estate of Maria Hatch, the 40-foot high band shell (named in honor of her late brother) fronts a two-acre lawn that provides a leisurely atmosphere for taking in all sorts of cultural activities. Easily the most popular is the annual Fourth of July extravaganza featuring fireworks and performances by the Boston Pops Orchestra, which routinely draws hundreds of thousands from New England and beyond. But public concerts in the park could be heard as far back as the 1910s, shortly after completion of what was then called the Embankment—a promenade overlooking the scenic Charles River Basin. Now known as the Esplanade, the area was improved in the late 1920s through the philanthropy of Helen Osbourne Storrow and became a fashionable retreat for Beacon Hill and Back Bay residents. A young Arthur Fiedler brought the Boston Pops to the Esplanade in the summer of 1929, marking the beginning of a longstanding tradition.

Today the Hatch Memorial Shell is more popular than ever. Beyond the Pops, the site plays host to jazz festivals, rhythm and blues acts, rock groups, and reggae bands as well as sponsoring "Free Friday Flicks" for movie buffs.

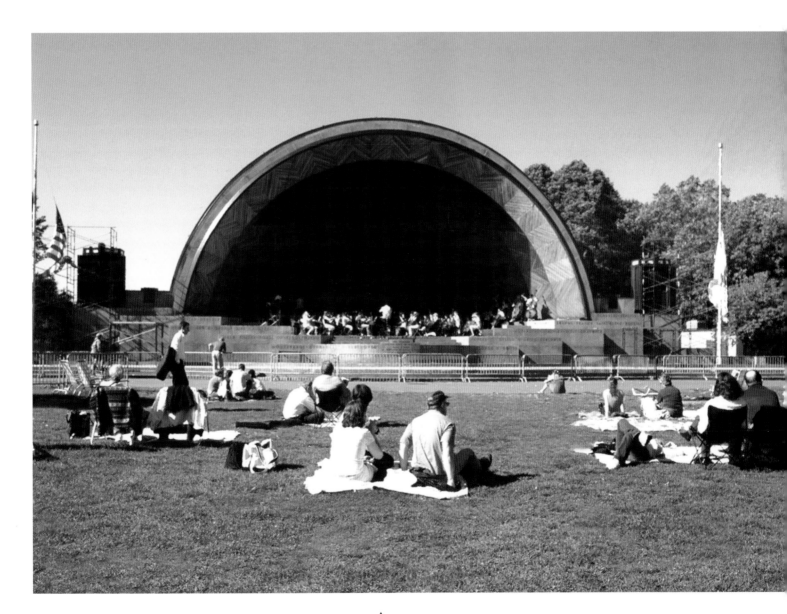

Since abolitionist William Lloyd Garrison described it in 1832 as an "obscure school-house," the African Meeting House has become a national landmark and a major attraction on Boston's popular Black Heritage Trail. Brought together by the end of slavery in the state and continued discrimination from whites, Boston's black population increasingly congregated on the north side of Beacon Hill after the Revolution. There they built the African Meeting House in 1806 as a place where they could freely gather to worship, to educate and entertain each other, and to push for the end of slavery in the new nation, which earned it the nickname "Abolition Church."

The meetinghouse proved priceless to Boston's black community. No longer forced to endure segregation at white churches or to borrow space at Faneuil Hall, they could enjoy the sermons of Baptist minister Thomas Paul in the upstairs hall.

Downstairs they set up a school for their children, who were as yet unwelcome at local white schools. During the Civil War, it served as a recruiting center for black soldiers and organized fundraisers to support the troops.

The post-Civil War period saw Boston's black population shift away from Beacon Hill toward the South End and even into neighboring Roxbury, which, along with the successful abolition of slavery in 1865, reduced the role of the African Meeting House in the community. At the same time, growing numbers of Jewish immigrants began moving into the area and purchased the building for a synagogue, a function it performed for most of the twentieth century. In 1972, however, the newly founded Museum of Afro-American History in Boston purchased the building and reclaimed it as part of the nation's black heritage.

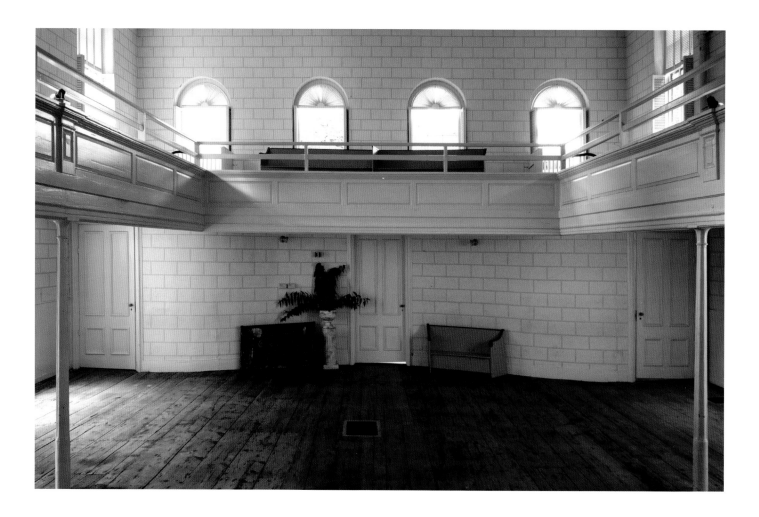

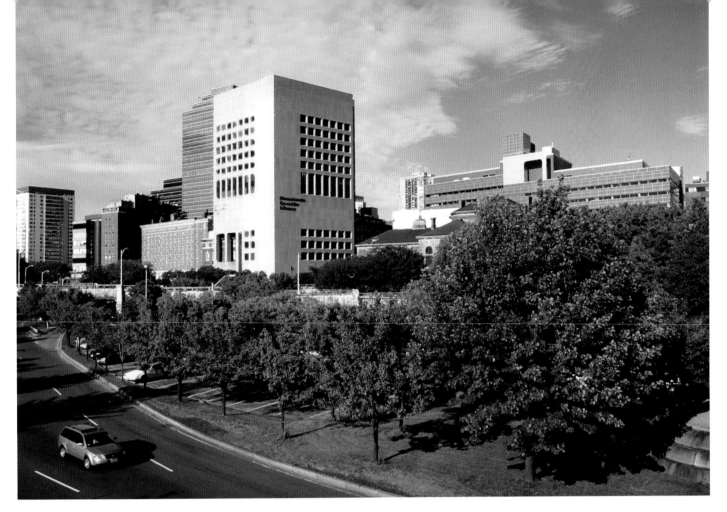

# Massachusetts General Hospital

**\*\*\*\*\*\*\*\*\*\*\*\*\*\*\*\*\*\*\*\*\*\*\*\*\*\*\*\*\*\*\*\*\*\*\*\*\*\*\*\*\*\*\*\*\*\*\*\*\*\*\*\*\*\*\*\*\*\*\*\*\*\*\*\*\*\*\*\***

Few institutions have proven more vital to Boston's development over the past two centuries than Massachusetts General Hospital. Founded in 1811, it is the oldest and largest hospital in New England, performing tens of thousands of surgeries every year and employing more workers than any nongovernmental agency in the city. Its cutting-edge research facilities reflect the hospital's historic and enduring relationship with the Harvard Medical School, and its commitment to innovative healthcare is evident in a research budget that annually exceeds $700 million. Progressive treatment methods contribute to Massachusetts General's reputation as one of the leading hospitals in the United States.

A major medical advance for which the hospital can claim credit is the first successful use of anesthesia in the operating room. Dr. William Morton had previously applied ether to his dental patients before offering it to Dr. John C. Warren, chief surgeon and co-founder of Massachusetts General Hospital, to help remove a tumor from the jaw of Gilbert Abbott in 1846. News of the event thrilled the medical community, prompting one doctor to declare, "every one who has any sympathy for human suffering must rejoice in the discovery." The operation has been memorialized on a monument located in the nearby Public Garden.

In spite of triumphs such as the discovery of anesthesia, some Bostonians cast a suspicious eye on the research being done for Massachusetts General in the 1830s and 1840s. Rumors were rife that so-called "resurrection men" were hired to secretly exhume bodies for use at the Boston Medical College next to the hospital. And when Dr. George Parkman went missing in 1849 only to be found murdered at the college, presumably at the hands of Dr. John Webster, the news led to rioting outside the hospital grounds. Massachusetts General and the Medical College survived the scandal, however, and during the Civil War provided emergency services for the Union cause. Since then the hospital has acquired a reputation as a world-class facility, enhanced in 2011 with completion of the fourteen-floor, state-of-the-art Lunder Building for cancer treatment and neuroscience.

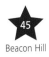

# Back Bay

********************************************************

*Boston's famed Swan Boats on Public Garden Lagoon.*
*Actors Grace Kelly, Shirley Temple, Bette Davis, Ted Danson,*
*Mark Wahlberg, and director Rob Reiner are among the*
*many celebrities to have enjoyed a leisurely cruise on the*
*Garden's famed Swan Boats over the years.*

# Public Garden: George Washington Equestrian Statue

Thomas Ball's 1869 equestrian statue of George Washington in Boston's Public Garden reflects the mood of the post-Civil War period, when a bloodied nation craving peace and unity anxiously turned to its Founders for strength and reassurance. Unveiled for the Fourth of July, Ball's remains the most beloved of the three Washington statues erected in Boston. Washington cuts a commanding figure in his military uniform, sitting over thirty feet above the ground astride his bronze mount and atop a granite foundation. He commanded the revolutionary army that drove the British King's troops out of Boston in the spring of 1776, an event still celebrated every March 17th as Evacuation Day. Ironically, his statue stands not far from where British soldiers had embarked upon their fateful march to Lexington and Concord in 1775.

The sculpture's appeal is surely enhanced by its verdant surroundings. Although botanical gardens had existed on the site since the 1830s, the Public Garden was just coming into its own when Ball's statue debuted in 1869. The area had been little more than a marshy tidal basin when Washington knew the city in the 1770s. But Boston's increasingly urban character in the antebellum era put pressure on the community to fill the Back Bay for land development. Instead of smelly mudflats, which they worried would compromise people's health, a few influential inhabitants envisioned fragrant flowers. Led by Horace Gray, a wealthy industrialist and avid gardener, they joined together in 1837 and created a botanical garden complete with a conservatory. The town took over the property in the 1850s and developed it further, giving Bostonians the distinction of possessing the first public garden in American history. A favorite retreat for locals and tourists alike on warm, sunny days, the Garden features a man-made pond where one can board one of Boston's famed Swan Boats for a leisurely cruise.

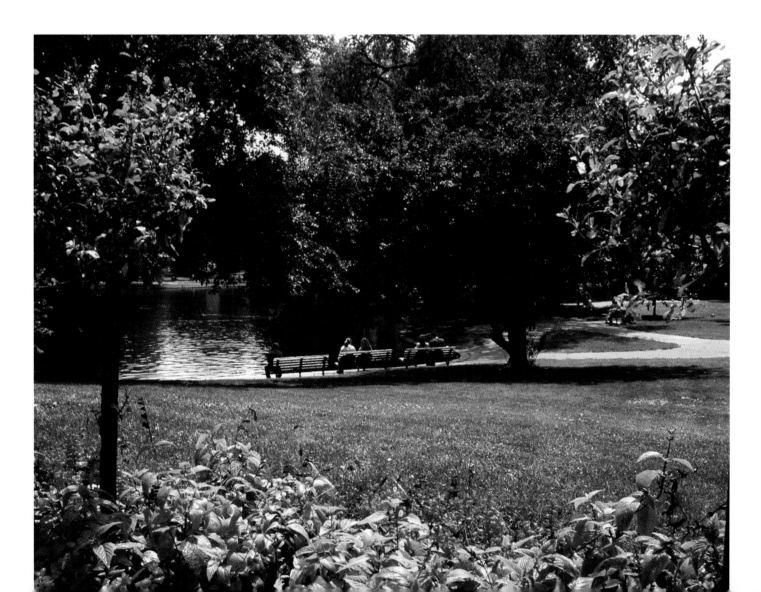

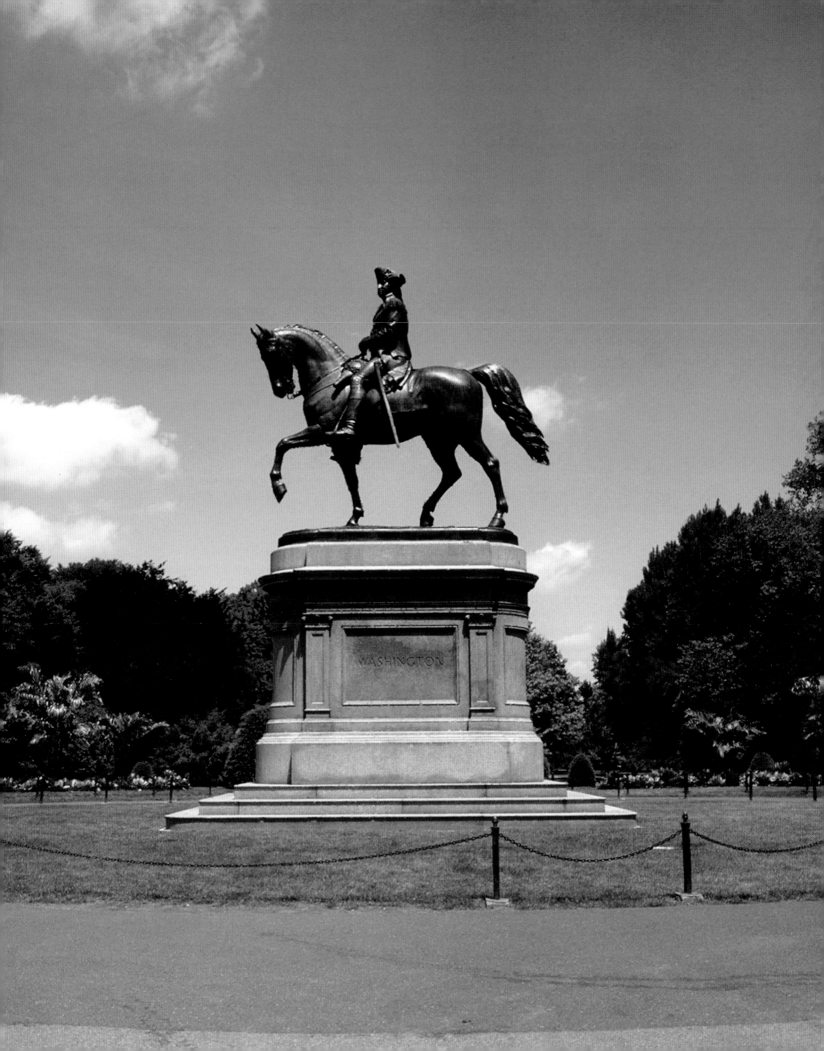

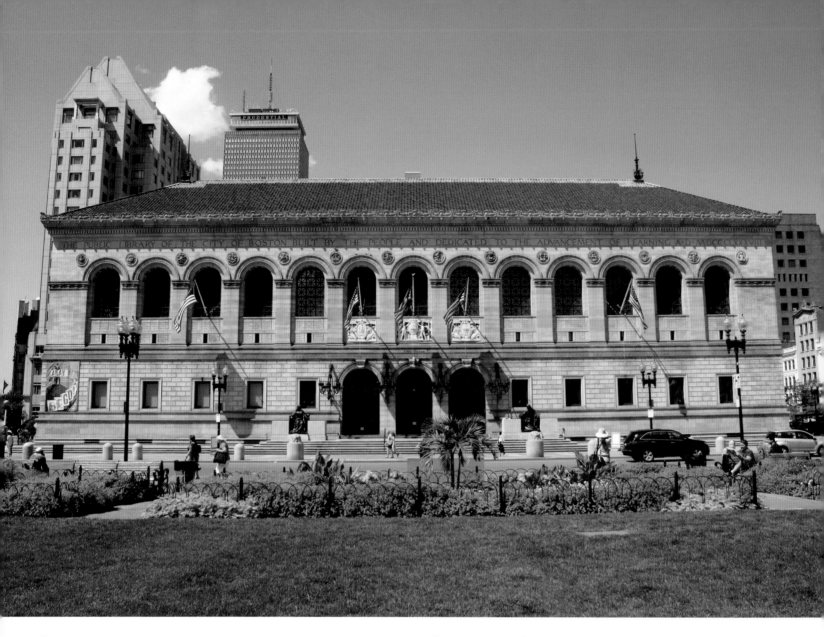

# *Boston Public Library*

\* \* \* \* \* \* \* \* \* \* \* \* \* \* \* \* \* \* \* \* \* \* \* \* \* \* \* \* \* \* \* \* \* \* \* \* \* \* \* \* \* \* \* \* \* \* \* \* \* \*

If H.H. Richardson's Trinity Church has an architectural equal in Boston, it would be its Copley Square neighbor, the Boston Public Library. Opened in 1895, the building came with a staggering $2.5 million price tag, which today seems a small price to pay for masterpieces by some of the era's best architects, sculptors, and artists. The intent of the library was to celebrate and inspire the advancement of learning not only through the books on the shelves, but also the paintings on the walls and even the walls themselves. Several architects were turned down before the library's trustees found someone who shared their bold vision, Charles Follen McKim of the renowned New York firm of McKim, Mead, and White.

No one disputed the fact that Boston needed a new public library by the 1880s. The original library had been founded in the early 1850s after city officials threatened to appropriate the Boston Athenaeum's private holdings for public use. Unwilling to see their exclusive society opened to the masses, yet believing in the value of libraries for shaping popular values, members of the Athenaeum were active in the creation of a public library. Temporary quarters were established on Mason Street not far from the Common in 1854, until a more substantial structure could be built on Boylston Street a few years later. The Boston Public Library was the first of its kind in any major American city.

The city's growing ethnic and religious diversity in the post-Civil

# Trinity Church

Given Boston's religious origins and rich spiritual heritage, it is rather fitting that a church should be judged its architectural masterpiece. And yet the Episcopal Trinity Church, built between 1873 and 1877, is precisely the kind of structure the Puritan founders would have found abhorrent. They strove for simplicity in their religious meetinghouses, rejecting the elaborate designs of European cathedrals in favor of plain wooden structures. Bostonians became more ambitious in the eighteenth century, adding steeples, adorning pews, and employing new building materials in their churches. The cosmopolitan tastes of the Anglicans, first evident in King's Chapel and Christ Church (Old North), are often credited with injecting more refinement into local church structure, although the original 1735 Trinity Church had a comparatively uninspiring exterior.

Having survived the Revolution against English authority in the 1770s and 1780s, Trinity thrived in the new republic. Its success as a congregation was manifested in the new, larger, and more elaborate Gothic-style church that replaced its predecessor on the Summer Street site in 1829. This solid stone structure existed until November of 1872, when one of the worst fires in Boston's history gutted the building along with hundreds of others in the downtown district.

To Trinity's new rector, Phillips Brooks, would fall the difficult task of keeping the congregation's faith in the trying times ahead. The spectacular church that now stands on Copley Square is as much a testament to his skilled leadership during the crisis as it is to H.H. Richardson's architectural talents. "The noble structure shall speak the genius of the architect," Brooks told those gathered for

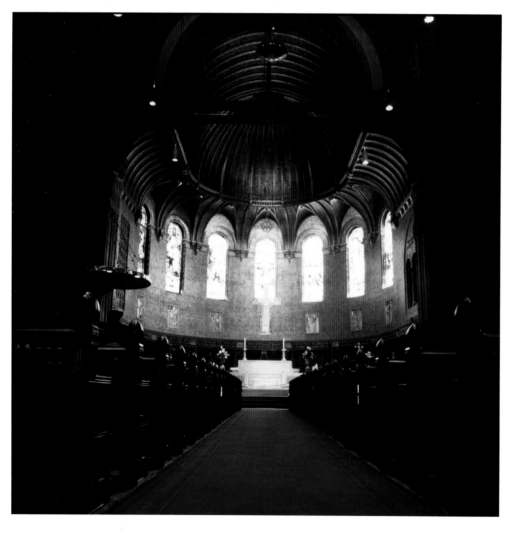

the 1877 dedication. "Its unshaken solidity proclaims the builder's skill and care, but only the gratitude of the people's hearts and the good works that shall be done here, can rightly honor the devotion of those who so long have been the wise and willing servants of the parish."

The solidity of the church's foundation has been shaken only once in the years since its completion, when construction of the neighboring John Hancock Tower in the 1970s shifted soil that cracked Trinity's walls and its precious stained glass. The result was a settlement of $11.6 million for repairs. In 2002, church leaders embarked on a multi-million dollar renovation that included restoration of ceiling murals, stained-glass windows, and the church's organ, as well as creating a geothermal heat exchange to warm the building's basement and create more usable space for the large congregation.

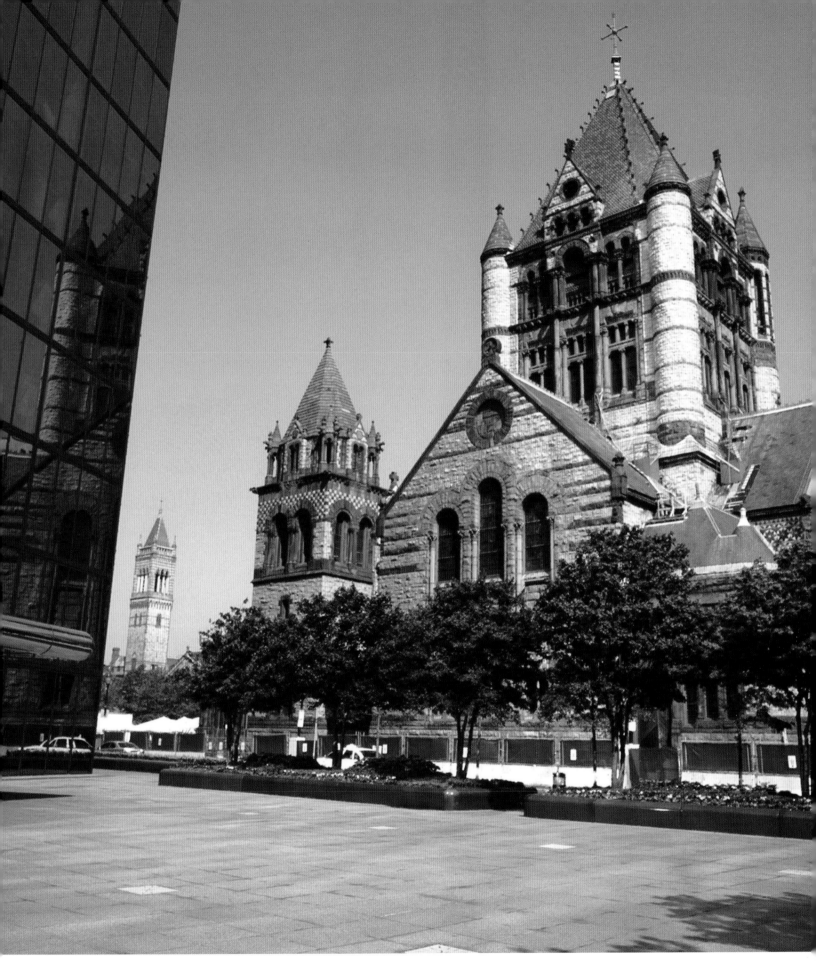

# Old South Church

The construction of Cummings and Sears's magnificent 1875 Italian Gothic church was a bittersweet moment for both the Old South Church congregation and Bostonians generally. For over two hundred years, the congregation had worshipped at their comparatively modest meetinghouse on Washington Street, which had worked its way deep into their hearts. But the city was changing around them after the Civil War. Families that had for generations lived nearby were now moving to the more fashionable Back Bay. The streets surrounding the old meetinghouse were becoming so crowded with commercial traffic and questionable characters that, as church leaders complained, "it is hardly a suitable place for females to walk in the evening." A major fire that devastated the city and damaged the Old South Meetinghouse in 1872 convinced many congregants that the time was right for a move. Although the move was unpopular with some members, construction of Old South's beautiful new Back Bay church got underway in 1872. When it was finished three years later, even critics begrudgingly admired its architecture. The brown, gray, and pink hues of its stonework proved irresistibly charming, and its 246-foot bell tower made it an instant landmark.

While their proud heritage remains, Old South has moved forward as a congregation. In 2005, Nancy S. Taylor became the first female minister in the church's 336-year history, a milestone that reflects the congregation's commitment to inclusiveness. Her progressive policies suggest that Old South will continue to be a leader in the future as it has been in the past. "[Old South] made trouble getting the Boston Tea Party started so many years ago," she proudly proclaims. "And we're going to keep getting into just that kind of trouble."

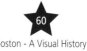

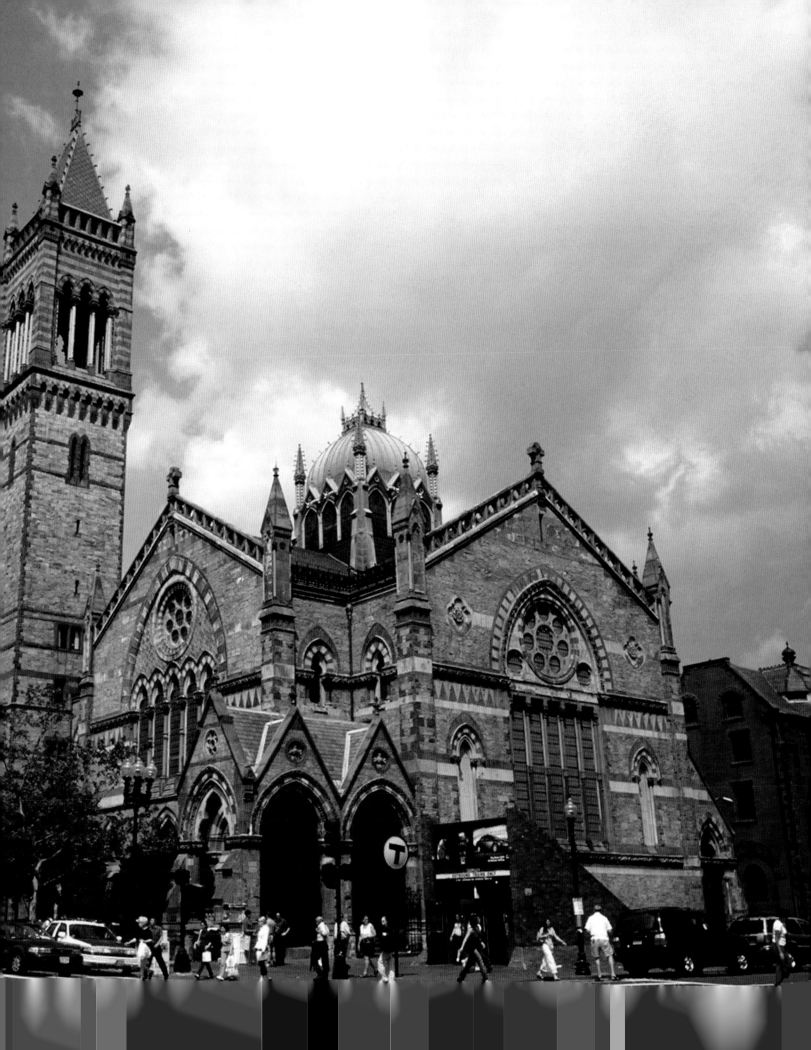

# Boston Women's Memorial

T he 2003 dedication of the Women's Memorial on the Commonwealth Avenue Mall capped a decade-long effort to correct the glaring gender imbalance in Boston's public art. In a city filled with commemorative sculptures, only two previous works had featured women—the statues of Anne Hutchinson and Mary Dyer on the grounds of the State House. Yet even these figures were cast primarily as seventeenth-century religious martyrs rather than as representatives of their gender.

The movement to better recognize women's accomplishments was spearheaded by Stella Trafford, the long-time chair of the Commonwealth Avenue Mall Committee, along with the city's Women's Commission. A task force composed of historians, artists, and interested Back Bay residents was created to launch fundraisers, search for a sculptor, and consider designs for the monument. Response from the community was generally positive, and over $425,000 was raised from public and private donors for the project.

Debates over the design were spirited. Should the memorial feature one woman or several? Should those memorialized be living or dead? What connection, if any, should the women have to

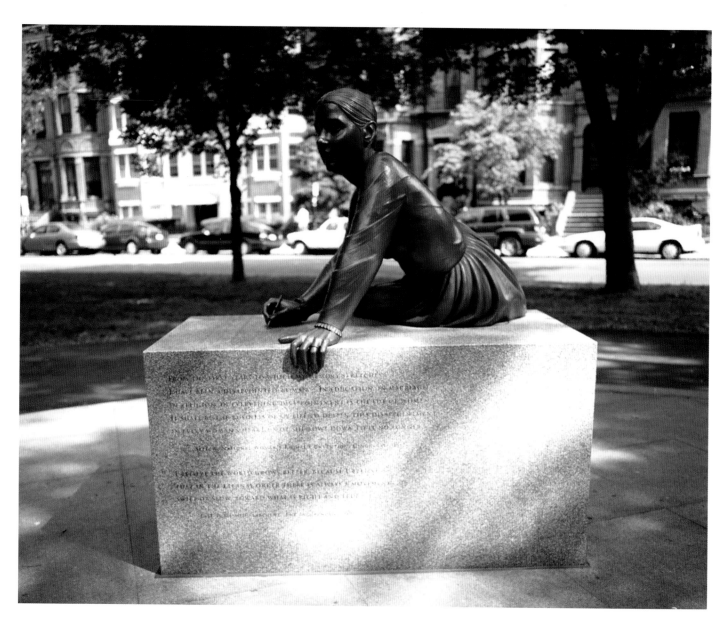

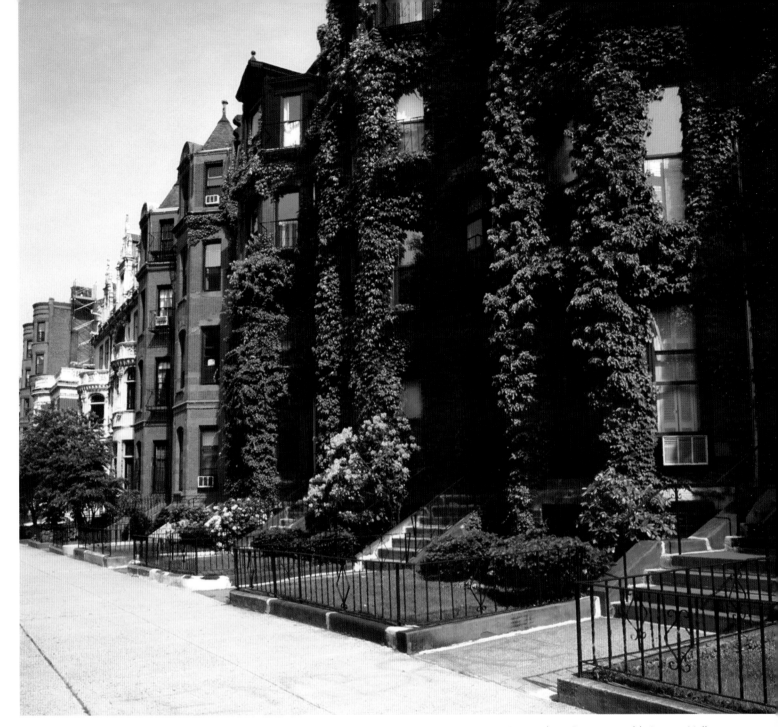

*Houses along Commonwealth Avenue Mall.*

Boston? In the end, the task force settled on three representative women: the African-American poet Phillis Wheatley, the Revolutionary patriot and eventual First Lady Abigail Adams, and the nineteenth-century abolitionist and feminist Lucy Stone.

The design of the Women's Memorial differs from many Boston monuments, which tend to physically distance themselves from the public through the use of pedestals, knolls, and larger-than-life figures. In order to encourage visitor interaction and identification with Wheatley, Adams, and Stone, sculptor Meredith Bergmann took the women off their pedestals and placed them at ground level. This innovative approach is also evident in other statues recently erected in the city, such as those depicting long-time Celtics owner Red Auerbach and former mayor James Michael Curley. But the design has added meaning for women, whom American society once placed on pedestals as domestic angels and shielded from public affairs. It was the kind of attitude that Abigail Adams challenged in 1776 when she warned her husband John that, if women were not considered in the new government, "we are determined to foment a Rebelion, and will not hold ourselves bound by any Laws in which we have no voice, or Representation."

# Vendome Firefighters Memorial

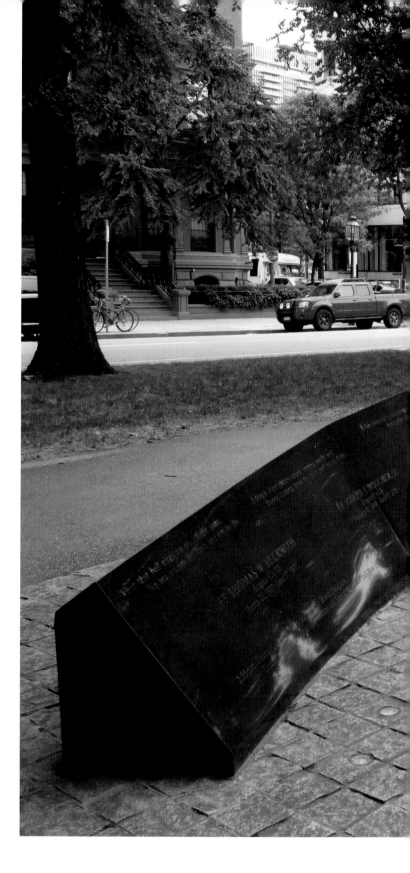

**B**oston has endured many devastating fires over its long history. The Great Fire of 1760 was reportedly so intense that the smoke was visible as far away as Portsmouth, New Hampshire. During World War II, a fire at the overcrowded Cocoanut Grove nightclub shocked the city and the nation. Nearly five hundred patrons and employees were killed in what remains one of the deadliest such fires in American history. But it was the tragedy that took place at the old Hotel Vendome on June 17, 1972 that has seared itself into the community's memory as one of its saddest moments.

Built in the 1870s, the Hotel Vendome reflected the Parisian splendor of Commonwealth Avenue with its mansard roof and French Second Empire design. For many years, it was one of Boston's premier hotels, but by 1972 was being remodeled to house condominiums. On the afternoon of June 17, workmen in the building spotted smoke on one of the upper floors and sounded the alarm. Within minutes the first fire engines arrived to find the fire spreading quickly. Fans at nearby Fenway Park could see the smoke from the stands as several companies converged on the hotel to battle the stubborn blaze, with a number of firefighters having come in before their shifts to help out. By 5:00 p.m. the four-alarm fire was contained and crews were "overhauling" the building to ensure it did not re-ignite. Without warning, a section of the century-old building collapsed, trapping scores of firefighters inside. Nine of them died, still the single greatest death toll in the Boston Fire Department's history. Adding to the sorrow was the fact that many of the men who died were fathers, and the next day was Father's Day. "Telling a son that his father was gone on the morning of Father's Day—it was heartbreaking," recalled Father Daniel Mahoney, who worked as an assistant chaplain for the Boston Fire Department at the time.

For years afterward there was talk of building a memorial to the men. In 1997, to honor the twenty-fifth anniversary of their deaths, the Vendome Firefighters Memorial was dedicated on the Commonwealth Avenue Mall, as a permanent reminder of a day the city has never forgotten. Its sweeping black granite wall bears the name of each man lost and leads the viewer's eye toward the building beyond it where the disaster occurred. A bronze casting of an empty firefighter's coat and helmet draped across the monument symbolizes both the presence and absence of those killed. While art critics have not always embraced the design, with one calling it "a clumsy adaptation of Maya Lin's Vietnam memorial," the community has. In 2001,

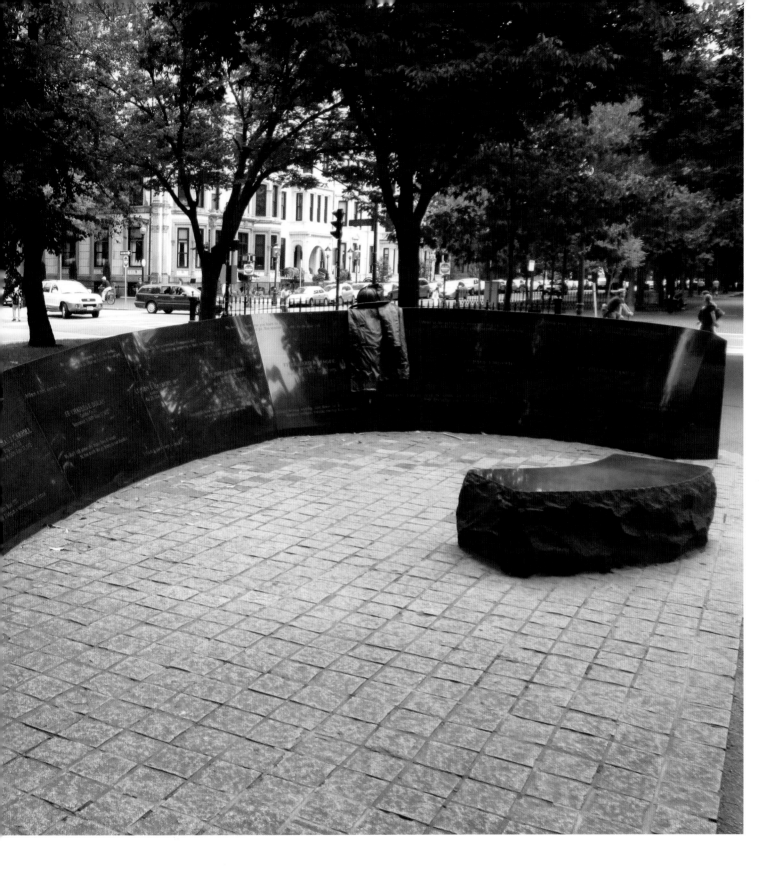

it received renewed attention in the wake of 9/11, becoming a local makeshift memorial to the rescue personnel killed in that tragedy. And in 2012, more than two hundred people, including family members of the fallen, gathered around the memorial to lay wreaths and mourn together forty years to the day after the Hotel Vendome fire.

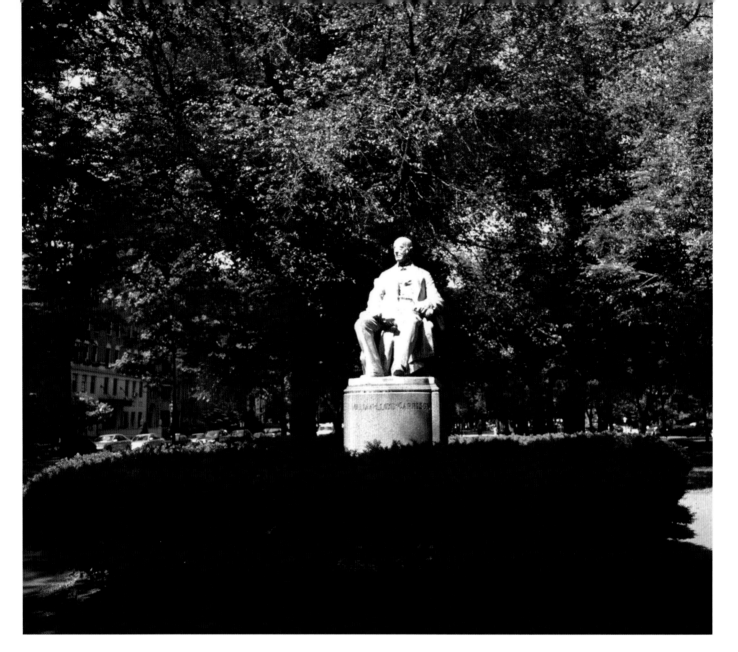

# William Lloyd Garrison Statue

✦✦✦✦✦✦✦✦✦✦✦✦✦✦✦✦✦✦✦✦✦✦✦✦✦✦✦✦✦✦✦✦✦✦✦✦✦✦✦✦✦✦✦✦✦✦✦✦✦✦✦✦✦✦✦✦✦✦✦✦✦✦✦✦

Sitting uncharacteristically quiet on the Commonwealth Avenue Mall is William Lloyd Garrison, the vocal abolitionist leader whose words stirred the conscience of a nation. "I am in earnest," he proclaimed from the pages of his anti-slavery newspaper the Liberator, "I will not equivocate—I will not excuse—I will not retreat a single inch—AND I WILL BE HEARD." Many white Bostonians in the 1830s did not particularly like what they heard from Garrison, who criticized both church and state for complicity with slaveholders, and in 1835 a mob dragged him through the streets in an effort to silence him. It is a testament to how much the city had changed that less than a decade after his death in 1879, Garrison's statue was dedicated on the Mall. Sculpted by Olin Levi Warner, the monument depicts a dignified, yet determined Garrison sitting forward with papers clutched in his hand. Near his feet sit bound volumes of the Liberator, and inscribed around the memorial are both his famed declaration of activism and his assertion of universal brotherhood: "My country is the world. My countrymen are all mankind." Garrison's rhetoric still has the power to inspire those who stop to contemplate his statue. At the height of the Cold War and the Civil Rights movement, President John F. Kennedy credited the Garrison memorial with strengthening his own political convictions.

# Cheers Beacon Hill

Cheers Beacon Hill may be the place "where everybody knows your name," but not everyone knows that the popular pub was once called the Bull & Finch. That original name was a clever play on the surname of architect Charles Bulfinch, who designed many of Beacon Hill's finest homes in the early nineteenth century. For over a decade after its 1969 opening, the Bull & Finch operated as an English-style pub patronized mostly by locals. All that changed in the early 1980s, after a visit from television producer Glen Charles led to the pub's likeness being featured in a new sitcom called *Cheers*. Long-time owner Tom Kershaw, a Harvard Business School graduate, recognized the potential benefit for his bar, but could not have predicted the show's enormous success and its true impact on the pub. Every week for eleven years, from 1982 to 1993, the Bull & Finch's exterior was broadcast into millions of American homes, transforming the bar into a major tourist attraction.

Fans of *Cheers* are often disappointed to find that the interior of the real Cheers is not identical to the Hollywood set. The major difference, besides the absence of such memorable characters as Sam, Norm, and Frasier, is the use of a wall bar instead of the island bar that appears on the show. Yet a closer look reveals many similarities, from the cigar-store Indian inside the door to the style of the windows and seats. During the show's heyday, those seats became notoriously difficult to get.

Boston's affection for the show was never more apparent than in 1993, when it was announced that *Cheers* would end its remarkable run on May 20th. Governor William Weld declared the day "*Cheers* Day" in Massachusetts, and cast members were invited to the then-Bull & Finch to celebrate. While they joined local sports legends and politicians for drinks inside the bar, out on the Common a giant screen was set up for Bostonians to enjoy the show's final episode together. Temporary bleachers were also erected in front of the pub so fans could watch a live airing of the "Tonight Show with Jay Leno" and join in for one last rendition of *Cheers's* catchy theme song.

The bar is still basking in the afterglow of *Cheers* years after the Hollywood spotlight has faded. For many visitors to Boston it remains a "must-see" attraction. In 2001, Kershaw responded to tourist demands for "authenticity" by replicating the television show's set at a second *Cheers* location in Faneuil Hall Marketplace. He also officially renamed the Beacon Hill bar "Cheers," much to the delight of out-of-towners confused by its original name. Thanks to Kershaw's marketing and the show's syndication, the pub should remain a Boston landmark for generations to come.

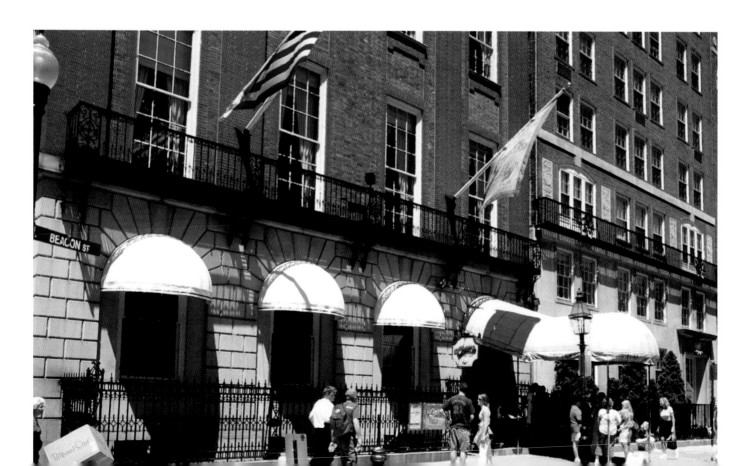

# Gibson House Museum

Once the proud cultural elite of the community, Boston's Brahmin families, which Oliver Wendell Holmes famously described as a "harmless, inoffensive, untitled aristocracy," had come to seem strangely old-fashioned by the early twentieth century. Indeed, when Charles Hammond Gibson, Jr. proposed that his family's home at 137 Beacon Street be maintained as a museum to exhibit the city's fading Victorian customs, even his relatives scoffed at the suggestion. But the unconventional Gibson persisted, convinced that someday people would again appreciate the Victorian era. Decades after his death in 1954, the verdict on that prediction is still out. Although Gibson's 1860 brownstone townhouse has been recognized as a National Historic Landmark, visitors to the city often overlook his museum despite its rich collections and quirky history.

The filling and development of Back Bay, where the Gibson House resides, dominated the last half of the nineteenth century and transformed the area from a muddy, smelly wasteland into the new heart of the city. Attracted by this "New Land" and disturbed by the flood of Irish immigrants settling into older neighborhoods, Brahmin families sought refuge in the Back Bay. Gibson's wealthy, widowed grandmother moved her family into their new home in 1860, making them among the first to relocate. The house featured many modern conveniences of the era, including indoor plumbing and gas lighting. Redecorated in the 1880s to reflect the latest fashions, the home still possesses many fine examples of period furniture, wallpapers, and textiles. In fact, Gibson began transforming the house into a museum while he was still living there. The Gibson House has since become the city's premiere example of life in the late Victorian period, so much so that it has been featured in films and advertisements depicting the era. It is also an enduring monument to one man's struggle against change and his own mortality, a sentiment similarly expressed in his poetry: "Oh, I would have you once remember me/ Not as I am.../ But as I was, a youth of twenty three...."

# First Baptist Church

* * * * * * * * * * * * * * * * * * * * * * * * * * * * * * * * * * * * * * * * * * * * * * * * * * * * * * * * *

The First Baptist Church on Commonwealth Avenue is a source of immense pride for a congregation that once worshipped secretly for fear of persecution. Boston's Puritans, determined to create a holy commonwealth, had little tolerance for Baptists, whose unorthodox practice of adult baptism they considered heresy. Yet despite the threat of imprisonment, corporal punishment, and banishment, a few committed Baptists met behind closed doors in the 1660s to follow their consciences.

Pressure from English officials in the 1670s and 1680s forced local authorities to relax their policies against nonconformists, enabling the Baptists to erect a small meetinghouse near the water in Boston's congested North End. First Baptist gradually migrated westward as both it and the city expanded in the nineteenth century. Having built themselves a brick church a few streets over from their original North End location, the congregation sold their colonial meetinghouse to another Baptist group in 1829. This was followed by another shift onto Somerset Street near Beacon Hill. Each move placed the once-shunned Baptists closer to circles of respectability in the community, especially in 1882, after acquiring the church that remains their home today.

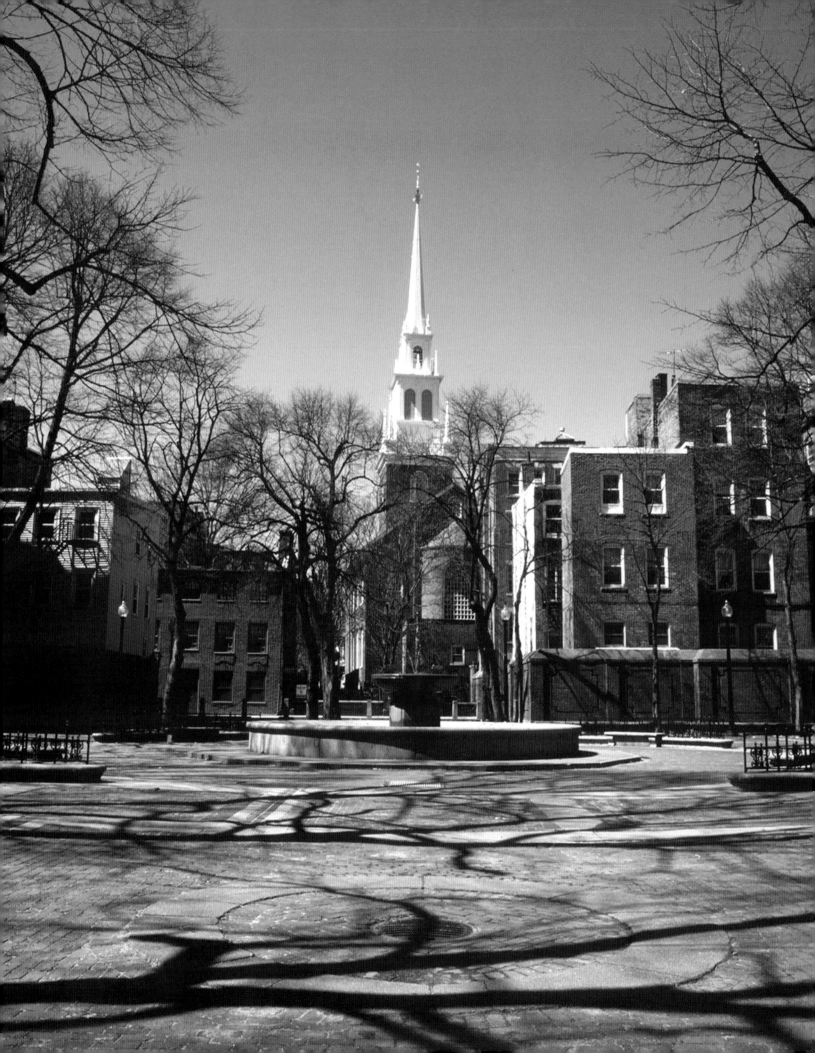

# North End and Charlestown

★★★★★★★★★★★★★★★★★★★★★★★★★★★★★★★★★★★★★★★★★★★★★★★★★★★★

*North End Church in the North End.*

# Paul Revere House

"Listen, my children, and you shall hear/ Of the midnight ride of Paul Revere...." So begins Henry Wadsworth Longfellow's famous 1860 poem about the Boston silversmith turned Revolutionary patriot, Paul Revere. On the night of April 18, 1775, Revere left his home and family on 19 Court Square to warn the Massachusetts countryside about an impending British march against rebel munitions at Concord. "You know the rest. In the books you have read/ How the British regulars fired and fled—/ How the farmers gave them ball for ball,/ From behind each fence and farmyard wall..." The Revolutionary War had begun.

Today the Paul Revere House has the unique distinction of being downtown Boston's only remaining seventeenth-century dwelling, its survival owing as much to Longfellow's celebrated poem as to Revere's residence. In fact, Revere was not even the original owner of the house, which was built for Robert Howard about 1680. The house's traditional post-and-beam design was already falling out of fashion by the time Revere bought it in 1770. Responding to recurrent outbreaks of fire, town officials encouraged residents to build in fire-resistant brick, a trend reflected in the 1711 Pierce/Hichborn House still standing two doors down from the Revere House. And while Revere's business, which he had inherited from his French immigrant father, generally did well, he could ill-afford the sort of fine Georgian mansions that some of his wealthier merchant patrons had built.

Revere's political activities on behalf of the patriot cause in the 1760s and 1770s often kept him away from home and his trade, although he sometimes turned his silversmithing and engraving skills toward producing anti-British propaganda. The two most famous examples are his 1768 "Sons of Liberty" punchbowl and his 1770 engraving depicting the Boston Massacre. Revere's outrage over the massacre, in which five civilians were killed during a confrontation with the King's troops, was on display at his Court Square home the following year as well. As part of the first annual commemoration of the event, he constructed silhouettes portraying the massacre and placed them before his windows for everyone to see. Such behavior did not endear Revere to royalist authorities, but it did earn him the respect of patriot leaders, for whom he acted as a valuable liaison with local artisans and other communities. Still, his efforts would not win him lasting fame until Longfellow's patriotic poem, written decades after Revere's death, stirred the imagination of Northerners preparing to defend the Union in the Civil War.

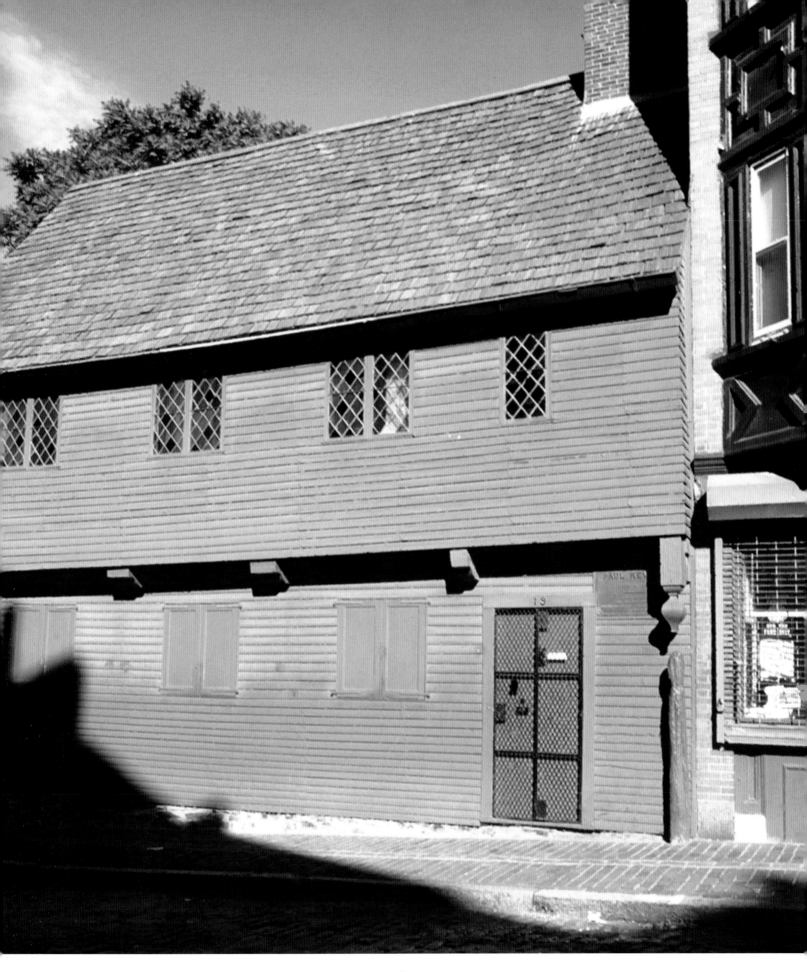

# Sacred Heart Church

The Sacred Heart Catholic Church has been the heart and soul of Boston's Italian community for well over a century, but its once strong, steady pulse has recently weakened as both the North End and the Catholic Church change around it. Even before the arrival of Italian immigrants in the late nineteenth century, the North Square site possessed a spiritual quality about it, serving as a seamen's bethel where transient sailors could go to worship and remember friends who had perished at sea.

Despite religious ties to other immigrant groups such as Irish Catholics, Italians settling in the North End after the Civil War wanted their own place of worship, where priests spoke their language and shared their cultural values. They built their first church, St. Leonard of Port Maurice, on the corner of Hanover and Prince Street in 1876. But tensions within the congregation, whose members came from different regions of Italy, caused a split that resulted in the creation of Sacred Heart.

Widely regarded as a cornerstone of the North End's Italian community, its sentimental importance has grown even as its congregation dwindled in recent years. Immigration from Italy has slowed, and many older residents with ties to the homeland have died. The younger generation is being pushed out of the North End by rising property values as other Bostonians rediscover the neighborhood's Old World charm, which is ironically being lost in the process. Sacred Heart now stands as one of the last remaining connections to the way the community once was. Yet it has never forgotten its roots. In 2009, the Sacred Heart congregation helped raise funds in Boston for victims of a devastating earthquake in central Italy.

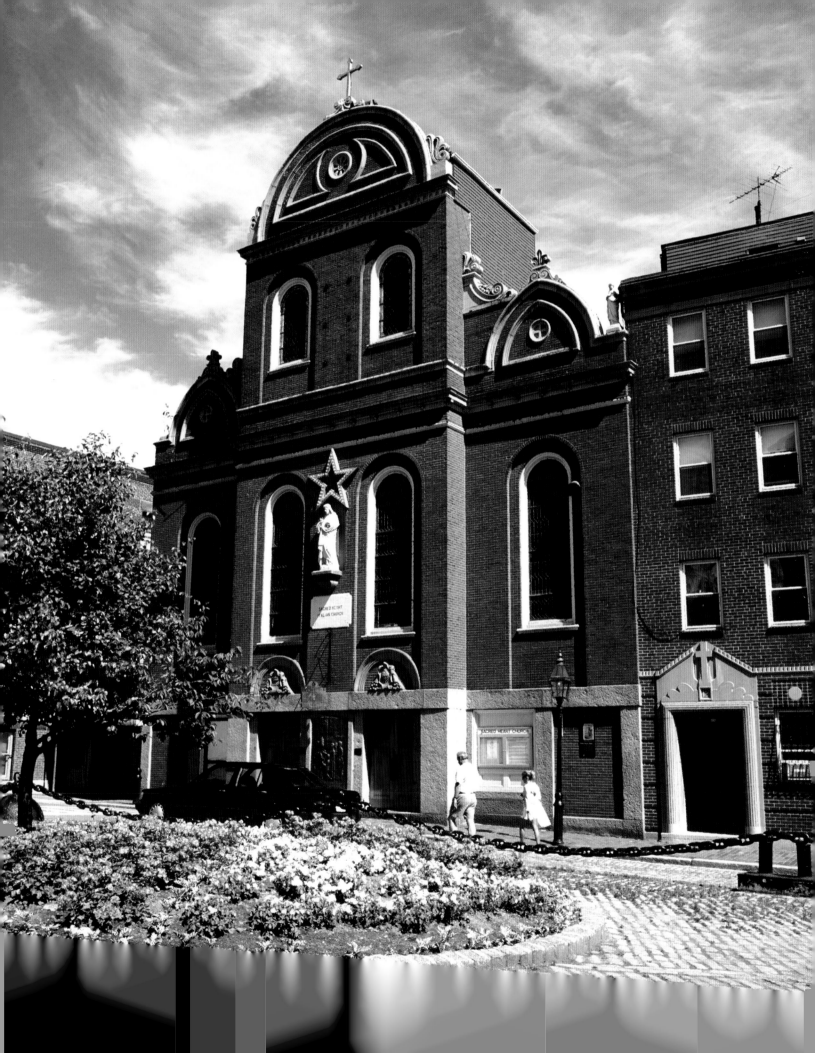

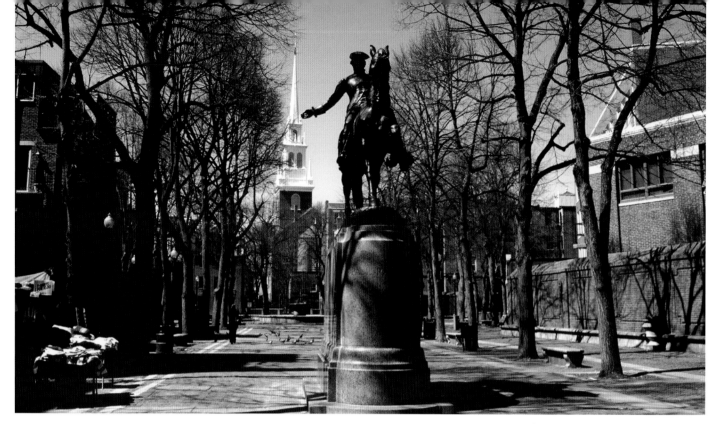

*Paul Revere Mall and North End Church.*

# Old North (Christ) Church

★★★★★★★★★★★★★★★★★★★★★★★★★★★★★★★★★★★★★★★★★★★★★★★★★★★★★★★★★★★★★★★★★★

It is rather ironic that a church so thoroughly identified with American independence should be affiliated with the Church of England. Christ Church, or, as it is more commonly called, Old North Church, reflected the expansion of the Anglican faith in eighteenth-century Boston. Having recently received protection against Puritan persecution through a new royal charter, Massachusetts Anglicans felt at liberty to worship openly. By 1722, King's Chapel in Boston could no longer contain its congregation, prompting the purchase of land in the North End for a new church.

In later years, the American Revolution deeply divided members of the congregation, some of whom agreed with Rector Mather Byles that loyalty to the Crown was both a political and religious duty. But incidents such as the Boston Massacre had convinced many otherwise. In the spring of 1775, as tensions in the city mounted, patriot leaders recruited the disgruntled church sexton, Robert Newman, to assist them in alerting neighboring Charlestown if the British began to move on the countryside. The Christ Church steeple was (and still is) easily visible across the Charles River, making it an ideal means of signaling trouble.

Trouble came on the night of April 18, when Paul Revere informed Newman that British troops were gathering near Boston Common to be ferried across the river. Eluding the officers lodging at his family's North End home, Newman went directly to the church and quietly unlocked its door with his key. Once inside, he grabbed a pair of lanterns that he had earlier prepared for the occasion and began ascending the narrow, winding staircase to the top of the steeple, where he (and perhaps another church member, John Pulling) briefly lit them to warn of the impending march. Some soldiers nearly nabbed Newman as he left the building, but he snuck out a sanctuary window and safely avoided capture. General Thomas Gage, who worshipped at Christ Church during the British occupation, suspected an inside job and had Newman arrested, although he was later released due to lack of evidence.

Newman's deeds would go unrecognized outside of Boston until immortalized in Henry Wadsworth Longfellow's 1860 poem "Paul Revere's Ride," which unfortunately fails to refer to the sexton by name. The steeple that Newman climbed no longer exists, having come crashing down during a storm in 1804— the same year of his death and burial at nearby Copp's Hill. The current steeple is a 1950s replica of the 1740 original made famous by Newman.

# Bunker Hill Monument

Charlestown's majestic Bunker Hill Monument, actually situated on nearby Breed's Hill, honors one of the worst cases of mistaken identity in American history, the so-called Battle of Bunker Hill on June 17, 1775. Stumbling back toward Boston after clashes at Lexington and Concord, British soldiers briefly licked their wounds on the heights above Charlestown before being ferried across the river, thereby leaving the strategic hills overlooking Boston to the besieging colonial militia. Why the Americans chose to fortify Breed's Hill rather than the taller Bunker Hill behind it is unclear, though it did position them closer to British-occupied Boston. The next day, the colonists repulsed two British attacks on the hill before being forced to retreat for lack of ammunition. Some British officers afterwards belittled the American effort, arguing that anyone could have defended such a strong position.

The Americans, of course, saw it differently. They lost the hill, but they gained the confidence that they could stand up to the mighty British army. The Continental Congress sent George Washington to take charge of the troops, and by March of 1776 they had driven the British out of Boston.

The 221-foot-tall Egyptian obelisk that dominates the site of the battlefield was begun in 1825 as part of the fiftieth anniversary of the battle, with some forty veterans of the battle in attendance at the July 17th dedication. Despite such a celebrated beginning, the granite monument took nearly twenty years to finish due to lack of funds. But for the philanthropy of industrialist Amos Lawrence and the Jewish merchant Judah Touro, the monument might never have been completed. Once finished, however, it became as popular a tourist site in the nineteenth century as it is today. "You clamber up three hundred steps to the top," recalled Russian traveler Aleksandr Lakier, who visited the monument in 1857, "but you absolutely forget your fatigue when you reach the summit and there, spread out before your eyes, is a vast panorama of the sea, the naval dockyard, and the piers for ships of various companies and countries." The scenery has certainly changed since Lakier's visit, but the monument still offers one of the better views of Boston.

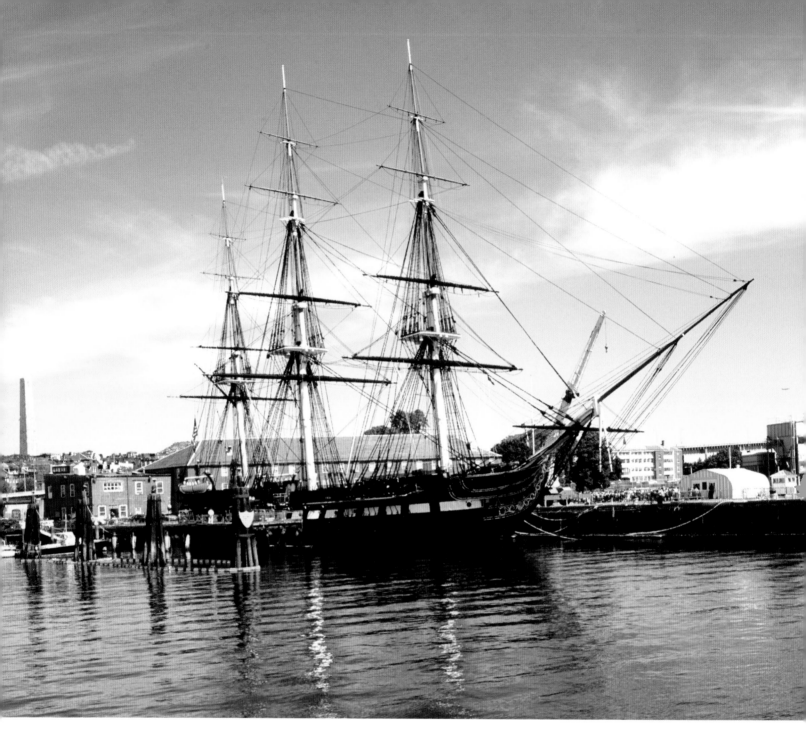

# U.S.S. Constitution

★ ★ ★ ★ ★ ★ ★ ★ ★ ★ ★ ★ ★ ★ ★ ★ ★ ★ ★ ★ ★ ★ ★ ★ ★ ★ ★ ★ ★ ★ ★ ★ ★ ★ ★ ★ ★ ★ ★ ★ ★ ★ ★ ★ ★ ★ ★ ★ ★ ★

Dubbed "Old Ironsides" for its unusually strong oak hull, the U.S.S. *Constitution* is the United States' oldest fully commissioned naval vessel, dating back to 1797. The successful revolution against Britain meant that Americans could no longer rely on the Royal Navy to protect their maritime trade. Especially worrisome were the Barbary pirates, who made a living plundering foreign ships off the North African coast. Relations with France also

deteriorated in the 1790s as America's erstwhile ally descended into civil war and revolution. In response to such international threats, Congress authorized the construction of several new frigates for its fledgling navy in 1794, including the *Constitution*—named in honor of the new system of federal government.

The *Constitution* was built at Edmund Harrt's shipyard in Boston's North End, as the Charlestown Navy Yard, where it now

resides, was not established until 1800. Ironically, the *Constitution* became famous in a war that many New Englanders opposed—the War of 1812. They feared its effects on their economy and suspected that Napoleon was baiting President James Madison into a conflict with England, but Congress agreed with Madison that America's integrity was at stake and declared war against Britain in June of 1812. Two months later, Captain Isaac Hull and the crew of the U.S.S. *Constitution* outgunned the British warship *Guerriere*, whose 18-pound cannonballs appeared to bounce off of Old Ironsides's thick hull. The *Guerriere* did not fare as well; it was so badly damaged that it was burned rather than towed to port as a war prize. The smashing victory became a source of national pride

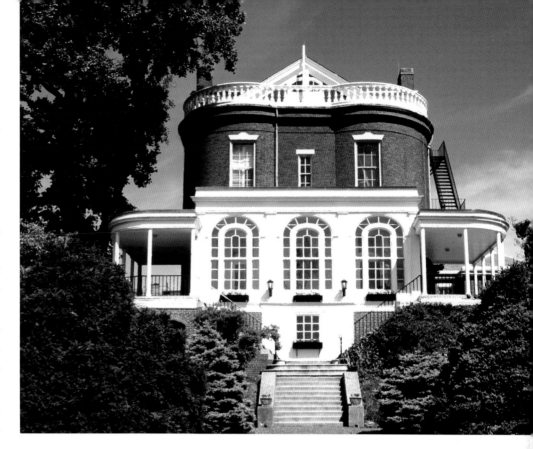

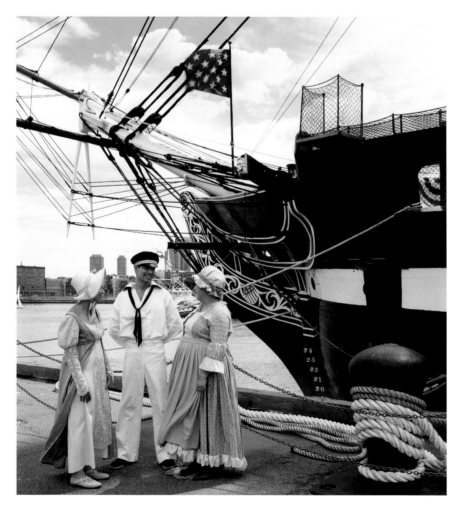

and bolstered the American war effort, much as the British feared it would. The *Constitution* bested several other British brigs, frigates, and schooners before the war ended in stalemate. For having never lost a single engagement in its long history, Old Ironsides remains a potent symbol of American naval prowess.

The *Constitution* and its accompanying museum consistently rank among the most popular sites on Boston's Freedom Trail thanks to their innovative, award-winning approach to education. Hands-on exhibits allow museum visitors to experience many aspects of life on board ship, from firing cannons to napping in a sailor's hammock. To meet the adolescent demand for more technologically entertaining activities, the museum features computer games based on the *Constitution's* history as well as a video that highlights areas of the ship not accessible to the public. The 1805 Commandant's House, with its elegant interior and spectacular view of Boston Harbor, is also open seasonally to the public and available for private functions.

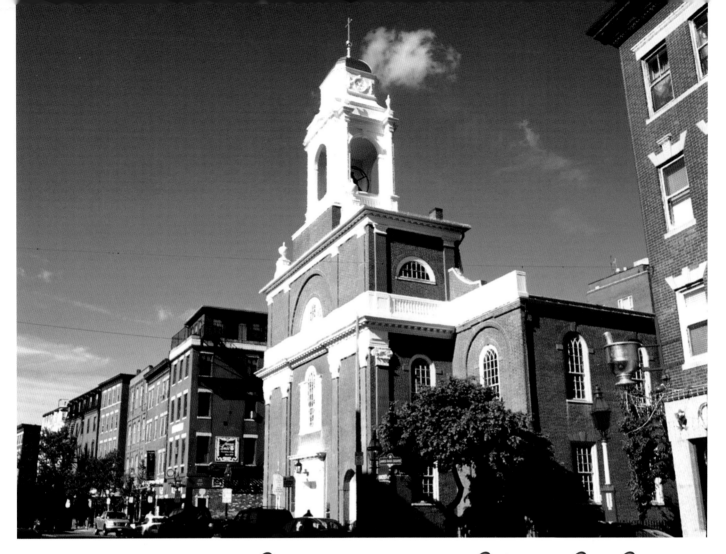

# Saint Stephen's Roman Catholic Church

★★★★★★★★★★★★★★★★★★★★★★★★★★★★★★★★★★★★★★★★★★★★★★★★★★★★★★★★★★★★★★★★★★★★★★

Saint Stephen's is best known as the last remaining church designed by famed Boston architect Charles Bulfinch, although he would have recognized it as the New North Church. Formed in 1714, the Puritan congregation built its first meetinghouse on North Street, not far from the wharves and shipyards where a number of its members worked. Less than a decade later, the young church was embroiled in a major controversy over the ordination of Peter Thatcher as assistant minister. Against the advice of many colleagues, the talented Thatcher abandoned his Weymouth flock in 1720 for a more prestigious position in Boston, which some at New North considered unfair and inappropriate. Tempers flared and resulted in part of the congregation leaving to organize a new church several blocks away.

The resilient congregation would weather other storms, including the disruptions of the Revolution, and in 1802 hired Charles Bulfinch to build them a larger, more modern meetinghouse on Hanover Street. The popular architect had already designed several area churches, most recently Boston's first Catholic church, Holy Cross. The cornerstone of New North was laid on September 23, 1802, and where possible Bulfinch used timber from the old wooden meetinghouse for his largely brick and stone building.

Under the leadership of the Reverend Francis Parkman, father of the renowned historian, New North flourished for decades and joined several other congregations in embracing Unitarianism. But the development of the fashionable Back Bay and the influx of Irish Catholic immigrants to the North End after mid-century prompted many of the congregants to leave the declining church, which was sold to the Catholic Diocese in 1862 for $35,000. Renamed Saint Stephen's Church, the largely Irish parish put its own touches on the building, including removal of the weathervane and the addition of a cross.

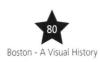

# Copp's Hill Burying Ground

High up on a hill overlooking the Charles River sits one of Boston's oldest graveyards, Copp's Hill Burying Ground. When the Puritan founders arrived in 1630, Shawmut Peninsula, as Boston was then known, was rather hilly, making John Winthrop's vision of a "City Upon a Hill" something more than metaphorical. Nineteenth-century urban "improvements" leveled much of the city, but Copp's Hill in the North End escaped relatively (though not completely) unscathed and remains a good example of Boston's natural terrain.

Before modern buildings enveloped it, the exposed hill was often buffeted by sea breezes that made it an ideal location for a windmill to grind meal. In fact, for much of the seventeenth century locals knew it as Windmill Hill, not Copp's Hill. Its latter name is likely derived from William Copp, a cordwainer or shoemaker who originally owned the land. Responding to the needs of its growing North End community, the town purchased the property and established a burial ground on the site in 1659. Perhaps the best-known figure buried there is the Puritan minister Cotton Mather, whom many remember for his role in the infamous Salem Witch Trials but was also a respected religious scholar and New England historian.

The burial ground is a featured stop on the Freedom Trail because of its many connections to the American Revolution. It is the final resting place of Robert Newman, the Old North Church sexton who lit the lanterns warning of a British march to Concord in 1775. Several men associated with the Boston Tea Party, whose names were meant to remain secret, are also believed to be buried there. It was no secret to royal officials that Captain Daniel Malcomb, a suspected smuggler, was interred at Copp's Hill. His public defiance of customs officers before his North End home in 1766 earned him their undying ire. After he passed away a few years later, British soldiers reportedly used his tombstone for target practice. The marks their musket balls left behind are still visible today. British artillery units also used the strategically placed hill to lob cannonballs across the Charles River during the Battle of Bunker Hill. Such a rich Revolutionary heritage made Copp's Hill the perfect backdrop for Esther Forbes's classic children's tale *Johnny Tremain*.

# Leonard P. Zakim Bunker Hill Bridge

✶✶✶✶✶✶✶✶✶✶✶✶✶✶✶✶✶✶✶✶✶✶✶✶✶✶✶✶✶✶✶✶✶✶✶✶✶✶✶✶✶✶✶✶✶

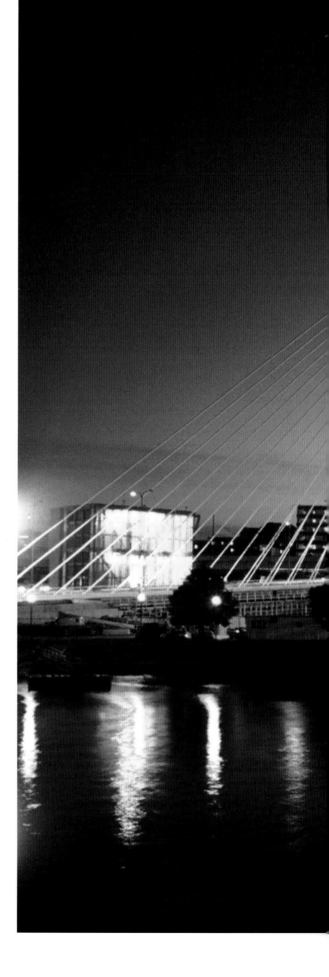

Boston's newest landmark is a stylish blend of innovation and tradition, a nod to the city's historic past as it looks forward to the future. Dedicated in October of 2002, the Zakim Bunker Hill Bridge began as part of the Big Dig project, which buried Interstate 93 beneath the city and opened up new avenues for pedestrians. Swiss engineer Christian Menn was brought in to design a 10-lane bridge that would funnel traffic over the Charles River and down toward tunnels below Boston's North End, a daunting task brilliantly executed. Mann's unique design also had to consider aesthetics and alewife, a fish closely related to herrings, whose migration patterns might have been disrupted by a massive shadow cast across the river. As such, sun holes were installed to allow light to filter through to the waters below. Charlestown's nearby Bunker Hill Monument, which is replicated in the twin towers that loom above the bridge, influenced Menn aesthetically, and his triangular cable structure reminds many of the sailing ships that once dominated Boston Harbor. Not everyone approved of its $100 million design, but the sleek bridge with the awkward name quickly won over the community and has become an instant icon.

The bridge's connection to Charlestown and its Revolutionary heritage led members of the local historical society to suggest the name Bunker Hill Bridge. Yet over on Beacon Hill, the Governor's office announced that it should instead be named in honor of the late Leonard P. Zakim, regional director of the Anti-Defamation League. Zakim's tireless efforts on behalf of civil rights were already legendary before his premature death in 1999, and many felt the bridge was symbolic of his work in bridging differences between peoples and faiths. Besides, they reasoned, the Revolutionary War patriots already had a fitting tribute to their sacrifices. Defenders of the Bunker Hill name shot back that the bridge's significance was too great to be dedicated to just one person and that Zakim should be honored in other ways. A compromise was finally reached when State Representative Eugene O'Flaherty proposed that both names be incorporated into the official title, the Leonard P. Zakim Bunker Hill Bridge.

Another rift that was never quite bridged pitted the chief engineer and architect, Christian Menn, against site managers and the engineer teams building the structure. Menn insisted, and tests later revealed, that a steel support beam was not properly reinforced with concrete. The problem was fixed, but not in the way he had recommended. Relations deteriorated to the point where Menn chose not to attend the ceremony dedicating his masterwork. However, the event did attract an impressive array of politicians and religious leaders as well as friends, family, and colleagues of Zakim, capped off by singer Bruce Springsteen's musical tribute to his friend. "This is a powerful teaching tool about this nation," Cardinal Bernard Law said of the structure afterwards. "It isn't just another bridge."

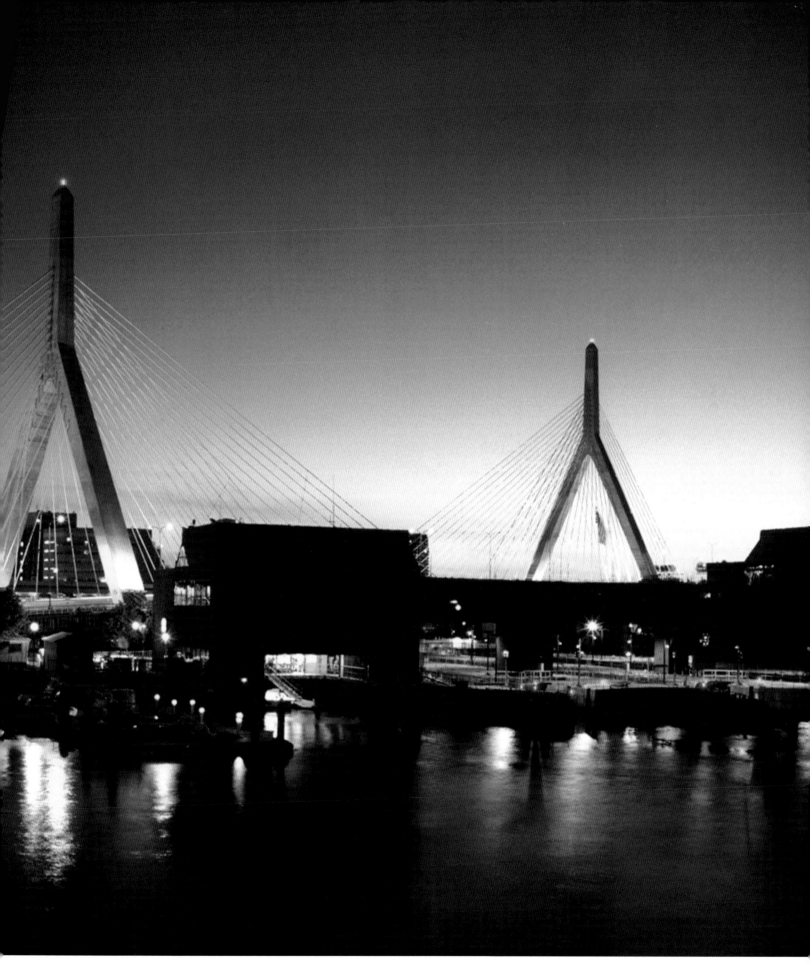

# TD Garden

**\*\*\*\*\*\*\*\*\*\*\*\*\*\*\*\*\*\*\*\*\*\*\*\*\*\*\*\*\*\*\*\*\*\***

Affectionately called "The Garden" by locals, TD Garden is best known as the home of basketball's Boston Celtics and hockey's Boston Bruins, two of the most storied franchises in professional sports. But its roots are in the boxing ring. The original Boston Garden was the brainchild of western boxing promoter Tex Rickard, who had brought the sport out of the shadows and into the national spotlight with a series of highly publicized bouts featuring legendary boxers such as Jack Johnson and Jack Dempsey. He hoped to build off of this success with a series of Madison Square Garden-like structures in various eastern cities and in 1928 built the Boston Madison Square Garden, soon shortened to the Boston Garden. Fittingly, the first event held in the new facility was a boxing match, but it soon began hosting Boston Bruins hockey games as well.

Led by Hall-of-Fame defenseman Eddie Shore, the Bruins took home the Stanley Cup their first year at The Garden and the city's love affair with the building was born. Much of The Garden's success as a sports venue in those early years had to do with its intimate design, originally meant for boxing, which brought players and fans in close proximity. "The fan is right on top of you," recalled Derek Sanderson, who played for the Bruins in the late 1960s and early 1970s. "They would insult you; they would shout at you; they would cheer you. You got to know them."

In 1946, The Garden's general manager, Walter Brown, began a new chapter in the building's history when he founded the Boston Celtics. Brown, who was also part of the Bruins organization, saw basketball as a way to keep the Garden profitable when hockey was not being played there. Unlike the Bruins, however, the Celtics struggled in their early days at The Garden. Not until the 1950s and the arrival of coach Red Auerbach did the team's fortunes turn around. By the decade's end, the Celtics had won three championships, and they won a remarkable eight in a row between 1959 and 1966. More titles followed in the 1970s and 1980s, making the team the toast of the town and turning players like Bill Russell, John Havlicek, and Larry Bird into legends of the game.

Basketball and hockey weren't the only games in town, however. As one of Boston's premiere popular entertainment venues, The Garden has played host to everything from three-ring circuses to political rallies and rock concerts over the years. The Beatles played Boston Garden in 1964 and the Grateful Dead in 1977. People still talk about the electrifying 1972 Rolling Stones performance with Stevie Wonder, part of their *Exile on Main Street* tour.

The Garden was beginning to show its age and lose some of its charm by the early 1990s. It had never been equipped with air conditioning. This sometimes created a layer of fog on the ice, which affected play during Bruins games. Along with these

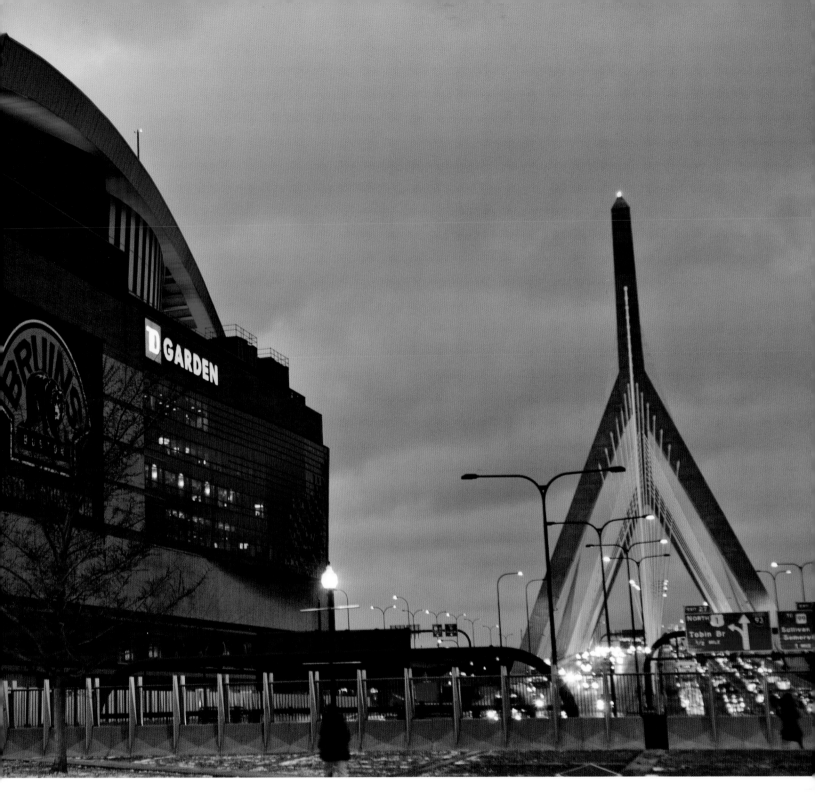

problems, The Garden's lack of luxury boxes and other corporate amenities translated into lost revenue as professional sports became more lucrative. The decision was made to construct a more modern facility nearby, a move that diehards and old-timers with fond memories of The Garden grudgingly accepted. But many locals were outraged that the new $160 million building would not retain the familiar "Boston Garden" designation and instead carry a corporate name. Opened in 1995 as the Shawmut Center and later the Fleet Center, the facility's current naming rights belong to TD Bank, which in 2005 bowed to public pressure and restored the original "Garden" moniker. Whatever its name, the new building continues the old Garden's winning ways, with both the Celtics and Bruins having won championships there since its construction.

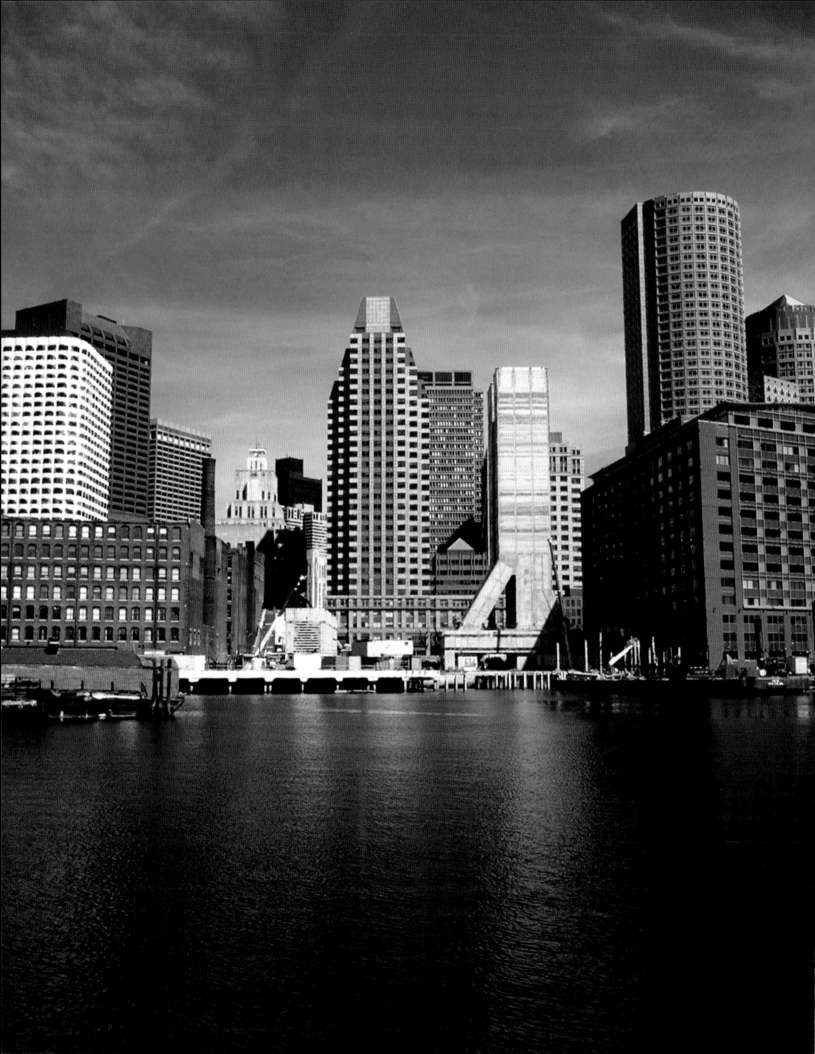

# Financial District

★ ★ ★ ★ ★ ★ ★ ★ ★ ★ ★ ★ ★ ★ ★ ★ ★ ★ ★ ★ ★ ★ ★ ★ ★ ★ ★ ★ ★ ★ ★ ★ ★ ★ ★ ★ ★ ★ ★ ★ ★ ★ ★ ★ ★ ★ ★ ★ ★ ★ ★ ★

*Financial district skyline.*

# Faneuil Hall

**"I**f you don't know Funnel-Hall, you are no Boston boy," proclaims a character in James Fenimore Cooper's Revolutionary War novel Lionel Lincoln. Indeed, no building has historically been more identified with the city than Faneuil Hall, even if Bostonians could not always get their thick Yankee accents around its founder's French surname. "The last generation of schoolma'ms has taught us to call it 'Fan-you-well,' recalled historian Samuel Eliot Morison in 1921. If it took locals so long to get the name right, then visitors to the popular Freedom Trail site may be excused for still mispronouncing it.

Given Faneuil Hall's political and commercial significance to the community, it is surprising to learn that many Bostonians only reluctantly embraced the handsome brick building when it was completed in 1742. The wealthy French Huguenot merchant Peter Faneuil had offered it as a convenient place for country traders to market their goods, but many inhabitants preferred the custom of door-to-door vending.

Even with the support of Boston's first citizens and the addition of an upstairs meeting hall, Faneuil's generous gift was only narrowly accepted by a town vote. Yet no one opposed naming the building in his honor, and everyone was genuinely saddened by his sudden death just a few months later. Bostonians would mourn the loss of Faneuil Hall itself in 1761 when a fire gutted its interior, leaving them without their marketplace or meeting hall. They fortunately resolved to rebuild it, for Faneuil Hall was about to take its place at the center stage of history.

Faneuil Hall became famous as the "Cradle of Liberty" for its role in resisting British tyranny during the American Revolution. Upwards of a thousand people could gather inside to hear town meeting leaders such as Samuel Adams denounce the Stamp Act and other policies as threats to their constitutional rights as British citizens.

After Independence, Faneuil Hall became a favorite venue for political rallies, public banquets, and annual Fourth of July celebrations. Because of Faneuil Hall's popularity, the town hired architect Charles Bulfinch to expand the structure in 1805.

While tourist trinkets have supplemented foodstuffs in the marketplace and local government has moved elsewhere, Faneuil Hall still performs the same basic functions that it has since the eighteenth century—to provide a convenient place for the community to gather and exchange ideas as well as money. Unlike their ancestors, Bostonians today would not think of closing the market or reducing their meeting hall to a mere museum.

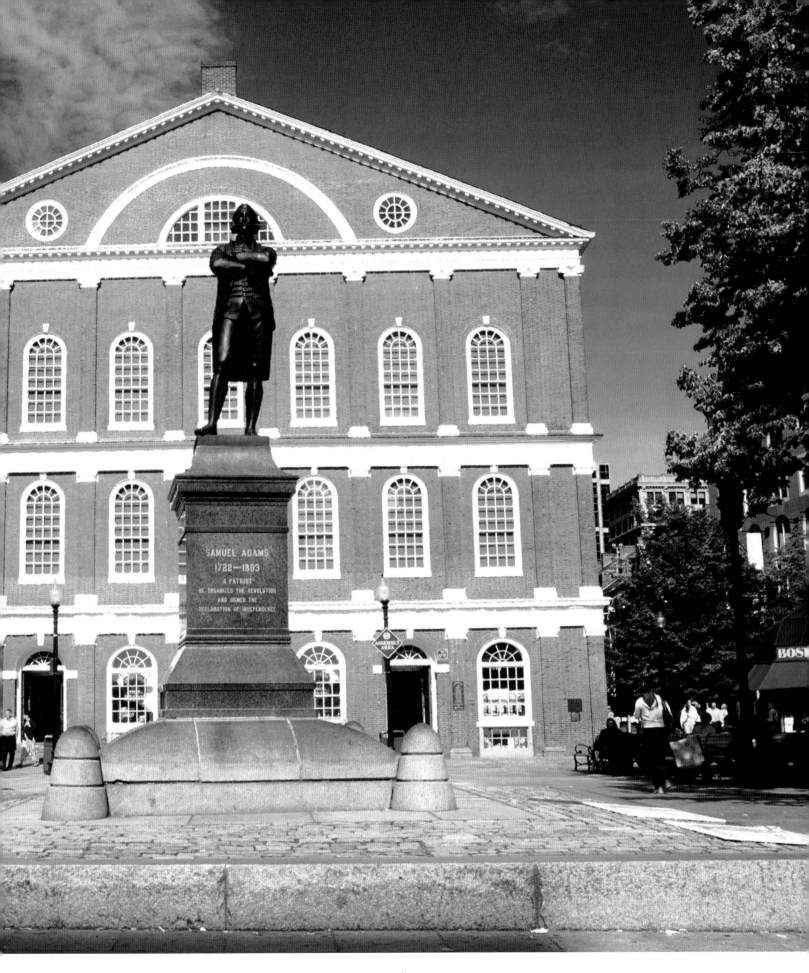

# Custom House Tower

Often mistaken as Boston's first skyscraper, the 1915 Custom House Tower nonetheless recalls the age when the city began to grow up. Landfill projects enabled Boston to expand outward during the nineteenth century, but many businesses hesitated to leave lucrative, if confining, downtown locations. Real estate developers such as Frederick Lothrop Ames recognized the financial rewards of adding height to maximize commercial space, and in the early 1890s he hired George Shepley, Charles Coolidge, and Charles Rutan, former associates of the late H.H. Richardson, to design the tallest building in Boston for him. With granite walls measuring nine feet thick, the Ames Building on Court Street remains among the loftiest load-bearing structures in the country, but both its design and size would soon be eclipsed by the Court House Tower.

The emergence of steel-framed skyscrapers in the 1880s, most notably Chicago's ten-story Home Insurance Building, obviated the need for massive load-bearing walls and allowed Boston's buildings to reach new heights. The Custom House Tower was not the city's first structure to employ this new technology, an honor belonging to the Winthrop Building on Washington Street, but it did become the tallest, after its completion in 1915. Architect Robert Peabody derived its design from the Campanile of St. Mark's in Venice. Buried beneath the new Italianate tower was the 1838 customhouse, a Greek Revival-style building that Walt Whitman once called "the noblest form of commercial architecture in the world." Located near some of the seaport's busiest wharves, it was at the heart of Boston's maritime trade. Nathaniel Hawthorne spent two mostly-miserable years as a measurer of salt and coal for the Boston Custom House while the new building was under construction. Hawthorne would probably find the Custom House a more hospitable environment today, since Marriott Hotels renovated the building in 1997 for use as luxury suites that offer guests breathtaking views of Boston Harbor.

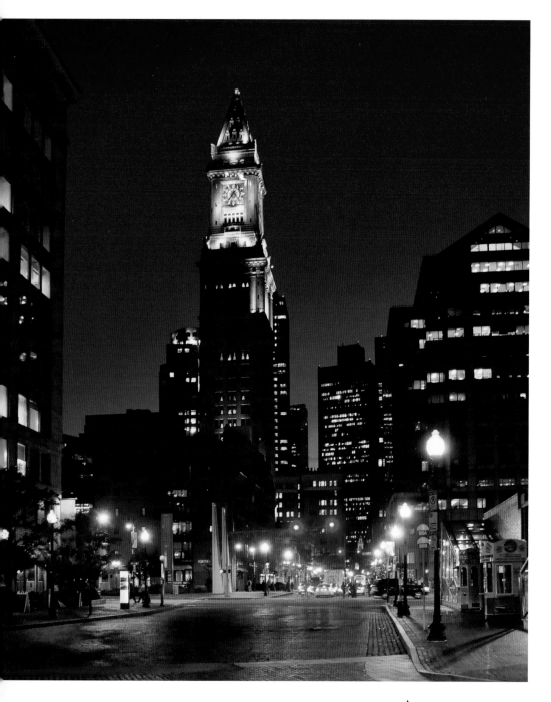

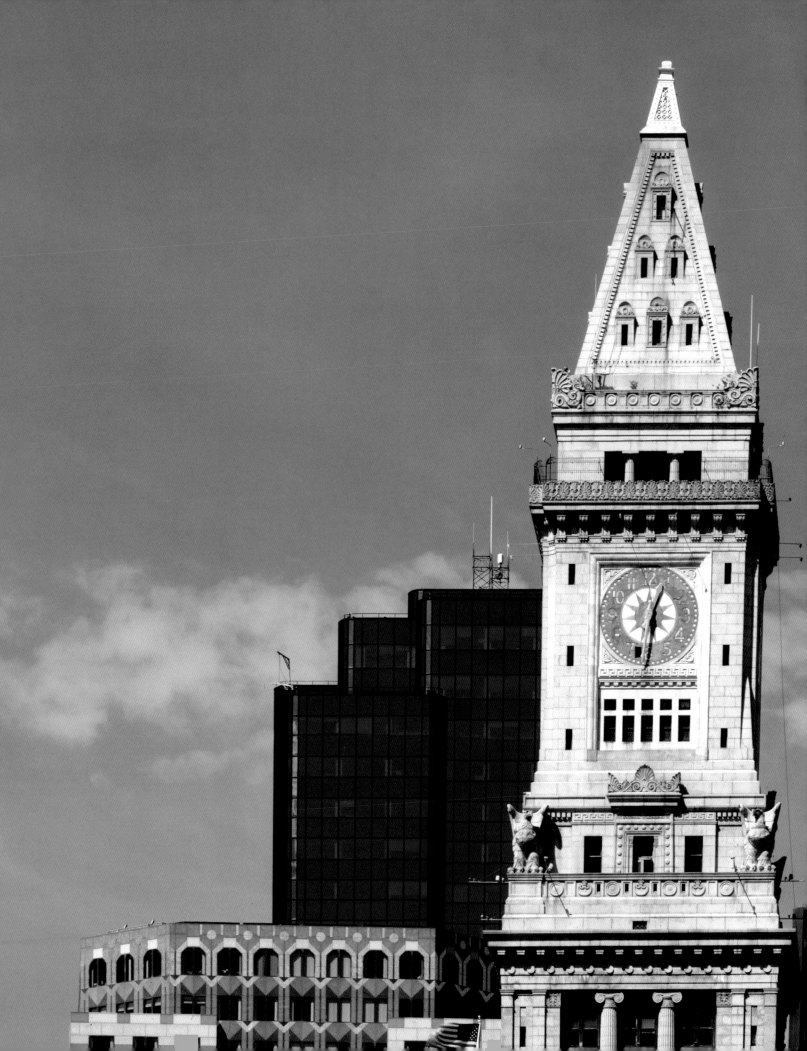

# Old City Hall

**************************************************

E ven as the Civil War shook the nation's foundation in 1862, Bostonians were laying the foundation for a new City Hall on School Street, so called because it was once the site of a public school attended by Ben Franklin and Sam Adams, among others. Now known as the Old City Hall, the white granite building reflects the immense popularity of French Second Empire design in the late nineteenth century.

That a city hall was even deemed necessary speaks to the sea change of opinion regarding government in nineteenth-century Boston. Throughout the colonial era, residents had resisted calls for incorporation and the elimination of the town meeting system, which they considered more democratic. But by the early 1820s, many felt that the political process had become perverted, with local Federalist elites maintaining an iron grip on the town meeting. The financial hardships caused by the Panic of 1819 galvanized popular opposition to elite rule and created widespread support for incorporation. Leading the successful charge for change in

1822 was Josiah Quincy, a former Congressman who had had a falling-out with Federalist leaders. He would later become mayor of Boston and define the office in its early days.

Old City Hall served the community for a century, until the construction of Government Center in the late 1960s ended its days as the hub of local politics. Some of Boston's most famous mayors held reign there: Hugh O'Brien, the city's first Irish-born Catholic mayor; John F. Fitzgerald, maternal grandfather of President John F. Kennedy; James Michael Curley, "the people's mayor," who broke tradition by being inaugurated at spacious Tremont Temple rather than the confining City Hall; and John B. Hynes, who oversaw much of Boston's redevelopment in the 1950s. His successor, John Collins, was the last to serve in the building, abandoning it for the new modern-looking City Hall just before his term ended. Instead of facing the wrecking ball, however, Old City Hall was recycled for use as private office space, making it a pioneering example of adaptive reuse.

# Financial District

Boston's financial district blossomed in the nineteenth century, but its roots can be found in the colonial period. Since the late seventeenth century, leading merchants had gathered around the Old State House to discuss market conditions at home and abroad. Many lived in the surrounding streets, their fine homes intermingled with shops and storehouses near the waterfront. However, the development of new residential neighborhoods drew them away from State Street after the Revolution, giving the area a predominately commercial character.

Unfortunately, the area bore the brunt of devastation during the Great Fire of 1872, which leveled nearly forty acres and bankrupted scores of companies. A thriving new business district emerged out of the ashes of the old after 1872. So many people crowded into Washington Street to shop at the Jordan Marsh and Filene's department stores that, according to the *Boston Herald*, "women were obliged to hold their paper boxes above their heads to keep them from being crushed." In 1891, the Boston Stock Exchange moved into its new home at 53 State Street, a twelve-story granite structure capable of housing over a thousand offices. Nearly a century later, in 1985, the building was attached to a forty-story glass skyscraper to form the Exchange Place office complex.

Federal deregulation of the banking and finance industries along with a robust local economy, dubbed the "Massachusetts Miracle," reinvigorated Boston's financial district in the 1980s, resulting in new construction such as Exchange Place.

Built at a cost of $97 million, Exchange Place helped reverse decades of decline in Boston's financial district. Once considered a "9 to 5 neighborhood," the area has also recently become home to several trendy nightclubs and restaurants, dispelling the notion that the financial district is all work and no play.

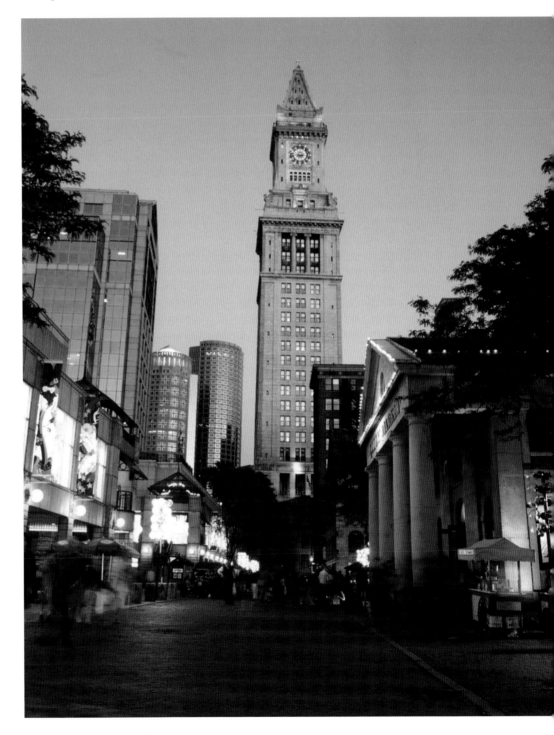

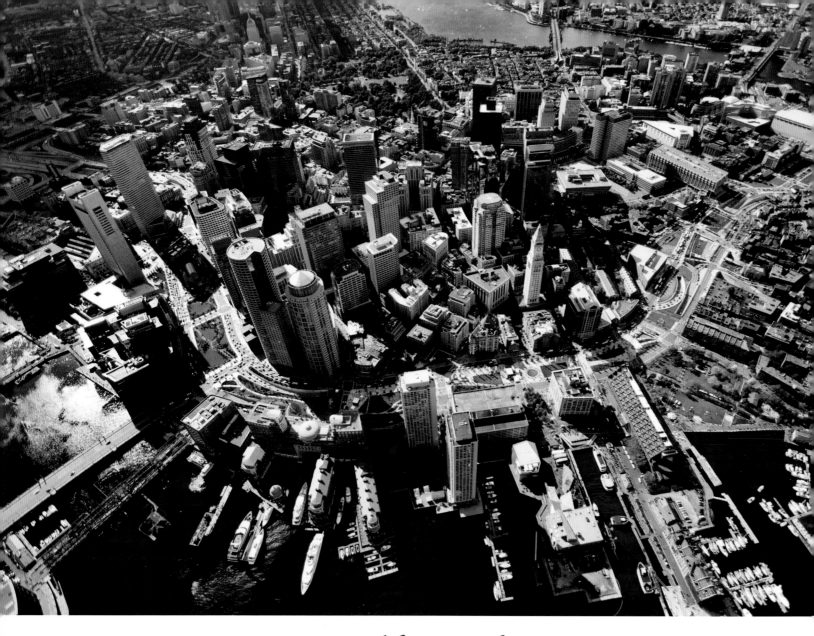

# Rose Fitzgerald Kennedy Greenway

✦✦✦✦✦✦✦✦✦✦✦✦✦✦✦✦✦✦✦✦✦✦✦✦✦✦✦✦✦✦✦✦✦✦✦✦✦✦✦✦✦✦✦✦✦✦✦✦✦✦✦✦✦✦

Dedicated in 2008 and named after the matriarch of the Kennedy family, the verdant Rose Fitzgerald Kennedy Greenway is Boston's reward for decades' worth of disruption caused by the Big Dig project, which dismantled the elevated expressway named in honor of Rose's father and buried Interstate 93 underground. The long, narrow expanse winds its way from the North End neighborhood where Rose was born, past Faneuil Hall and the waterfront, before ending near Chinatown and the South Station transportation terminals. Though not part of Frederick Law Olmstead's famed Emerald Necklace system of parks and waterways, the Kennedy Greenway carries that nineteenth-century tradition into the twenty-first century, by providing the

congested city with open recreational spaces that create a precious green valley amidst mountains of steel, glass, and concrete.

The thirteen-acre Greenway hasn't been without controversy, however. Several proposed construction projects have been abandoned due to high costs, concern about overdeveloping or commercializing the space, and political wrangling. The Boston Museum initially planned to build on a parcel of land that proved too costly and too confining, so it has set its sights on another nearby location. The YMCA of Greater Boston unveiled an ambitious $70 million plan for a site in the North End section of the Greenway that also proved unfeasible and was canceled. Such projects were meant to help draw visitors to the Greenway,

cover up ramps associated with Interstate 93 below, and make the spaces economically viable for the city. Public funding for the space has also threatened to be cut as Massachusetts looks to trim the state budget, leaving the burden of care squarely on the shoulders of the private, non-profit Rose Fitzgerald Kennedy Greenway Conservancy.

Even without buildings and big budgets, the Greenway has become a focus of activity within the Hub, especially on warm summer days. Kids and adults alike can enjoy splashing in Canal Fountain or strolling along Mothers' Walk, where family members inscribe loving tributes to each other. The Massachusetts Horticultural Society has provided the Greenway with stunning displays of seasonal colors in the stands of trees and gardens that soften Boston's hard urban landscape. The serpentine design of Chinatown Park, complete with pavers shaped like scales, creatively conjures up the image of mythical dragons from ancient Chinese lore, while the Greenway's Custom Carousel features whimsical creatures of its own that are sure to delight young and old.

# Old State House

"Then and there the child Independence was born," said John Adams of the Old State House, home to the colonial government. He was referring specifically to James Otis's 1761 defense of private property against general writs of assistance, which gave customs agents wide latitude to search for smuggled goods. "I will to my dying day," Otis declared, "oppose... all such instruments of slavery on the one hand, and villainy on the other, as this writ of assistance is." Although the Superior Court was unmoved, he won the hearts of Bostonians and was returned to the State House later that year as their representative to the legislature, where he became a thorn in the side of royal officials.

For much of the eighteenth century, the Old State House was better known as the New Town House, having replaced an earlier wooden structure after the Great Fire of 1711. Only after the town government moved to Faneuil Hall in the 1740s and the Beacon Hill State House was completed in 1797 did the noble brick building at the intersection of Washington and State Streets become "old." The site had originally been an open-air market where locals bought their provisions from country traders.

The State House was at the epicenter of the American Revolution in Boston. It was one of the few places where loyalists felt relatively safe from mob violence, especially after British troops set up headquarters on King Street and set up cannons before the State House doors in 1768. Their intimidating presence so offended James Otis that he requested that government affairs be moved to Faneuil Hall. The powder keg that King Street had become exploded violently on the night of March 5, 1770, when British troops fired upon a taunting crowd, killing five civilians in the shadow of the State House. Exhibits inside the Old State House highlight this so-called "Boston Massacre," which is re-enacted every March on the street below.

*Left: The Freedom Trail is a 3-mile walking tour of 16 sites and structures of historic importance in downtown Boston and Charlestown.*

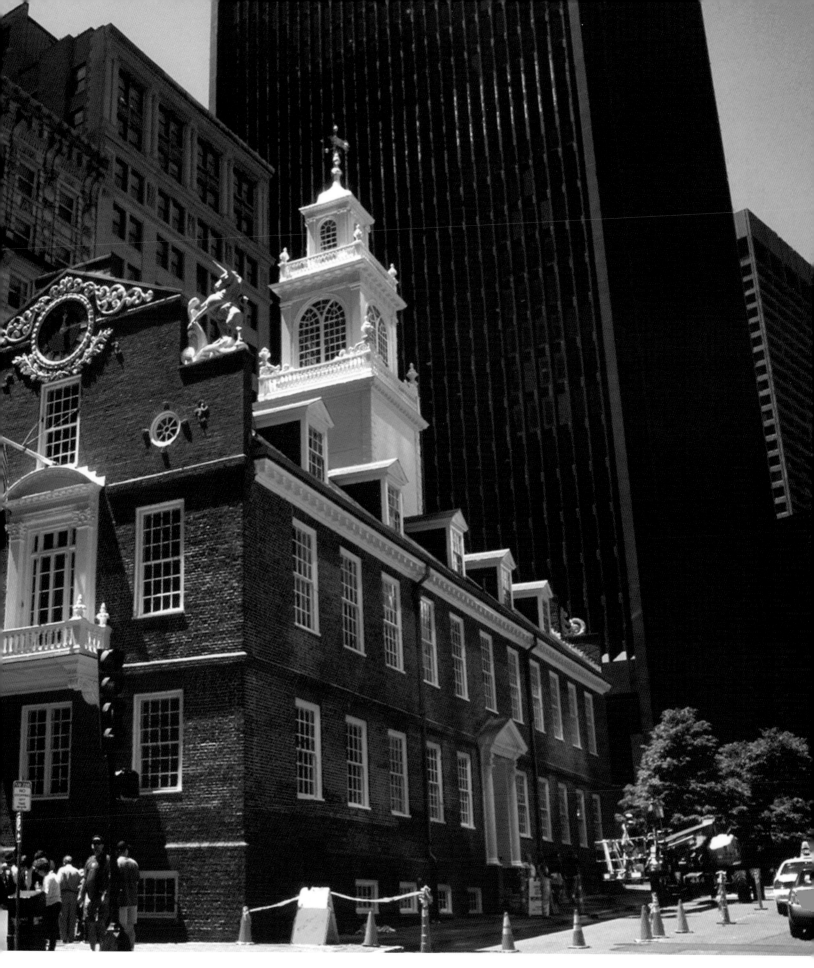

# Old South Meetinghouse

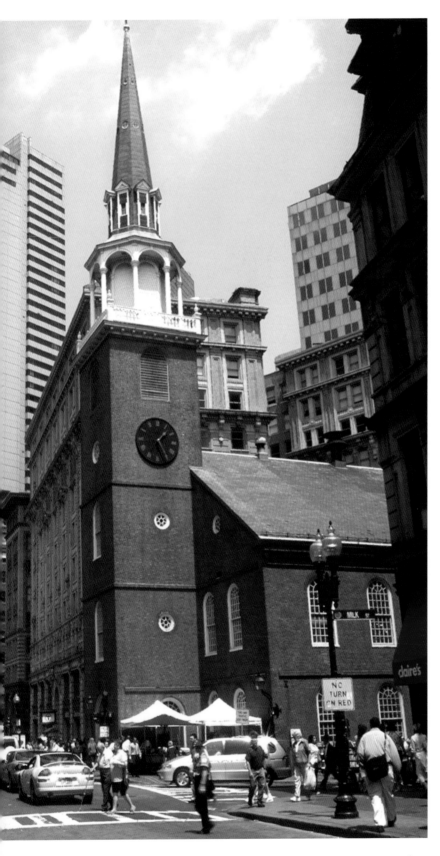

The story of the Old South Meetinghouse is one of remarkable survival. Built in 1729, the "Sanctuary of Freedom," as it is often called, has withstood war, natural disasters, abandonment, and the often-destructive hand of progress, to remind Bostonians of their glorious past. If the child Independence was born at the Old State House and nurtured at Faneuil Hall, then it was baptized at Old South Meetinghouse, where the Boston Tea Party is said to have originated. And long before he became a leading revolutionary, young Benjamin Franklin was also baptized at Old South in the days when its walls were still wooden.

As Boston's South End developed during the eighteenth century, the size of the Old South congregation grew with it, resulting in the original 1669 church being replaced by the sturdy brick structure that still stands in its place. Because of its size and the political sympathies of its minister, Old South hosted several crucial Revolutionary meetings that proved too large for Faneuil Hall. In the aftermath of the Boston Massacre, for instance, angry citizens met there to demand the removal of British troops from their community. Not even Old South could contain the crowd that gathered there on the evening of December 16, 1773, however. Over at Griffin's Wharf sat boatloads of British tea that Bostonians wanted out of their town. But Governor Thomas Hutchinson had refused their request. After listening to speakers warn not "to flatter ourselves that popular resolves [and] popular harangues... will vanquish our foes," a war whoop went up from someone in the crowd and protestors marched down to the waterfront, where they dumped the accursed tea into the harbor. More than anything else, it is Old South's connection to this so-called "Boston Tea Party" that has earned it everlasting fame.

Although the crowds of worshippers and patriots that once animated Boston's Old South Meetinghouse are now gone, their voices can still be heard thanks to the efforts of the Old South Association, the private, nonprofit group that has operated the building as a museum dedicated to First Amendment rights since 1878. In 2011, the church steeple became the proud new home of an 1801 bell cast by patriot Paul Revere, its hourly toll giving new meaning to the expression "Let Freedom Ring."

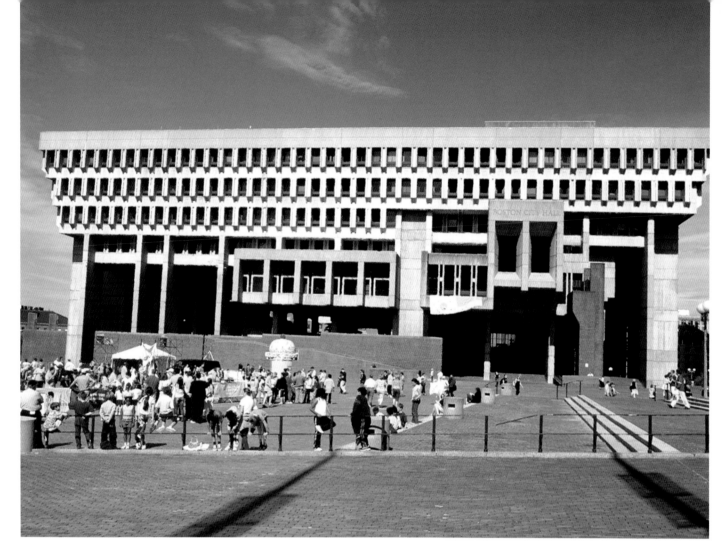

# City Hall Plaza

Decades after its construction, Boston City Hall and its extensive plaza are still as perplexing to casual tourists as they were to many locals when the plan was unveiled in 1962, one of whom purportedly asked, "What the hell is that?" Indeed, the much-maligned building has been variously described as a cement fortress, the crate that nearby Faneuil Hall came in, or just plain ugly. For residents used to the traditional styles of Charles Bulfinch and Asher Benjamin, City Hall seemed completely out of character for the city. Mayor Tom Menino once called it "unfriendly, cold." Yet experts have praised its unusual design, which to some evokes ancient Mesoamerican architecture and to others exhibits the modern Brutalist style. The American Institute of Architects showered it with accolades and awards, and one of its chief designers, Gerhard Kallmann, remained convinced right up until his death in 2012 that Bostonians would eventually embrace the building.

For years there had been talk of relocating city officials from the beautiful, but cramped Old City Hall on School Street, though the idea floundered for lack of both funds and political will. The funds finally came in the form of federal urban renewal dollars, and the will was provided with the upset election of Mayor John Collins, who took office in 1960, promising a "New Boston." The new City Hall was to be the centerpiece of a much larger Government Center that would help revitalize the downtown district. Its location near Faneuil Hall, one of Boston's most venerated structures, presented unique challenges to the Columbia University architectural team chosen to design it.

Determined to give the building a contemporary look, yet sensitive to the history surrounding it, the architects decided on a style that emphasized horizontal rather than vertical lines. As Kallmann later explained, "It had to be awesome, not just pleasant and slick."

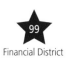

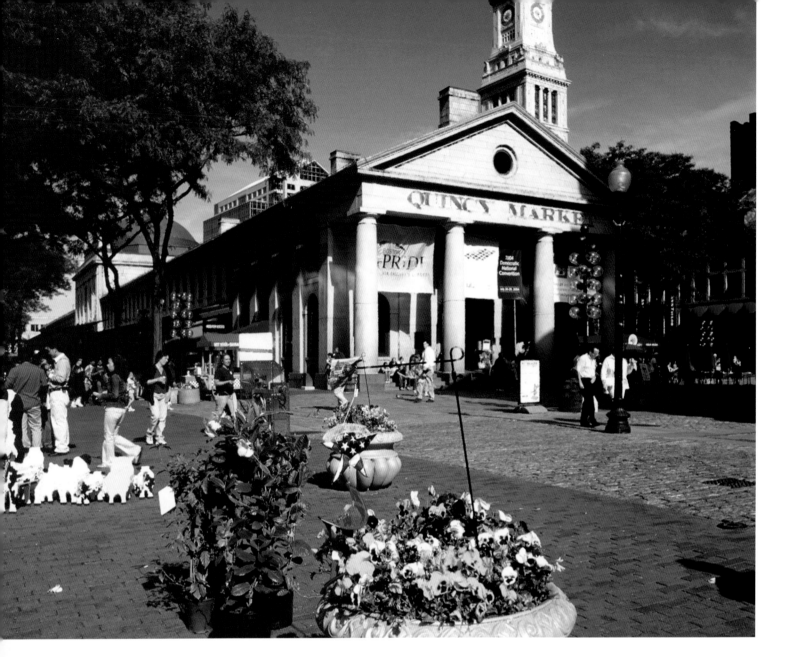

# Quincy Market

Boston's Quincy Market has become the envy of other American cities seeking to rehabilitate their commercial districts. Its wide array of shops, cafés, and special events create a festive atmosphere that attracts thousands of people to downtown Boston every year. On warm summer days, outdoor performers entertain crowds with everything from magic acts to dance routines, while inside the main market building vendors prepare smorgasbords of foods to please almost any palate. Those looking to experience Boston's nightlife often come to Quincy Market for a drink, dinner, and a show. Christmas brings its own charms to the market, as the tree-lined promenades are strung with glittering lights and shop windows decorated in holiday style. Whatever the season, the sights, sounds, and smells of Quincy Market can be quite intoxicating.

It was not always this way, however. Before the market was built in 1825, the area was a malodorous eyesore known as Town Cove. Generations of Bostonians had used it to dump their garbage, hoping the tide would take it out to sea. Instead, the cove became a stagnant pool of rotting food and broken wares from nearby Faneuil Hall marketplace. It also acted as an unceremonious final resting place for dead pets. Stiff ocean winds and warm temperatures carried the stench into surrounding

streets, prompting public health concerns as well as embarrassing the community. "In the season of danger the sons of fortune can seek refuge in purer atmospheres," noted Josiah Quincy. "But necessity condemns the poor to remain and inhale the noxious effluvia [vapors]."

Quincy Market lost much of its allure in the early twentieth century when businesses plastered their signs and billboards all over its once-beautiful façade, now blackened from decades of accumulated soot. Suburban growth in the post-World War II era pulled people out of the market toward the shiny new malls and supermarkets in surrounding towns. By the 1950s, both the building and its business had deteriorated so much that there was serious talk about tearing it down. Naysayers argued that Quincy Market's best days were behind it, that it could never again be a vibrant commercial center.

Exactly who is responsible for resuscitating the dying the market is unclear. Some credit historian Walter Muir Whitehill's campaign to raise public awareness of Quincy Market's historical significance. Others point to Edward J. Logue, director of the Boston Redevelopment Authority in the 1960s, or to Mayor Kevin White, who championed urban renewal. Still others praise the vision and persistence of Benjamin and Jane Thompson, architects of the festival marketplace idea that has animated Quincy Market since its 1976 rededication. All likely deserve some measure of credit for what is widely considered Boston's best urban renewal effort and a model for others to follow.

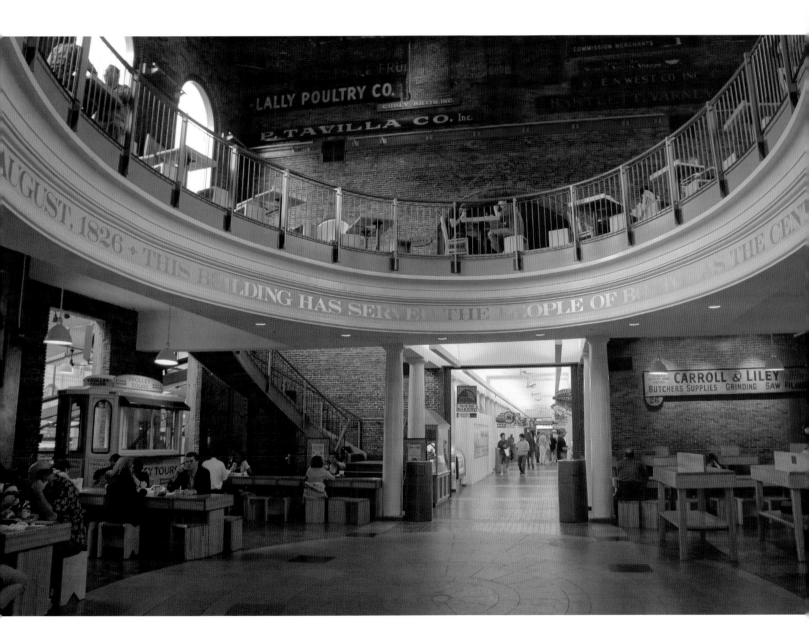

# Big Dig

\*\*\*\*\*\*\*\*\*\*\*\*\*\*\*\*\*\*\*\*\*\*\*\*\*\*\*\*\*\*\*\*\*\*\*\*

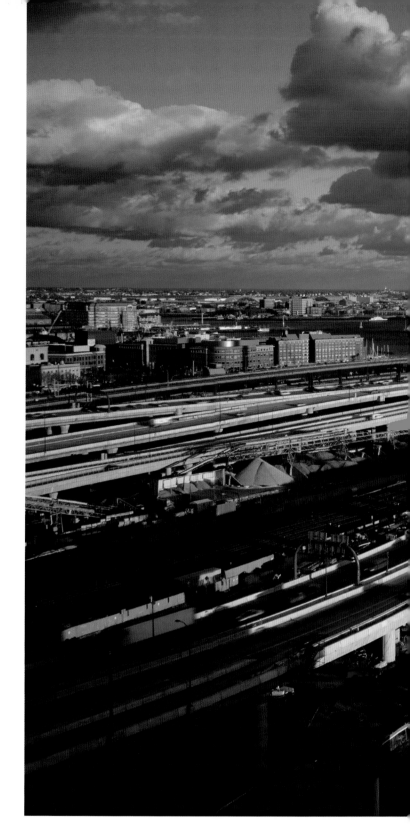

Two simple words describe the largest, most complex, and most expensive urban highway project in American history—Big Dig. Some speak of it proudly, amazed by the marvels of modern technology and human ingenuity. Others curse it under their breaths and shake their fists at the man most responsible for the costly project, the M.I.T.-trained engineer Fred Salvucci. Yet no one will miss the universally detested Central Artery, an elevated north-south freeway that separated Boston from its waterfront and North End neighborhood for half a century.

While residents protested the Central Artery's impact on their neighborhoods, commuters sought alternate routes to avoid the congestion that increasingly manifested itself on the John F. Fitzgerald Expressway, as the Central Artery was officially known. By the year 2000, it was funneling upwards of 190,000 vehicles through Boston every day. The slightest fender-bender or smallest road obstruction could back up traffic for miles, defeating the freeway's purpose. As early as the 1970s, Salvucci had found a political ally in his efforts to bury the Expressway—Democratic state legislator Michael Dukakis. When Dukakis later became governor, he appointed Salvucci to be his Transportation Secretary.

Meanwhile, residents had become wary of such grand schemes, after the Turnpike and Artery projects of the 1950s and 1960s. As late as 1989, Salvucci had yet to receive all the local building permits he needed to begin construction, and with every passing month the price tag rose by millions in interest. Governor Dukakis's failed bid for the presidency in 1988 would end his political career two years later, forcing Salvucci out as Transportation Secretary. Undaunted, he continued his crusade while teaching at MIT and gained the support of the incoming administration of Republican William Weld.

The Big Dig finally broke ground in 1991 with construction of the Ted Williams Tunnel in South Boston, which would provide service to Logan Airport. Problems persisted, even after parts of the Big Dig opened to motorists. In January of 2004 and again in September, water gushed through defective walls in the tunnel below South Station, tying up traffic for hours and adding to the project's estimated $24-billion price tag. Tragedy struck in July of 2006 when a concrete ceiling panel gave way, crushing a car below and killing a woman on her way to Logan airport with her husband. Governor Mitt Romney spoke for many outraged motorists at the time when he declared, "People should not have

to drive...with their fingers crossed" along what some critics had ominously begun to call the "road to Hell."

If Bostonians thought the Big Dig's official completion in 2007 would signal the end of controversy, they soon discovered it was only the beginning. Some complained that the project had merely

# Waterfront

Lewis Wharf.

# Community Boating

O f the many ways to take in the sights and sounds of Boston, few are more satisfying than a sail along the Charles River courtesy of Community Boating. Joseph Lee, Jr. founded Community Boating back in 1936 to provide Depression-era youths with a unique outlet for their energies and a chance to enjoy nature. At that time, the Charles River was beginning to come into its own as a recreational site. Construction of the Charles River Dam in 1910 blocked the harbor tides that had once made it a muddy mess, transforming it into a more navigable freshwater river. The Esplanade quickly followed and in the 1930s was redesigned through the philanthropy of Helen Osbourne Storrow. Among the improvements made at this time were the addition of boat landings and the creation of Storrow Lagoon for summer sailing and winter skating. Storrow's money also furnished the increasingly popular Community Boating with a new boathouse in 1941.

The hallmark of Community Boating has always been its work with children and young adults. Boston University's sailing team practiced there in the 1950s before acquiring its own facility. By that time, Community Boating maintained a fleet of thirty fiberglass Mercury boats for kids to enjoy through its Junior Program. Even today, boys and girls can join for only one dollar and participate in all kinds of activities, including the annual "Kids Sail the Stars" regatta that lets them race with some of the sport's best athletes. A number of area high school sailing programs also owe their existence to support from Community Boating, which provides equipment otherwise beyond the reach of many school districts.

Because Community Boating is a non-profit organization, it relies on modest membership fees from adults to maintain its youth programs. Fortunately, grown-ups are as anxious to climb aboard as the kids. The stalwarts arrive early on Opening Day, April 1st, and are often among the last off the boats when the season ends on Halloween. In between, thousands of casual members from all walks of life come to relax on the docks, attend barbeque picnics, and take romantic midnight sails. Such activities have helped make Community Boating the largest organization of its kind in the United States, and its contributions to both the sailing world and the community of Boston have earned it countless awards.

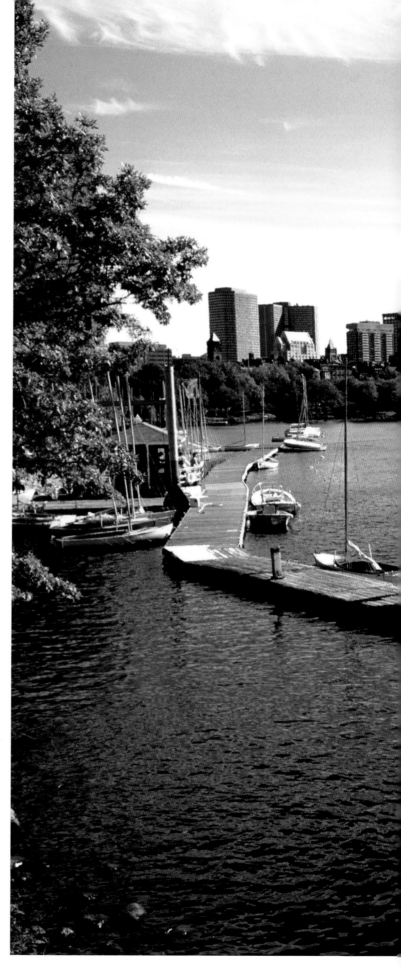

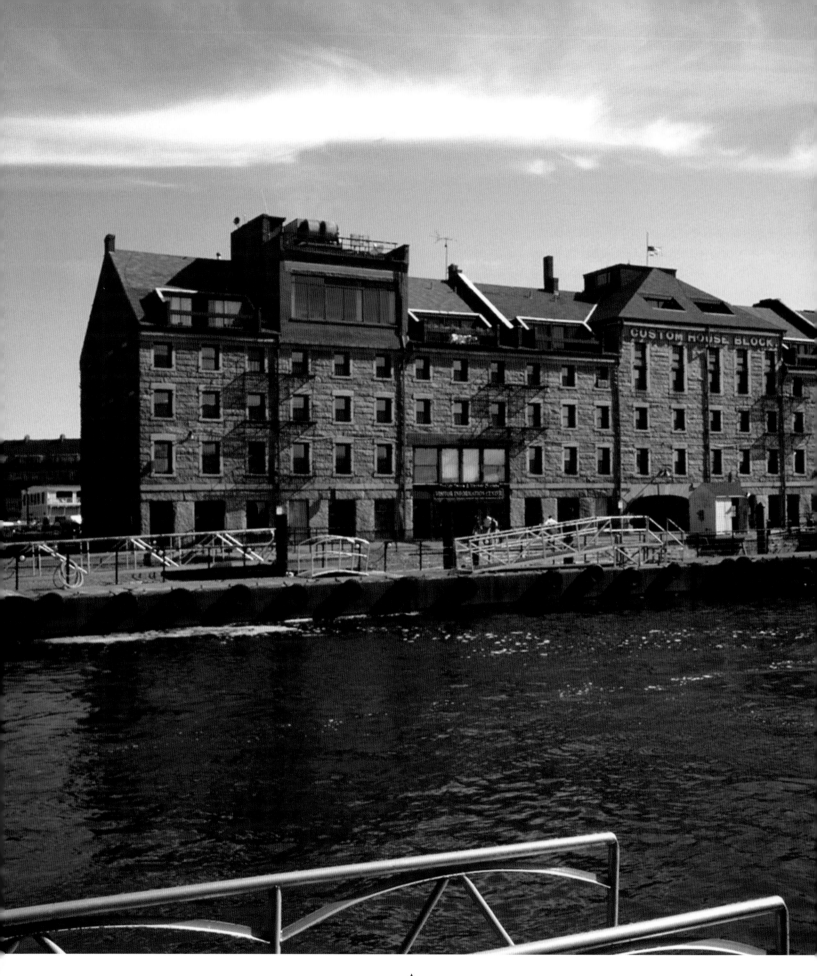

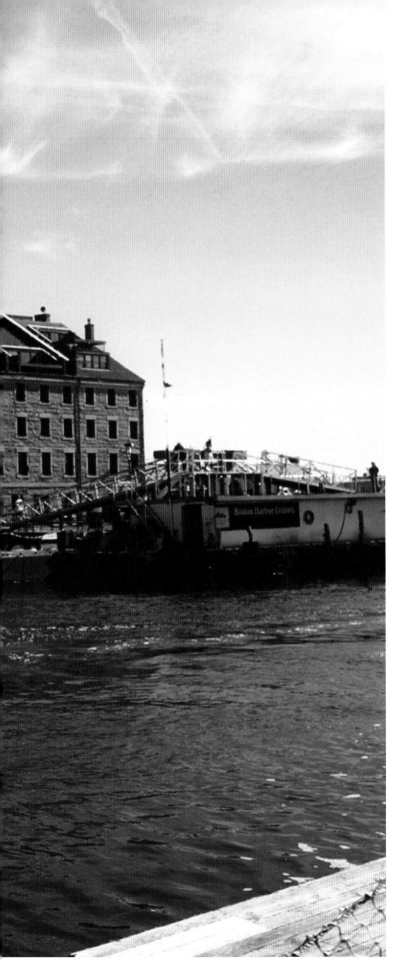

# Custom House Block

✦✦✦✦✦✦✦✦✦✦✦✦✦✦✦✦✦✦✦✦✦✦✦✦✦✦✦✦✦✦✦✦✦✦✦✦✦✦

B uilt around 1848, the granite-faced Custom House Block on Boston's Long Wharf reflects an era when the seaport was alive with maritime activity. Architect Isaiah Rogers, who had recently completed work on nearby Commercial Wharf, designed the four-story warehouse building to replace several smaller wooden warehouses that had sat on the wharf since the colonial period. Walking along Boston's waterfront in the 1840s, Alexander Mackay was amazed by the abundance that characterized the Custom House Block. "[T]hickly strewn around you, are all the insignia of an extensive commerce," he wrote. "Raw cotton in countless bales; piles of manufactured goods for the South American and Chinese markets; whole acres covered with parallel rows of clean white barrels, some of them well-nigh busting with flour, others full of salt."

Although the decline of Boston's waterfront in the twentieth century rendered the Custom House Block obsolete as a warehouse, the federal government recognized the structure's importance to maritime history by naming it a National Historic Landmark in 1966, which protected it from demolition. It thereafter became an important part of the city's renewal plan for the waterfront district. In the early 1970s, Anderson Notter Associates, the architectural firm that won praise for its renovation of Boston's Old City Hall, adapted the Custom House Block for reuse as office and living space.

# Long Wharf Marina

**✦✦✦✦✦✦✦✦✦✦✦✦✦✦✦✦✦✦✦✦✦✦✦✦✦✦✦✦✦✦✦✦✦✦✦✦✦✦✦✦✦**

If Boston is the "hub" of the solar system, as Oliver Wendell Holmes once suggested, then Long Wharf is historically the hub of Boston. Built between 1710 and 1713, it extended an unprecedented 800 feet into Boston Harbor, enabling large vessels to unload their cargo directly onto the dock. Wooden warehouses lined the north side of the wharf, and upwards of 50 ships could moor there at any given time. Located at the foot of King (now State) Street, it both reflected and contributed to Boston's commercial growth in the eighteenth century. Some of the best inns and coffee houses in the city could be found there, patronized by everyone from British customs agents to merchant smugglers.

By the early nineteenth century, the wharf had been elongated to about 2,000 feet and acquired some new neighbors to the south—India and Central wharves. India Wharf quickly became a must-see attraction along the waterfront and the fashionable mooring site for merchant ships. But Long Wharf remained busy, too. Nathaniel Hawthorne spent the better part of his time there as a Boston customs agent, supervising its activities and complaining to his fiancée, "Everything that I do here might be better done by a machine. I am a machine, and am surrounded by hundreds of similar machines." Life at Long Wharf was not always work, however. Boat races from the wharf to Castle Island were a favorite pastime of Bostonians in the nineteenth century, especially among the Irish immigrants living on nearby Broad Street.

Today, Long Wharf has almost wholly been given over to recreation. New forms of shipping reduced the commercial need for the wharf, contributing to decades of decline before the urban renewal initiatives of the 1960s. While hotels have replaced the old warehouses than once lined the wharf, passenger ferries occupy the moorings formerly reserved for merchant vessels. And the Waterboat Marina allows for more pleasure boats to enjoy the wharf, although it has become a source of controversy in recent years. Critics complain that its tax rate has not kept pace with rising property values along the wharf, but officials insist that the marina's role in attracting wealth to the waterfront is worth more than the added tax dollars that might drive it under.

# Boston Children's Museum

F ounded in 1913, the Boston Children's Museum is the legacy of progressive-minded teachers who believed that active learning was a "hands-on" experience, not a trait typically associated with museums. This innovative approach to education had been pioneered by the Brooklyn Children's Museum in 1899, making the Boston museum just the second institution of its kind in the country. Its early collection reflected the scientific interests of its founders, with activities that sought to reconnect city kids with the wonders of the natural world. It continues this tradition with such exhibits as the Science Playground. More recently, however, the museum has come to emphasize the arts and humanities.

By 1979, the museum had outgrown its original Jamaica Plains home and moved into an old woolens warehouse along Fort Point Channel, where it remains today.

Many of the museum's exhibits and programs aim to teach children the value of cultural diversity. In 2007, the Children's Museum completed a major renovation and expansion that added over 20,000 square feet of space to the existing facility, improved visitor flow through the building, and made it the city's first LEED-certified museum. The improvements have given added emphasis to themes of environmental sustainability and activities that promote healthy, active lifestyles in children, issues of growing concern in

contemporary American society. Proper nutrition has been a theme of the museum ever since its affiliation with a forty-foot milk bottle began back in the 1970s. Built in the 1930s for a homemade ice-cream shop, the whimsical wooden carving was later purchased by the Hood Company, New England's largest dairy, and moved to Museum Wharf, where it functions as a refreshment stand. On hot summer days, visitors to the museum can cool off with a wide variety of frozen dairy treats and cold beverages.

# Boston HarborWalk

\* \* \* \* \* \* \* \* \* \* \* \* \* \* \* \* \* \* \* \* \* \* \* \* \* \* \* \* \* \* \* \* \* \* \* \* \* \* \* \* \* \* \* \* \* \* \* \* \* \* \* \* \* \* \*

Once the lifeblood of a bustling seaport, Boston harbor was all but forgotten as the city evolved away from it in the nineteenth and twentieth centuries. Landfill projects eliminated much of the original waterfront, creating new neighborhoods distant from the harbor. Maritime shipping also slumped as the local economy increasing relied on other sources of wealth. And modern skyscrapers obscured street-level views of the water, while construction of the elevated Central Artery expressway in the 1950s effectively cut off the harbor from the downtown district. It was if the city had turned its back on its seafaring tradition, leaving it to rot at water's edge alongside the old wharves and warehouses.

Revitalizing Boston's waterfront has taken decades of work, beginning with construction of the New England Aquarium in 1969 and culminating with the recent creation of Boston HarborWalk. Nearly fifty miles long, the HarborWalk follows the coastline from the Neponset River in Dorchester through downtown Boston and across the harbor to Charlestown and even Deer Island. Along the way, visitors are treated to splendid views of the harbor and a history lesson in Boston's rich maritime heritage. Among the many sites featured are Castle Island, whose military fortifications once guarded the harbor, and the old Charlestown Navy Yard, where the World War II-era destroyer *Cassin Young* and the famed U.S.S. *Constitution* are anchored. Inside the posh Boston Harbor Hotel on Rowes Wharf, visitors can view a collection of rare, centuries-old maps of the seaport on display, or walk out to the end of historic Long Wharf to see where centuries of seafarers once came ashore.

The waterfront isn't the only attraction of the Boston HarborWalk, however. Cultural activities abound. The Fort Point Channel portion, for instance, takes pedestrians into the largest and most dynamic artist colony in New England, near the new Institute of Contemporary Art on Fan Pier, and past the site of the legendary underground nightclub The Channel, which shook with the sounds of punk and New Wave acts such as The Cars, The Ramones, and the B-52s in the 1980s. Public art and sculpture are on display at various parks along the path, as are several architectural gems. But for many patrons it is the simple pleasure of escaping the hustle-and-bustle of urban life that has proved to be Boston HarborWalk's greatest attraction.

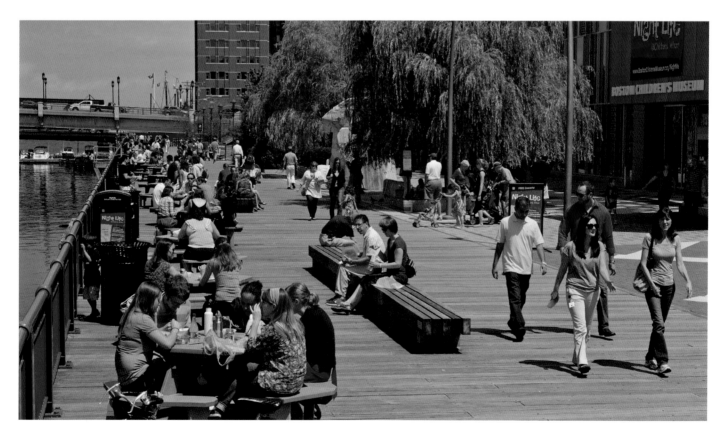

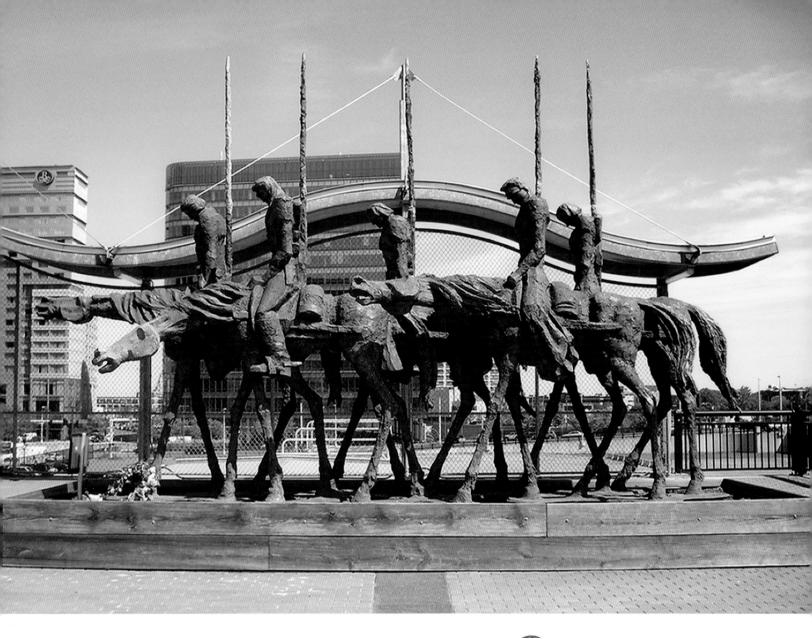

# *Partisans Statue*

\* \* \* \* \* \* \* \* \* \* \* \* \* \* \* \* \* \* \* \* \* \* \* \* \* \* \* \* \* \* \* \* \* \* \* \* \* \* \* \* \* \* \* \* \* \* \* \* \* \* \* \*

There has been no shortage of debate about Andrzej Pitynski's statue *Partisans* since its debut on Boston Common in 1983. Designed as a memorial to those who suffer in the cause of liberty and human rights, the aluminum-cast sculpture depicts five weary Polish freedom fighters on horseback. Pitynski, whose own family had struggled against communism in his native Poland, believed Boston was the best place to display his work because of its historic reputation as the "Cradle of Liberty." Originally accepted with the understanding that it was to be a temporary exhibit at City Hall Plaza, the unpopular statue was instead installed on the Charles Street side of Boston Common, where it remained for decades. Some found it moving; others considered it an eyesore and could not understand its connection to the city. "The Boston Common is the first park in the United States, and the monuments on it should have to do with America and its history," explained Beacon Hill resident Eugenie Beal. The statue's close proximity to the Public Garden especially irked the organization responsible for its aesthetic integrity. Its members joined forces with the Boston Art Commission and the Parks Department to lobby for the sculpture's removal, a goal finally achieved in early 2006. But the decision outraged Boston's Polish-American community, which rallied behind the embattled sculpture and found it a fitting new home near the Institute of Contemporary Art in the South Boston neighborhood that many of them call home.

# Boston Tea Party Ships & Museum

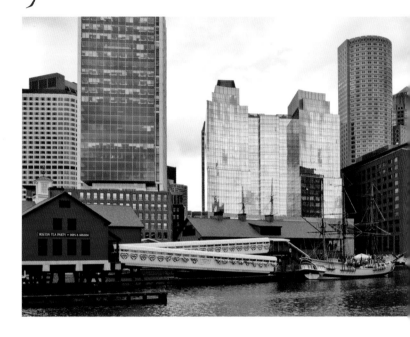

"This Destruction of the Tea is so bold, so daring, so firm, intrepid, & inflexible" wrote John Adams in the wake of the Boston Tea Party, "... that I cannot but consider it as an Epocha in History." Indeed, the events of December 16, 1773 marked an important turning point in the American Revolution, taking England and its colonies down a rocky path that would end in war and independence.

Earlier that year Parliament had granted the East India Company permission to sell its surplus tea directly to the American colonies free of English customs duties. To compensate for its lost revenue, the imperial government expected colonists to pay a tax on the tea delivered, which would be used to help defray the administrative costs of Britain's very expensive trans-Atlantic empire. But the colonial patriot movement cried foul, accusing Parliament of using the popular drink to buy obedience to unconstitutional taxes and vowing to resist the measure. After repeated negotiations with royal officials broke down in December, a group of Bostonians thinly disguised as Indians made their way under cover of darkness to Griffin's Wharf, where three cargo ships laden with East India Company tea awaited. They worked quickly and quietly as they broke open hundreds of tea chests and poured their contents into Boston Harbor. Participants were sworn to secrecy, and to this day

many of their identities remain uncertain. An infuriated Parliament punished the entire community by shutting down the harbor to commercial traffic until compensation was made, resulting in a standoff that crippled the local economy, prompted a mass exodus out of the city, and pushed political tensions to new heights.

Though their "Tea Party," as it was later called, plunged Bostonians into dark days they would have rather forgotten, later generations of Americans have embraced the event with patriotic pride, most recently the conservative political movement known as the T.E.A. Party. And thanks to the joint efforts of the City of Boston and Historic Tours of America, history buffs can enjoy a twenty-first century immersion in the eighteenth-century past with a visit to the newly renovated Boston Tea Party Ships & Museum, located near where Griffin's Wharf once stood. The museum was first opened in 1973 to honor the bicentennial of the Tea Party, but was closed in 2001 after a lightning strike sparked a fire that caused extensive damage. Before it could be re-opened, however, a second fire in 2007 shuttered it again until its grand reopening in 2012. Among the entertaining features of the enlarged museum are holographic images of revolutionary-era figures, participatory re-enactments in which visitors toss tea into the sea, and the display of what is believed to be one of only two surviving tea chests from that fateful night. Given the museum's own history, it also wisely invested in state-of-the-art fire alarms and a suppressant system.

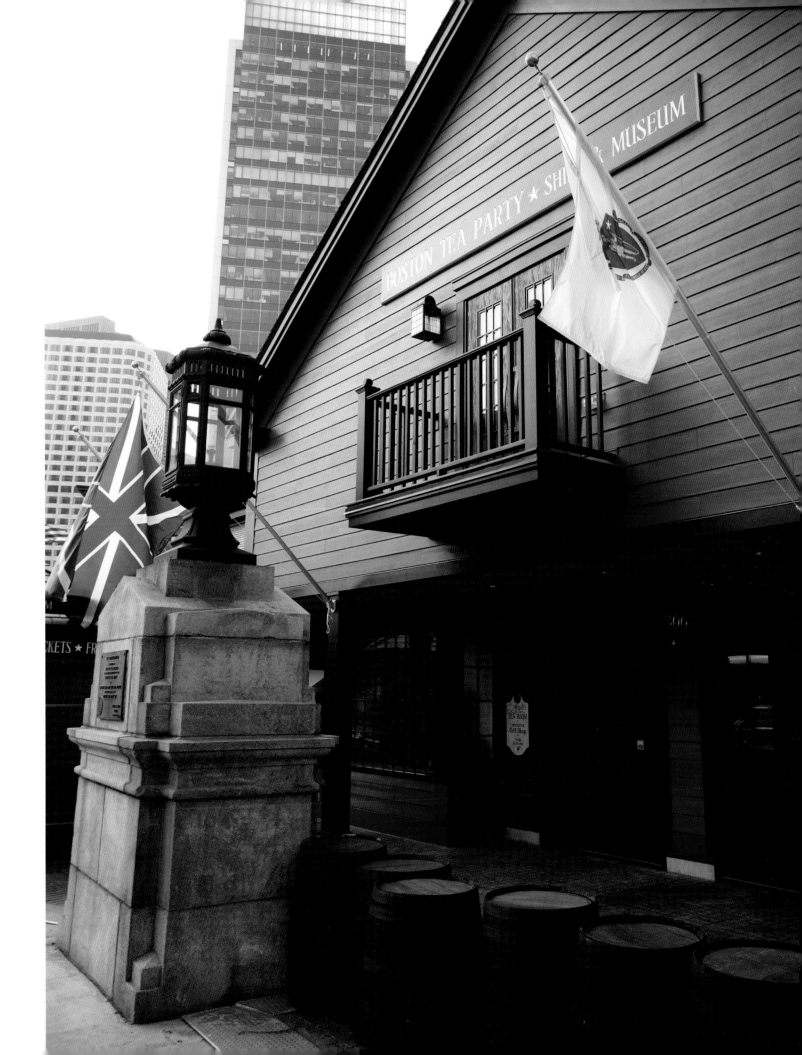

# Fort Point Channel

\* \* \* \* \* \* \* \* \* \* \* \* \* \* \* \* \* \* \* \* \* \* \* \* \* \* \* \* \* \* \* \* \* \* \* \* \* \*

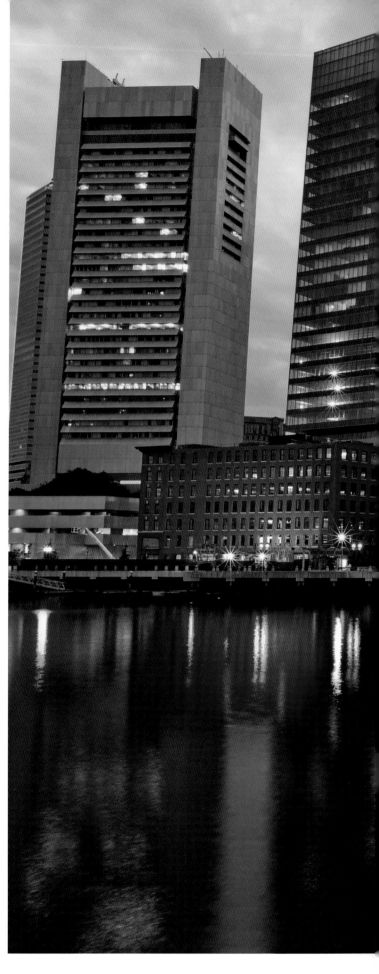

Few areas of Boston's waterfront have undergone greater transformation over the centuries than Fort Point Channel. Located at what was originally the eastern end of Shawmut peninsula, its name is derived from Fort Hill, a natural prominence that once overlooked the harbor and where a wooden fortification was built to defend colonial Boston from naval attacks. Despite the fact that it was neither the deepest part of the harbor nor the densest part of town, over time a number of wharves, warehouses, and shipyards began to dot the waterfront below the hill, including Griffin's Wharf (later site of the Boston Tea Party).

In the years after the American Revolution, the fortification fell into decay and the area emerged as a fashionable neighborhood for wealthy Bostonians looking to escape the more crowded North End and central commercial district. It was here that architect Charles Bulfinch created one of his most ambitious projects, the Tontine Crescent, in the 1790s. In the early 1800s investors also built a toll bridge across Fort Point Channel to the newly annexed South Boston on the other side. Between the hill and the bridge, this part of Boston offered residents and visitors alike some of the grandest panoramic views of the growing city. After mid-century, however, the view began to change quite dramatically as Fort Hill was leveled, landfill projects narrowed the channel, railroads and industrial buildings went up, and working-class Irish immigrants took up residence around the Fort Hill neighborhood.

Fort Point Channel retained its gritty industrial character into the twentieth century, with a number of prominent corporations located along its banks, from the New England Confectionary Company (NECCO) to the Gillette Razor Company. But in the years after World War II, the area fell on hard times as some of the factories relocated to other parts of Boston and beyond. Its recent renaissance began in the 1970s when the Boston Children's Museum moved there and it became a popular destination for artists seeking cheap studio space. Since then Fort Point Channel has evolved into an extension of the downtown and symbol of a new Boston with the construction of several public buildings nearby, such as the Moakley Federal Courthouse and the massive Boston Convention Center. But no building better captures what Fort Point Channel has become, and once was, than the award-winning InterContinental Hotel. Completed in 2006, the hotel's design quite literally reflects Fort Point Channel's maritime past with its twin glass towers capturing the shimmer of the waters below and curving like a ship's billowed sails.

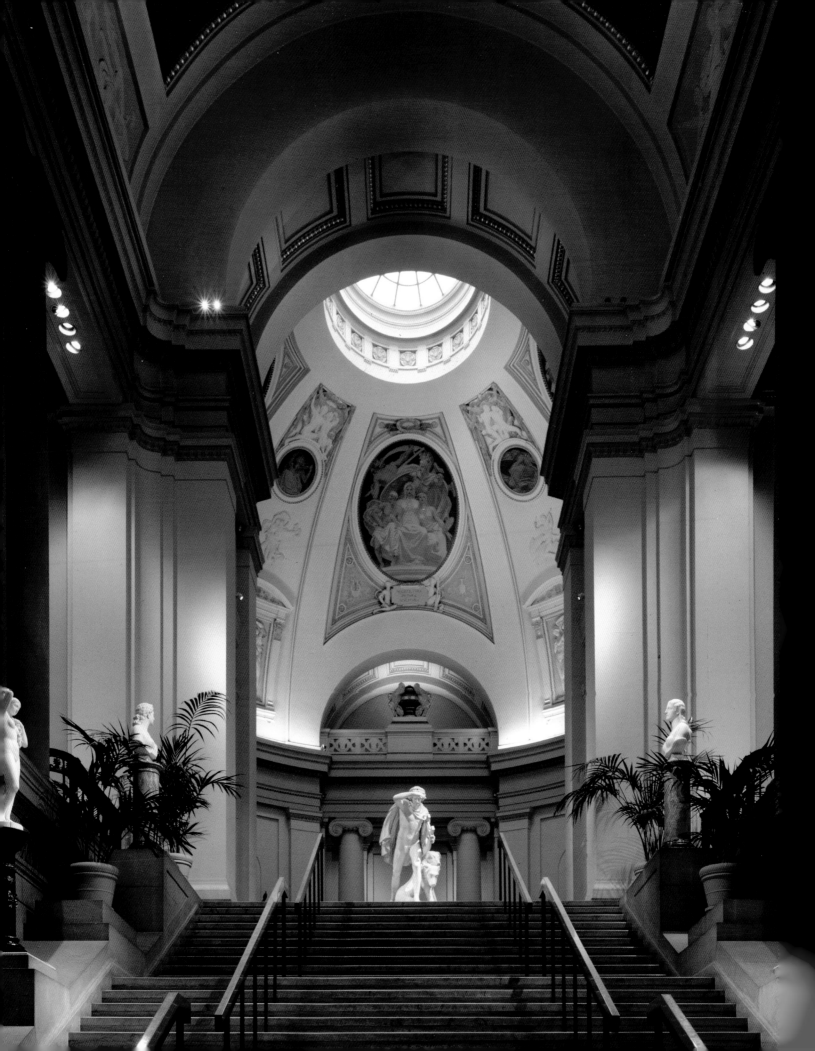

two additions to the building, however, it was bursting at the seams by 1899 and abandoned for the museum's current location, near Frederick Law Olmsted's Emerald Necklace park system. Architect Guy Lowell provided the MFA's now-familiar neoclassical façade in 1909, while Cyrus Dallin designed the eye-catching sculpture *An Appeal to the Great Spirit*, which greets visitors outside the Huntington Street entrance. Erected in 1913, the statue captures contemporary concern over a supposedly vanishing American frontier, as well as reflecting the museum's interest in indigenous art and culture.

Most of the MFA's early collection featured European and Euro-American artwork, including portraits by Gilbert Stuart and some of Paul Revere's silver. It proudly possesses one of the largest collections of Claude Monet's paintings found outside of Paris. But the museum has also developed outstanding non-Western and Ancient World collections. Visitors are sometimes surprised to find themselves surrounded by Egyptian mummies and samurai swords

in the middle of Boston. Indeed, the MFA's collections encompass far more than the predictable paintings and portraits; they feature everything from unusual musical instruments and textiles to rare Roman coins.

The museum's recent renaissance has not been without controversy, however. Curators who questioned its direction were dismissed, while the director has come under fire for certain fundraising tactics. In 2004, valuable Monet paintings were loaned to the Bellagio Casino's unaccredited art gallery, a deal that generated a million dollars for the MFA. But critics argued that the risk to the artwork was too great, especially after a power outage temporarily left the Las Vegas gallery without climate-control. Others accused the non-profit museum of abusing its tax-exempt status with such "fast buck" schemes. Undaunted, Malcolm Rogers remains committed to making the "new" Museum of Fine Arts, in his words, "a landmark in our community and a magnet for visitors who come to Boston."

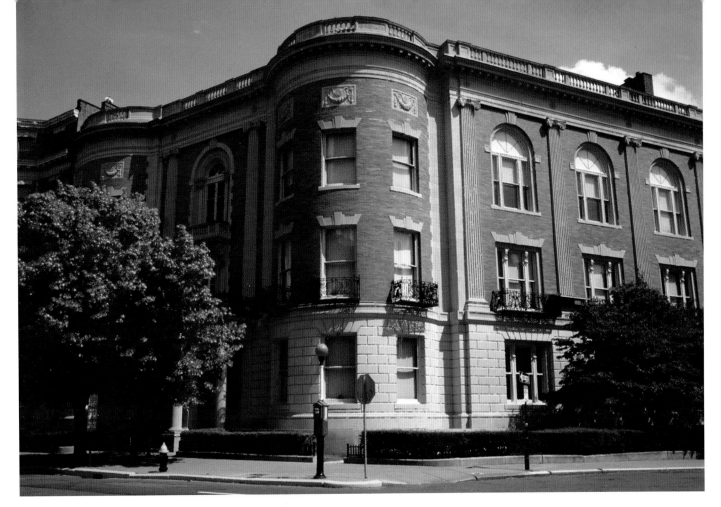

# *Massachusetts Historical Society*

★★★★★★★★★★★★★★★★★★★★★★★★★★★★★★★★★★★★★★★★★★★★★★★★★★★★★★★★★★★★★★★★★★★

Founded by Reverend Jeremy Belknap in 1791, the Massachusetts Historical Society was the first organization of its kind in the country and remains one of the nation's most prestigious historical societies. Belknap had been a staunch supporter of the American Revolution who believed that history was the way to knit the new United States together. Yet he was also aware that this would prove impossible without the creation of a repository for researchers to find the necessary documents, a problem that he had encountered while working on a history of New Hampshire. He also worried that much would be lost to posterity if such a place were not established quickly. Both fires and British soldiers had already carried off irreplaceable records in recent years.

Belknap initially approached Harvard College with his idea, but decided to found an independent historical society after school officials dragged their feet on the matter. Membership was originally limited to thirty, all of whom had to be serious about helping the society prosper. Belknap personally donated his extensive collection of books and manuscripts to get the archive started and solicited donations from others as the corresponding secretary of the Society.

The Massachusetts Historical Society relocated to its current home at 1154 Boylston Street in 1899. The new headquarters exuded an air of culture and sophistication, though it proved somewhat impractical as a research facility.

The Society nearly closed its doors in 1950 due to decades of mounting debt caused by war and economic depression. Officials swallowed their pride and asked the public for aid, to pull the organization back from the brink of bankruptcy. It worked. By the end of the decade, the Society was again thriving and even considered admitting women members into its all-male ranks. It would take several years to wear down resistance to the idea, but in the late 1960s the first female scholars were finally invited to join.

Today the Massachusetts Historical Society attracts scholars from all over the world, drawn to Boylston Street by the organization's rich archives and extensive fellowship program.

# Isabella Stewart Gardner Museum

"Unique." "Eclectic." "Innovative." "Enchanting." These words and more have been used to describe the Isabella Stewart Gardner Museum, home to some of the world's most valuable works of art. One would hardly know it looking at the museum's unassuming exterior, however. In contrast to the classical columns and colossal size of other museums, Gardner's collection is housed in a fifteenth-century Venetian palazzo that reflects its founder's fascination with the Italian Renaissance. Guests often assume that it was once a private residence, but in fact Mrs. Gardner expressly built it as an art museum after her husband's sudden death in 1898. Another common misconception is that she had the building moved intact from Italy, when actually it was cobbled together from several sources.

Isabella Stewart Gardner was herself something of a mystery to Bostonians. Born in New York of Scottish descent, she was a child of privilege with a strong sense of *noblesse oblige*. Her father made a fortune in various nineteenth-century industries and sent the teenaged Isabella to school in Paris, where she began a lifelong love affair with European culture. Her marriage to John Lowell Gardner, Jr., son of a wealthy merchant-industrialist, brought her to Boston's Beacon Hill in the 1860s. "Mrs. Jack," as Isabella was known in polite circles, endured the loss of her only child

in 1865 and a subsequent malaise that only extensive European travel remedied. Convinced that America lacked art and culture, she made it her mission to fill that void with her museum and befriended others who shared her passion, including the painter John Singer Sargent, novelist Henry James, and art critic Bernard Berenson, among others.

But Gardner became as famous around Boston for her personal eccentricities as for her art collection. She supposedly drank beer while other ladies sipped tea. Many of these stories are greatly exaggerated, yet at least one is known to be true. After her beloved Red Sox won the 1912 World Series, she shocked proper society by attending the Boston Symphony wearing a conspicuous headband reading "Oh, you Red Sox!" The stunt may have offended concertgoers, but endeared her to the hearts of generations of Red Sox fans, who can receive a discount on museum admission by sporting team paraphernalia.

Two thieves paid a backhanded compliment to the quality of Gardner's collection in 1990 when they posed as Boston police officers and stole artwork valued today at over $300 million. After conning two inexperienced night watchmen into opening the doors, the burglars handcuffed the confused guards, led them to the basement, and spent the next hour loading thirteen museum pieces into their getaway car. Rembrandt and Degas were the most popular targets, but the thieves also made off with Vermeer's *The Concert* and Manet's *Chez Tortoni*. Why they did not take Titian's *Europa*, probably the most valuable piece in the Gardner collection, is still a mystery, as are the identities of the two men. Despite some promising leads and a $5 million reward, the case has never been solved and remains the biggest heist in art history.

Though museum officials have never forgotten the theft, they have moved forward. They continue the Gardner's acclaimed artist-in-residence program and maintain the nation's longest-running museum concert series, featuring music by classical composers. In early 2012, they unveiled a $114 million expansion intended to bring the museum into the twenty-first century while retaining Isabella's uncompromising vision. Because Gardner's will expressly prohibits alterations to the original building and its collection, the new wing is located directly behind it. Renowned Italian architect Renzo Piano, who designed the extension, likened its relationship with the Gardner to that of a great-grandaunt and her nephew. Most Bostonians agree they make a very handsome pair.

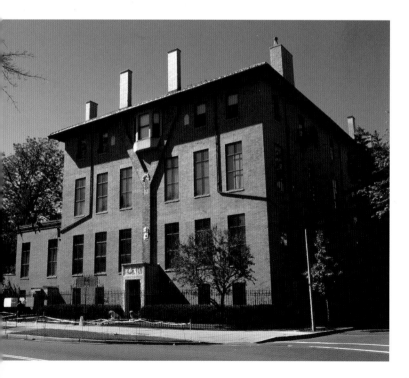

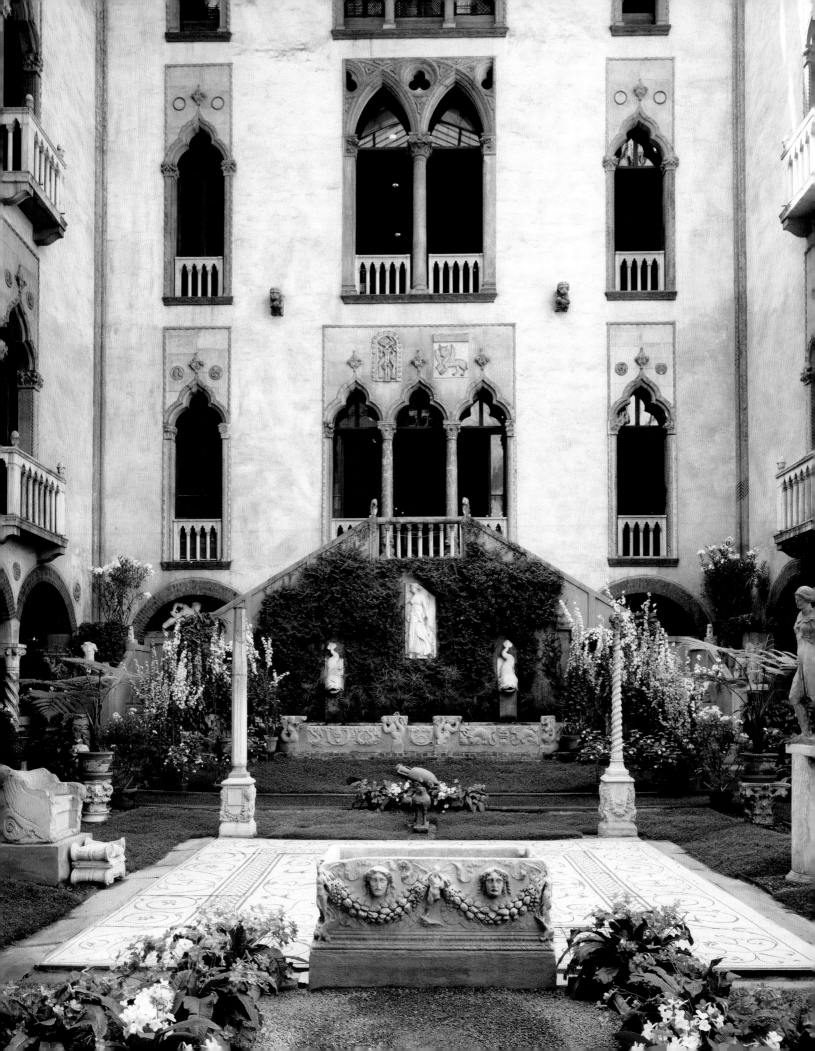

# Marsh Chapel

★★★★★★★★★★★★★★★★★★★★★★★★★★★★★★★★★★★★★★★★★★★★★★★

Since its dedication in 1950, Marsh Chapel has served as both the architectural and spiritual center of the Boston University campus. Its name has nothing to do with the marshlands, or fens, that once dominated the area. Rather, the building is named in honor of Daniel L. Marsh, the school's long-time president, who was instrumental in its creation. "Let this chapel at the center of the university campus," wrote Marsh, in words now inscribed above the chapel door, "signify forever the centrality both of intellectual and experimental religion in education and also of devotion to God's righteous rule in human lives."

The end of World War II and the opening of Marsh Chapel began a new chapter in Boston University's history. The Methodist school had spent decades wandering from Brookline to Beacon Hill to Copley Square before settling along the Charles River in the 1920s. But war and depression hampered its growth and shifted its priorities. Over two hundred students and alumni died serving their country in World War II, including the Reverend George L. Fox. Fox was one of four army chaplains who sacrificed their lifejackets and their lives to save others aboard the sinking U.S.S. *Dorchester* in February of 1943. Their inspiring story is remembered on a wall panel inside Marsh Chapel.

In later years a young man from Atlanta, Georgia, named Martin Luther, King, Jr., began doctoral coursework at Boston University's renowned School of Theology. He came contemplating a career in academia, but graduated in 1955 determined to be a preacher, after falling under the spell of Howard Thurman, the first black dean of Marsh Chapel. Thurman's message of Christian tolerance and compassion touched the hearts of his diverse congregation, which crowded into the chapel to hear his sermons. Thurman was also an inspiration for King's Civil Rights strategy of passive resistance. To honor King's legacy, his alma mater erected the sculpture *Free at Last* before Marsh Chapel. The memorial depicts fifty doves of peace flying skyward together.

Open to people of all faiths, Marsh Chapel and its adjoining plaza have provided students with a place to come together in celebration, protest, and mourning. Antiwar demonstrations were held there during the Vietnam conflict, and more recently students and faculty filled the Marsh Chapel Plaza for an emotional candlelight vigil after the terrorist attacks of September 11, 2001. Such an outpouring of faith reaffirmed the role that Reverend Howard Thurman had ascribed to Marsh Chapel nearly a half-century earlier, "a symbol of the intent of the University to recognize religion as fundamental in the human enterprise."

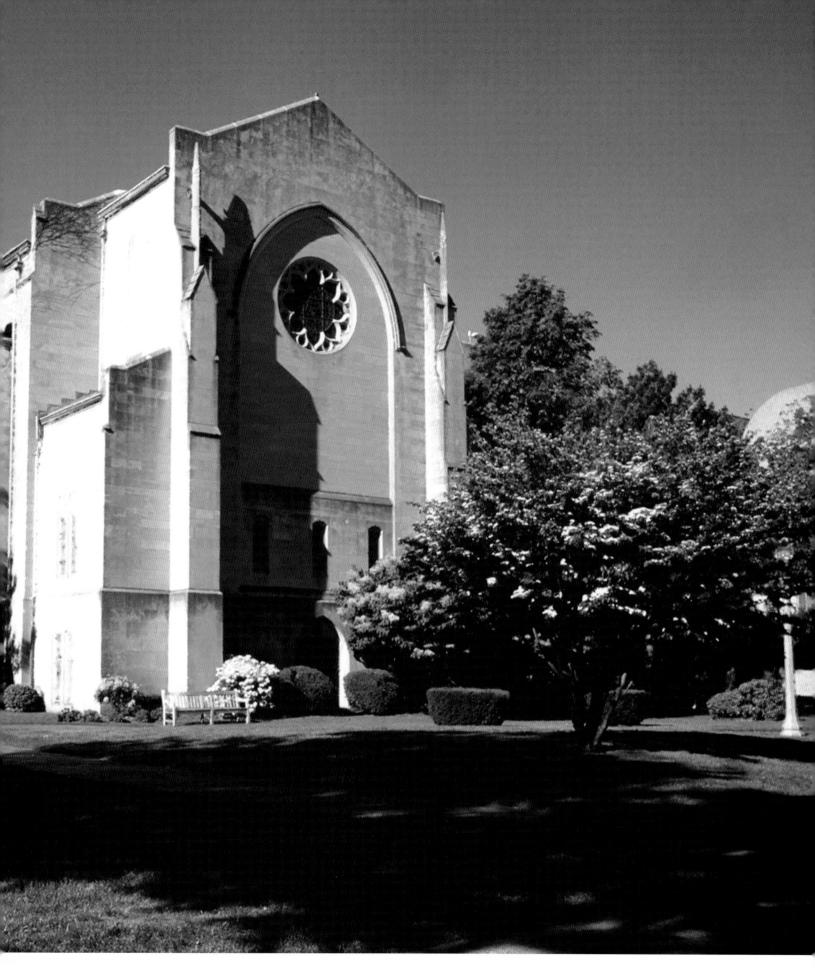

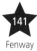

# The (Christian Science) Mother Church

Puritanism has cast such a long shadow over Boston's religious history that the city's role in other prominent religious movements is often overlooked. Yet it is hard to miss the grand Mother Church that has served as headquarters for the First Church of Christ, Scientist for over a century. The sprawling fourteen-acre complex, complete with a reflecting pool, water fountain, and an unusual three-story glass globe (called the Mapparium), attracts some 250,000 visitors a year, even as church membership declines and financial difficulties mount. Critics argue that Christian Science itself has become like the 1935 Mapparium, a hollow shell frozen in time, but believers are banking on the country's recent conservative turn and renewed emphasis on faith to help restore the church to its former glory.

Christian Science is no stranger to controversy. With its emphasis on the healing powers of prayer, the religion has been both praised as an innovative form of alternative therapy and condemned as spiritually unorthodox and physically dangerous. Born of a backlash against the scientific determinism of modern medicine after the Civil War, it initially appealed to the factory-working families of Lynn, Massachusetts, where Christian Science founder Mary Baker Eddy lived at the time. Eddy had endured many hardships in her life which, Eddy later claimed, inspired her to promote the power of prayer for bodily as well as spiritual health. In 1875, she published her ideas in Science and Health, which has since sold over ten million copies and provides the doctrinal basis for the Christian Science religion.

# Muddy River

★★★★★★★★★★★★★★★★★★★★★★★★★★★★★★★★★★★★★★★★★★★★★★★★★★★★★★

As its name suggests, Muddy River is a rather murky stream that empties into the Charles River and forms the boundary between Boston and Brookline to the west. In the colonial period, its fertile banks were prized farmland for some of Puritan Boston's leading citizens, including Reverend John Cotton and Judge Samuel Sewall. A small agricultural settlement emerged there by the early eighteenth century, and Muddy River farmers were among those who carted their produce through the streets of Boston to Faneuil Hall market.

The river would likely be of little note today were it not for Frederick Law Olmsted's efforts to feature it in his famed Emerald Necklace park system. Not everyone shared his enthusiasm for the project, however. Brookline had been fighting off annexation by Boston since the 1870s and was reluctant to sell its share of the Muddy River, delaying the development of Riverway Park until the 1890s. Olmsted's improvements, which better controlled silt deposits, made Muddy River something of a misnomer and transformed an otherwise nondescript stream into a popular recreational retreat. Recent pollution problems have again muddied its waters and tarnished Olmsted's Emerald Necklace, prompting public campaigns to clean up Muddy River as both an historic and natural treasure for the community.

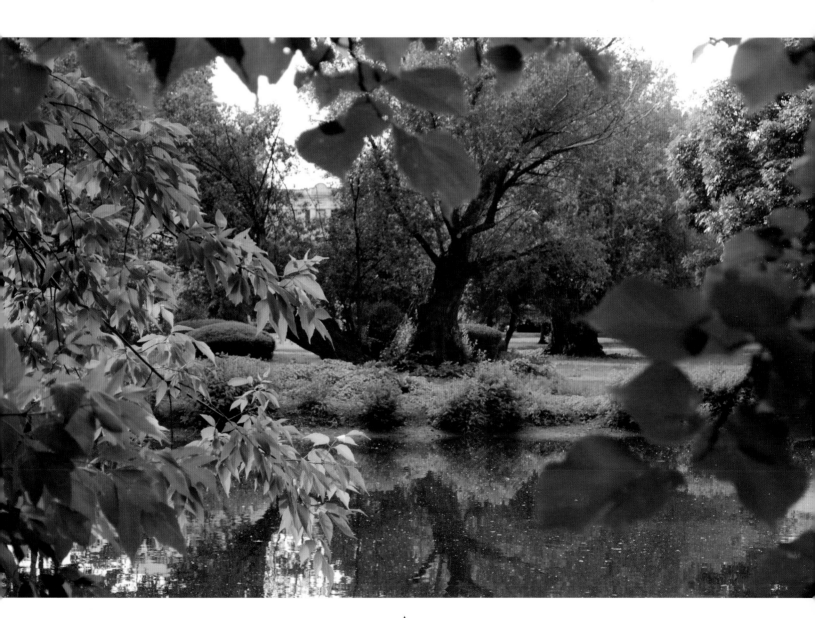

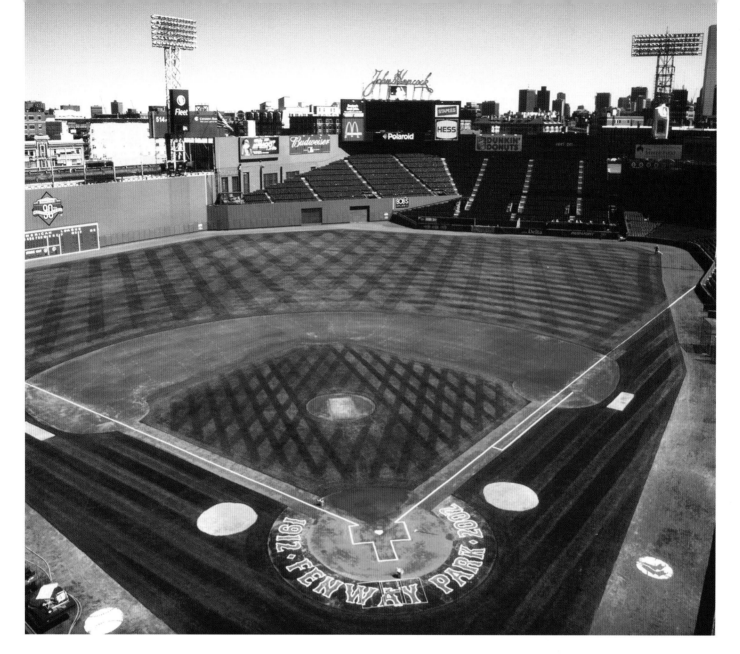

## Fenway Park

★★★★★★★★★★★★★★★★★★★★★★★★★★★★★★★★★★★★★★★★★★★★★★★★★★★★★★★★★★★★

Fenway Park, home of the Boston Red Sox, is a mecca for baseball fans worldwide. Every year, millions of them make a pilgrimage and pay homage to this "Cathedral of Baseball," the oldest stadium in the major leagues. They come to connect with the sport's storied past, watch current stars play ball, and perhaps catch a glimpse of a future Hall-of-Famer. For many fans, Fenway Park is also an indelible part of their personal history, a magical place their parents took them as kids or where they spent a memorable afternoon with their own children. And players likewise never forget the first time they stepped onto the legendary field where some of the game's greatest athletes have performed. Perhaps

former pitcher Tom Seaver put it best when he said, "Fenway *is* the essence of baseball."

Before the construction of Fenway Park in 1912, the Red Sox leased a stadium on Huntington Avenue, where the first World Series was played in 1903. But owner John I. Taylor found the arrangement unacceptable and was determined to build a new facility on land being developed by his real estate company, a move that enhanced the value of both the land and the team. He called the structure Fenway Park because of its location. The team's home opener, played in the wake of the *Titanic* tragedy, drew nearly 27,000 spectators and began a banner year for the

Red Sox, who went on to win the 1912 World Series. Two years later Babe Ruth started his brilliant career as a Sox pitcher before being sold to the New York Yankees in 1920.

And so began the infamous "Curse of the Bambino." Ruth's departure ended a decade of dominance and initiated a steady decline that saw the club struggle both on and off the field. There was even talk of closing Fenway Park. An organization that was repeatedly crowned champions in the 1910s could no longer even post a winning record and would not win the World Series for the rest of the century! Meanwhile, Ruth's Yankees opened their new stadium in 1923 with a victory over the Red Sox and went on to win the first of their record twenty-seven World Series titles.

Things began to look up for the Fenway faithful when millionaire Thomas A. Yawkey purchased the Red Sox in 1933 and renovated the stadium, painting it its characteristic green color and installing a still-used scoreboard that counts balls and strikes with colored lights. Several years later, in 1939, he brought in "The Kid," Ted Williams, to play in front of the park's monstrous left field wall. Williams would guard this so-called "Green Monster" for the next twenty years, although most of his 521 career home runs went over the right field fence, an area nicknamed "Williamsburg." A red seat marks the spot in right field where he once crushed a ball 502 feet, for the longest home run ever recorded in Fenway Park.

Leading them back to the World Series in 1946, Williams almost made Red Sox fans forget Babe Ruth. But "the Curse of the Bambino" remained until 2004, when the Red Sox finally won their first World Series since 1918 off the bat of Series-MVP Manny Ramirez. "It's time to put Babe Ruth's picture away and don't worry about him anymore," proclaimed one old-timer. "He's history." Three years later the Sox repeated as league champs and in 2012 celebrated their centennial season at Fenway.

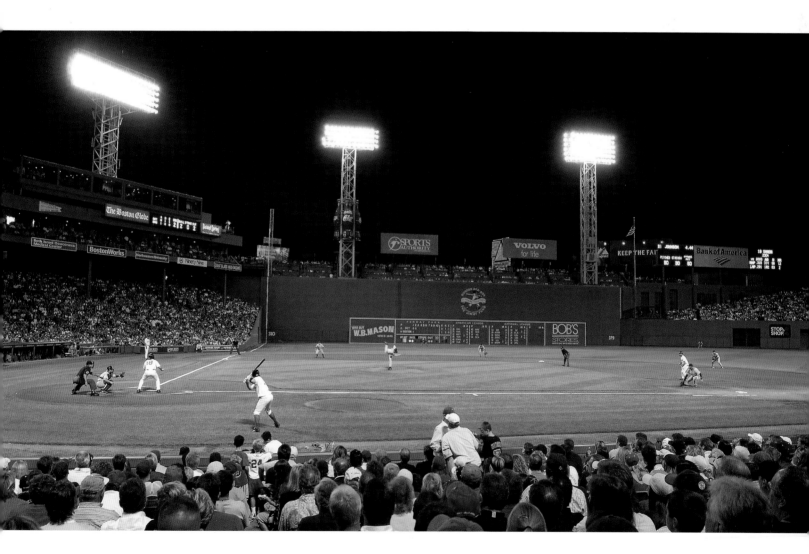

# Frederick Law Olmsted National Historic Park

Although Frederick Law Olmsted is best known as the architect of New York City's Central Park, the native New Englander spent much of his distinguished career in suburban Boston, where he designed a series of interconnected parks affectionately called the "Emerald Necklace." Olmsted was brought to Boston in 1878, at the behest of public officials concerned about the city's stifling effects on its residents. Boston Common, long a retreat from the hustle and bustle of urban life, seemed smaller with each passing year as the city expanded around it. Olmsted's plan called for the Common, the Public Garden, and the recently completed Commonwealth Avenue Mall to be joined with new parks beginning at Charlesgate, near where the Muddy River meets the Charles River, and continuing south through the Back Bay Fens and Jamaica Pond before finishing at Franklin Park, the crown jewel

of the necklace. Columbia Road was to have been the next link in the chain, but was never completed after Olmsted's death in 1903.

Perhaps to better supervise his ambitious project, Olmsted left Manhattan in 1883 for a Brookline farmhouse near the Emerald Necklace and close to his friend H.H. Richardson, architect of Boston's Trinity Church. The 1810 home also doubled as an office until construction of a formal office complex on the property began in 1889. An old hay barn was refurbished to provide additional office space for Olmsted and his sons Frederick, Jr. and John Charles, who assisted their father with his expanding business. As one would expect from America's premiere landscape architect, his 1.76-acre estate, which he named "Fairsted," was beautifully designed and featured elements also applied to the Emerald Necklace. Although many original plants and trees have

naturally succumbed to the ravages of time, the grounds remain much as they appeared in Olmsted's day.

After declining health forced Olmsted into retirement in 1895, his sons capably maintained both the firm and the farm well into the twentieth century. Frederick, Jr. helped create the National Park Service, which ironically would assume ownership of Fairsted and its rich archival collection in 1979. A major, two-year renovation of the site began in 2005 to improve fire protection, remodel the barn for public use, and address drainage problems on the property. Were he alive, Frederick Law Olmsted might have some expert advice on that last matter, for proper drainage was the key to building his Emerald Necklace along the marshy lowlands of Boston's Back Bay.

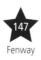

# *Larz Anderson Auto Museum*

\*\*\*\*\*\*\*\*\*\*\*\*\*\*\*\*\*\*\*\*\*\*\*\*\*\*\*\*\*\*\*\*\*\*\*\*\*\*\*\*\*\*\*\*\*\*\*\*\*\*\*\*\*\*\*\*\*\*\*\*\*\*\*\*\*\*\*\*\*

Massachusetts has a history of transportation innovation. While still a part of the British Empire, Boston had a reputation for producing handsome horse-drawn carriages and sturdy sailing vessels. As the cradle of American industry in the nineteenth century, the Bay State constructed the nation's first subway system in Boston and built some of the first American automobiles. The Duryea brothers of Springfield are credited with designing a gasoline-powered vehicle as early as 1897. And while that western Massachusetts city later became famous as the home

of Indian motorcycles, it was Sylvester Roper of Boston's Roxbury neighborhood who developed the steam-powered prototype that some consider the first motorcycle. It is thus quite fitting that Massachusetts should have what may well be the oldest private automobile collection in the United States, albeit one composed mostly of foreign-made cars.

The European flair of Brookline's Larz Anderson Auto Museum reflects the tastes of its founders, Larz and Isabel Anderson. Larz was born in Paris, but educated in New England at the prestigious

Phillips Exeter Academy and later Harvard. It was as a member of the U.S. Diplomatic Corps in Rome during the 1890s that he met Isabel Weld Perkins, a young Massachusetts debutante who had inherited millions from her maternal grandfather's shipping empire. They married back in Boston in 1897 and soon afterward bought their first automobile, the rare Winton Runabout. In the days before Henry Ford promised to "democratize the automobile," sales were largely restricted to wealthy families such as the Andersons, who would accumulate over thirty motorcars in their collection. Contrary to popular belief, however, the Andersons did not keep every car they ever owned, only their favorites.

Though they also owned homes in Washington, D.C. and New Hampshire, Larz and Isabel stored their automobiles at their sixty-four acre Brookline estate on property once owned by her grandfather. Anxious to share their passion for cars with others, the Andersons announced their auto museum in the pages of the Boston Globe as early as 1927. Larz's death ten years later and his wife's passing in 1948 might have ended the museum, had

Isabel not made provisions in her will to protect it. Given Isabel's instrumental role in the creation and maintenance of the museum, it would be more aptly named the "Isabel Anderson Museum." The town of Brookline inherited the Anderson estate, while the Veteran Motor Car Club of America operated the museum.

In recent years, the Auto Museum has re-invented itself under innovative new directors, making it well worth the drive to visit. Its popular outdoor "Lawn Events" series attracts car enthusiasts from around the world, while themed exhibitions inside feature period vehicles loaned from antique collectors and other museums. Past examples include "The Fabulous Fifties," "Muscle Cars: Power to Burn," and "L'automobile," which focused on such French beauties as Peugeots, Renaults, and Delahayes. New England's automotive tradition was celebrated in the popular 1989 exhibition "Putting America on Wheels: New England Paves the Way." To enhance the viewing experience, visitors are now able to walk around and between the cars, watch films on the history of the automobile, and see vintage prints and photos.

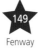

# Around the Hub

* * * * * * * * * * * * * * * * * * * * * * * * * * * * * * * * * *

*Charles River.*

# John F. Kennedy Library and Museum

**✦✦✦✦✦✦✦✦✦✦✦✦✦✦✦✦✦✦✦✦✦✦✦✦✦✦✦✦✦✦✦✦✦✦✦✦✦✦✦✦✦✦✦✦✦✦✦✦✦✦✦✦✦✦**

"Libraries are memories," John F. Kennedy once said, "and in this library you will have the memory of an extraordinary American." Though he was speaking of the Robert Frost Library in Amherst, Massachusetts, his prophetic words also describe the presidential library and museum later built in his honor. Located on Columbia Point near the University of Massachusetts-Boston campus, the John F. Kennedy Library and Museum overlooks Boston Harbor south of the city. The site is a splendid tribute to a navy man who loved the ocean, and architect I. M. Pei's building beautifully captures the setting with a 115-foot high glass pavilion. Outside near the water sits Kennedy's sailboat *Victura*,

a silent reminder of the President's favorite pastime. "His passion for the sea would have made him a great explorer," his brother Edward declared.

The Kennedy Library has a long history of community outreach and educational programming that make it more than a simple repository of documents for scholars. Since 1989, for instance, it has hosted the prestigious Profiles in Courage Award ceremony, so named for Kennedy's 1957 Pulitzer prize-winning book about principled politicians. Winners of the non-partisan award, which is personally handed out by Kennedy family members on JFK's birthday, have included Senators John McCain and Russell Feingold,

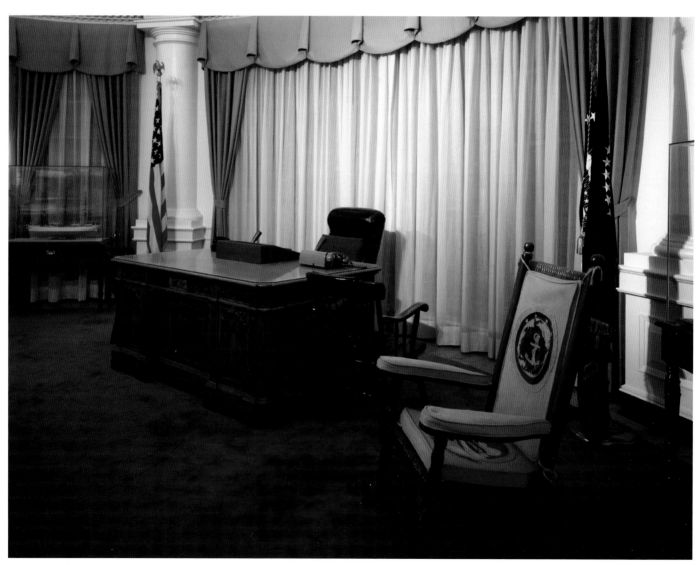

*President John F. Kennedy's White House office replicated at the John F. Kennedy Library and Museum.*

who together sponsored legislation regulating federal campaign contributions. In 2001, the award went to former President Gerald Ford for his controversial pardon of Richard Nixon in 1974, a decision that some believe cost him the presidency two years later. The previous year had seen California state senator Hilda Solis become the first female honoree for her environmental efforts.

The Library is especially active in educating today's youth, who have no recollection of Kennedy or the monumental events that defined his presidency. Yet when the library first opened, adults who remembered him treated it as a shrine to their fallen hero, though the President is not buried on the site. The museum does not shy away from either John's or Robert's untimely deaths at the hands of assassins, and since Jacqueline Kennedy's passing in 1994 more space has been dedicated to her own extraordinary life. Lest one leave sullen, however, the museum ends with a stirring "Legacy Exhibit" that conveys the Kennedys' eternal optimism in words that echo across the years.

*"Some men see things as they are and say why.*
*I dream things that never were and say why not."*
- Robert F. Kennedy

# John F. Kennedy
# National Historic Site

★★★★★★★★★★★★★★★★★★★★★★★★★★★★★★★★★★

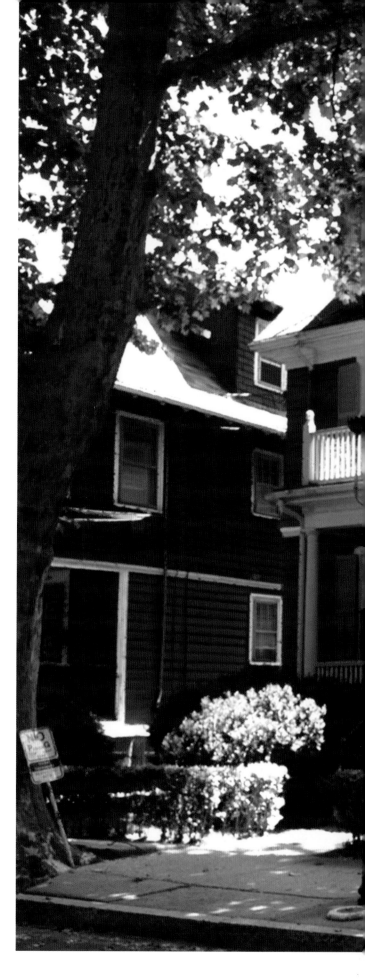

Casually passing by the humble, two-and-a-half story home at 83 Beals Street in Brookline, one might not realize that it was the birthplace of President John Fitzgerald Kennedy. It is a far cry from the family's familiar Cape Cod estate and scarcely fits the grand images of Camelot that surrounded Kennedy as an adult, although his boyhood copy of *King Arthur* can still be found there. John's parents, Joseph and Rose, purchased the house shortly after their marriage in 1914, when Brookline was a fashionable address for many wealthy Bostonians. Joseph had just begun a career as a banker and investor, while Rose was the well-known daughter of former Boston mayor John F. Fitzgerald, for whom the future President was named.

Rose Fitzgerald Kennedy fondly recalled their years in the home, saying "We were very happy here and although we did not know about the days ahead, we were enthusiastic and optimistic about the future." But she and her husband endured plenty of trials and tribulations there as well. Beginning with the birth of Joseph Jr. in 1915, Rose was nearly always either pregnant or nursing. Baby pictures of the four children born in the house are on display today, as is the bed where John Kennedy was born in 1917. He proved to be a rather sickly child, battling everything from measles, mumps, and whooping cough to a serious bout of scarlet fever that sent him to the hospital in 1920. His worried father was a near constant companion at his bedside, and Rose would spend time at home reading books to young John in the nursery. "You couldn't give a sick child a radio or a television set then, to keep him occupied, because there were none in 1917," she would later say. Fortunately, the busy mother had help from a live-in nursemaid and cook.

By 1921, the house on Beals Street was becoming crowded and Joseph's financial success enabled them to move into a large Victorian home on nearby Naples Street. A few years later, they left Brookline altogether. The family and the town rediscovered the house after John Kennedy was elected president, affixing an historical plaque to its exterior in 1961. Kennedy's assassination two years later prompted his mother to repurchase the home, furnish it with family heirlooms, and donate it to the federal government for preservation as a national historic landmark. She even recorded an audio house tour for visitors to the site. "It is our intention and hope to make a gift of this home to the American people so that future generations will be able to visit it and see how people lived in 1917 and thus get a better appreciation of the history of this wonderful country," she explained.

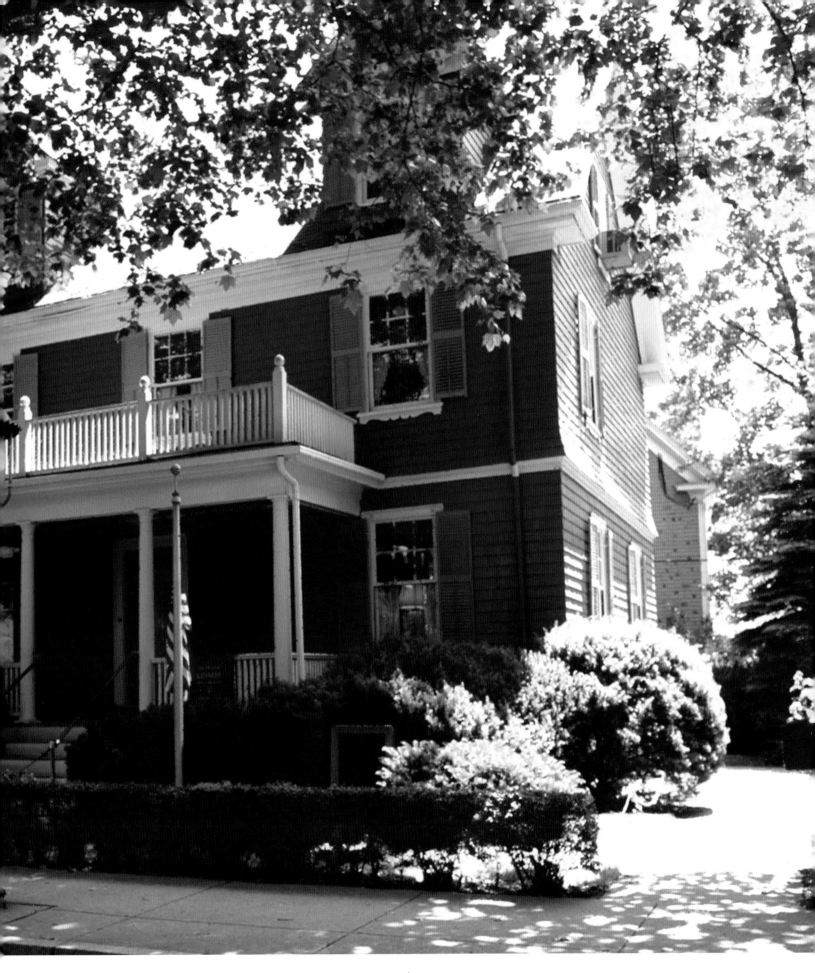

# Massachusetts Institute of Technology

"*Mens et Manus*," meaning "Mind and Hand," is the proud motto of the Massachusetts Institute of Technology, better known as M.I.T. It reflects the vision for the school put forward by its founder, William Barton Rogers, who believed in the practical application of higher learning to better society. As the son of an Irish-born chemistry professor, Rogers and his brothers had been exposed to the wonders of science from an early age. After attending the College of William and Mary in the 1820s, he taught for a while in Maryland before returning to William and Mary as a professor. But it was while teaching at the University of Virginia in the 1840s that he began to seriously consider creating a polytechnic school dedicated especially to the sciences, which often received only secondary consideration at liberal arts colleges.

Boston's developing Back Bay neighborhood was where Rogers envisioned establishing the new school. He admired the "Yankee ingenuity" of New England industrialists as well as the region's historic commitment to education embodied in such institutions as Harvard. Further incentives were provided by his marriage to a Boston native and by the Governor's support for educational institutions in the Back Bay. A charter incorporating the Massachusetts Institute of Technology was granted in April of 1861, but the outbreak of the Civil War that same month made fundraising and student recruiting difficult. Temporary quarters were established in downtown Boston while Rogers awaited completion of a more permanent home not far from Copley Square.

With the war over and construction of the new campus complete in 1866, M.I.T. began carving out its reputation for academic excellence. It established the nation's first architectural program, developed a highly-praised civil engineering department, and earned accolades for its innovative approaches to learning. Alexander Graham Bell used its facilities; Thomas Edison's son studied there, as did members of the Du Pont family; and in 1873 Ellen Swallow Richards became the school's first female graduate. In fact, M.I.T. became so well respected that wealthy Harvard repeatedly tried to buy the cash-strapped institute to shore up its own weakness in the sciences. It was nearly sold in 1904, but M.I.T. faculty and alumni vigorously protested and the purchase became hopelessly entangled in legal difficulties.

Instead of being absorbed by Harvard, M.I.T. became its next-door neighbor in 1916. President Richard C. Maclaurin oversaw the purchase of forty-six acres along the Cambridge side of the Charles River, after rejecting an offer to relocate the school to Springfield,

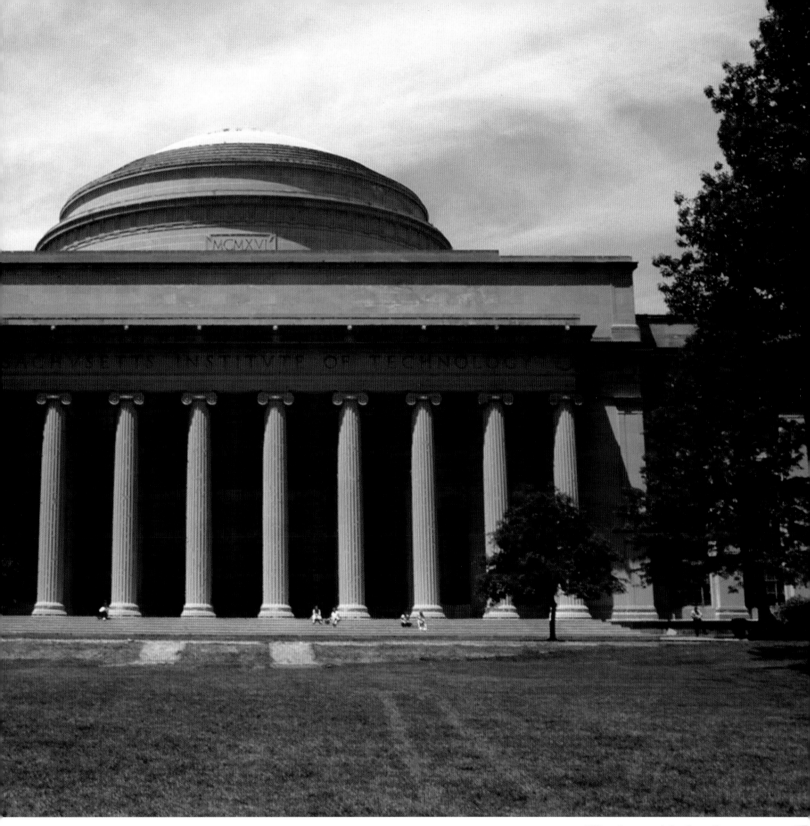

*Killian Court and the Great Dome.*

Massachusetts and ignoring warnings from Harvard that the move would imperil both colleges. To finance construction of a new campus, he turned to wealthy businessmen and philanthropists, such as George Eastman of Eastman Kodak, who shared his vision for the school. Armed with millions, Maclaurins hired alumnus

William Welles Bosworth to design the complex of buildings that would bear the president's name. All this from a man who, by his own admission, had "often criticized the educational authorities for acting as if buildings make the institution."

The most distinctive features of the Maclaurin Buildings are

*The Ray and Maria Stata Center.*

the beautiful courtyard they surround and the Great Dome that forms their focal point. Commencement ceremonies are usually held in the Great Court, also known as Killian Court, with the Great Dome providing a striking backdrop. Below ground lie passageways that connect campus buildings and enable students to avoid harsh New England winters. In typical M.I.T. fashion, most buildings are referred to by number rather than name, a system that often disorients outsiders.

At the opposite end of the architectural spectrum from the Maclaurins Buildings stands the Ray and Maria Stata Center for Computer, Information, and Intelligence Sciences, opened in 2004. The Statas donated $25 million toward the construction of a $285 million building that Cambridge mayor Michael A. Sullivan initially thought "looked like something my kids built and then took a hammer to." More money for the facility, $20 million to be exact, came from Microsoft's Bill Gates, who had once attended rival Harvard. Architect Frank O. Gehry's whimsical Stata Center replaced the simple, yet much-loved Building 20 that had occupied the site since World War II.

Born of military necessity, Building 20 housed part of a radiation laboratory where researchers worked on advancing Allied radar technology. The infusion of federal dollars and military contracts during World War II and the Cold War transformed M.I.T. into the nation's premiere scientific research institution in the 1950s and kept Building 20 bustling for decades. Its demolition in 1998 to make way for the Stata Center reflected the historic changes that had ended the Cold War and signaled the end of an era at M.I.T.

Times may have changed, but M.I.T. remains an elite institution. It has produced nearly eighty Nobel Prize winners from the ranks of its alumni, staff, and faculty, many of them in the fields of physics and economics. Newspaper and magazine polls consistently rate M.I.T. as one of the most selective and rigorous schools in the country. "The thing that really struck me when I first got to M.I.T.," alumna Eleni Digenis told the *Boston Globe* in 1994, "was that everyone just seemed so totally focused." Perhaps that's why the school chose the industrious beaver as its mascot and even named its sports teams the Engineers.

# Harvard University

✦✦✦✦✦✦✦✦✦✦✦✦✦✦✦✦✦✦✦✦✦✦✦✦✦✦✦✦✦✦✦✦✦✦✦✦✦✦✦✦✦✦✦✦✦✦✦✦✦✦✦✦✦✦✦✦✦✦

If Boston is the self-styled "Athens of America," then Harvard University, located across the Charles River in nearby Cambridge, is its Lyceum. Not only is Harvard the oldest institution of higher education in the United States, its name remains synonymous with academic excellence over three centuries after its 1636 founding. It is a school steeped in tradition, from its ancient architecture to its forty-six Nobel Prize winners. Eight American presidents have graduated from Harvard, as have many of the nation's top lawyers, doctors, and business executives. Though it is often accused of a conservative and elitist character, the university's renowned faculty routinely produces innovative, cutting edge research that transforms our understanding of the world, whether it concerns discovery of distant galaxies or the latest breakthrough in cancer treatment. Indeed, Harvard has always been a school that forges the future while sustaining the past.

Stepping into Harvard Yard, one immediately senses the history that surrounds the venerable institution. The Puritans founded the school as a place to provide the Massachusetts Bay Colony with its own trained ministry. Toward this end, The Reverend John Harvard willed his extensive personal library and much of his estate to the fledgling college when he died in 1638. Officials were so thankful for his generosity that they named the school in his honor.

*Harvard Square.*

Tragically, nearly all of the minister's 400 books were lost in a fire that swept through the campus in 1764.

Yet the school has never forgotten Harvard's deed, even if it has sometimes mistaken the particulars. In 1884, it unveiled a bronze statue of the benefactor designed by Daniel Chester French, best known for his work on the Lincoln Memorial in Washington, D.C. The sculpture has since become known as "The Statue of Three Lies" for fabricating an image of Harvard, whose likeness was never set to canvas, and mislabeling him as the school's 1638 founder. He may not have been the founder, but he is the university's mascot. Students and visitors alike rub the statue's left shoe for good luck.

Harvard's statue is situated in front of University Hall, which Charles Bulfinch designed for his alma mater in 1814. The building was supposed to feature one of the architect's signature cupolas, but the expense proved prohibitive. It did, however, include a chapel used until construction of Appleton Chapel in the 1850s.

That building was located behind University Hall to the east, a site now occupied by the familiar white spire of Memorial Church. The church was dedicated in 1932 to the memory of Harvard men killed in World War I. Interestingly, it also memorializes four students who served in the German army, an honor not accorded to the school's Confederate soldiers in the 1878 Memorial Hall for the Union dead.

Since its opening, Memorial Church has also commemorated students who perished in wars as recent as Vietnam. In November of 2001, the university erected a plaque honoring three graduates of Radcliffe, Harvard's historic sister school for women, who lost their lives in World War I. It was another step in moving the campus toward more complete gender integration and combating lingering allegations of discrimination against women. Unfortunately, those efforts suffered a setback in 2005, when Harvard's president Lawrence H. Summers suggested that men

and women might have different intellectual capacities for the sciences. He later apologized for the comment after a firestorm of protest and (perhaps not co-incidentally) was succeeded in office in 2007 by historian Drew Gilpin Faust.

The president's office is located in Massachusetts Hall, the oldest building on campus. The 1720 brick structure stands opposite University Hall to the west, across the Old Yard. It was originally used as a dormitory, and during the siege of Boston in 1775 and 1776 it acted as a barracks for the Continental troops of George Washington. The General (before he became President) briefly used the wooden Wadsworth House, built in 1726 for the college's president, as his headquarters. Today it serves as the Alumni Office. Nearby Matthews Hall is the approximate location of Harvard's Indian school, which provided religious training for a handful of Christian Indians in the seventeenth century.

Harvard's religious roots remain visible in a number of ways, including the school song "Fair Harvard," which concludes with the lines "Be the herald of light, and the bearer of love/ Till the stock of the Puritans die." The university also boasts one of the nation's best divinity schools, though it is no longer affiliated with one particular faith. The curriculum has also diversified since its colonial days, when students were required to take courses in religion, logic, ethics, Hebrew, and metaphysics among others. Neither has Harvard sustained its traditional ranking system based on family status rather than academic merit. For a time regarded as "a fashionable finishing school for young gentlemen," according to Samuel Eliot Morison, Harvard is now arguably more diverse and dynamic than at any time in its storied history.

*John Harvard Statue located in front of University Hall (designed by Charles Bulfinch and completed in 1815), was cast in 1884 by Daniel Chester French (sculpture of the Lincoln Memorial) and is known as "The Statue of Three Lies." Although the inscription reads "John Harvard, Founder, 1638," none of these three statements is true. The seated figure is not really John Harvard, since no authentic pictures of Mr. Harvard existed; John Harvard was not the founder of Harvard College; and the College was founded in 1636.*

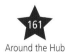

# *Museum of Science*

I n a city chock full of cultural museums, from those reflecting Boston's storied history to others aimed at the fine arts, the Museum of Science offers a decidedly different experience, yet one as quintessentially Bostonian as any old Brahmin exposition. Scientific inquiry had been a hallmark of the City upon a Hill at least as far back as Reverend Cotton Mather's membership in the Royal Society of London. Science courses were part of the Harvard curriculum in the colonial era, and the college established a medical school even before the American Revolution had ended. Several local doctors evinced an interest in the sciences and natural history, prompting them to form the Boston Society of Natural History in 1830. From this group of amateur naturalists sprang

the New England Museum of Natural History, which served as the nineteenth-century predecessor to the Museum of Science. For decades after the Civil War, the museum shared a block in the Back Bay with the Massachusetts Institute of Technology, whose first president, William Barton Rogers, was also a member of the Boston Society of Natural History.

The modern Museum of Science was a creation of the same post-World War II emphasis on science that pushed M.I.T. to the forefront of scientific research. Responding to this new cultural climate, the museum's director Bradford Washburn, a world-famous mountain climber, dropped the traditional "natural history" designation from its title in favor of a new identity as

a science museum. He also relocated the museum to its current position overlooking the Charles River in downtown Boston, making the Museum of Science one of the early examples of post-war urban redevelopment. America's space race with the Soviet Union in the 1950s increased the museum's interest in astronomy and resulted in construction of the Charles Hayden Planetarium, built in 1958 and still one of the museum's main attractions.

Today the Museum of Science attracts over 1.5 million visitors annually, a figure that many other local

*An audience at the newly transformed Charles Hayden Planetarium at the Museum of Science enjoys a scene from the Museum's own astronomy show, Undiscovered Worlds: The Search Beyond Our Sun, which makes its public premiere on February 13, 2011. Here, visitors take in an artistic rendering of exoplanet Corot 7b, a rocky world so close to its star, its surface might be seething with lava.*

museums can only dream about. Director Ioannis Miaoulis has taken it in invigorating new directions with exhibitions such as *Star Wars: Where Science Meets Imagination*, now a traveling exhibition where guests can learn about robotics and futuristic transportation through references to the popular George Lucas films. And in 2009, the museum became the first of its kind in the nation to install a wind turbine lab. Museum officials work especially hard to instill an appreciation for science in children, as evidenced by the hundreds of school groups that visit every year. Teaching aids and science workshops are also made available to area educators.

*Visitors observe the state-of-the-art Zeiss Starmaster in the newly transformed Charles Hayden Planetarium at the Museum of Science. The Starmaster is one of only two in the United States, and the only one on the East Coast.*

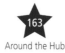

# Weeks Memorial Footbridge

The Weeks Memorial Footbridge may not be the largest or longest bridge to span the Charles River, but it is certainly the most charming. Built in the 1920s, the bridge honors the broker and politician John Wingate Weeks, who served as Secretary of War under the Republican administrations of Warren Harding and Calvin Coolidge. The New Hampshire native was also a champion of environmental conservation and urged the federal government to purchase lands for national forests, especially in his beloved White Mountains.

Weeks's friends and colleagues in Boston, where his brokerage firm was based, believed a bridge across the Charles to be the best way to remember his love of the outdoors and of the water, since Weeks was also a Naval Academy graduate. The site chosen for the bridge would connect the new Harvard School of Business with the rest of the campus on the Cambridge side of the river. The renowned architectural firm of McKim, Mead, and White, most famous for remodeling the White House, designed the brick and limestone bridge to harmonize with the buildings they had created for the Business School. The Weeks Memorial Footbridge was dedicated in 1927, the year after Weeks' death from complications following a stroke.

Since its opening, the footbridge has become a site of celebration as well as a utilitarian means of conveyance. It especially appeals to those with a passion for romance and nature. The Tango Society of Boston used the Weeks Bridge as the setting for its "Tango by Moonlight" affair in 2000, and the Charles River Conservancy, which helps manage the bridge, holds its "RiverSing" festival there to mark the autumnal equinox. Thanks to the fundraising efforts of the Conservancy, Harvard University, and the LEF Foundation, the Weeks Memorial Footbridge was outfitted with permanent light fixtures in 2004, making it a bit less romantic, perhaps, but more accessible.

for a national holiday during the Civil War. Today it is celebrated with bountiful amounts of turkey, cranberries, and pumpkin pie, probably none of which were actually served in 1621. Fish was more likely the fare then, and, along with the fur trade, fishing would sustain the colony in its early years. Never one of England's wealthier or more populace colonies, however, Plymouth was absorbed into the neighboring Massachusetts Bay colony as part of an imperial reorganization of New England in the 1690s.

Gone but not forgotten, the Pilgrims' story was brought back to life after World War II through the efforts of the Hornblower family, wealthy Bostonians who summered in Plymouth and who donated money and land

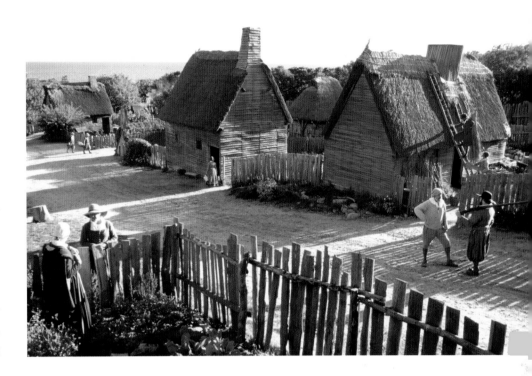

for a reproduction village called Plimouth Plantation south of the original settlement site. Initially the village presented visitors with a rather romanticized view of life in the Plymouth colony circa 1627, but by the 1960s it had evolved into an innovative living history museum under the leadership of director James Deetz. Deetz was a trained archaeologist who demanded authenticity in everything from the design of village houses and inclusion of livestock to the dress and dialect of the costumed interpreters, all of whom were trained to stay in character as they interacted with visitors. In the early 1970s, Plimouth Plantation responded to increased awareness of Native American history by including a Wampanoag Indian homesite adjacent to the colonial settlement, though some members of the Native American community initially balked at what they feared was a patronizing gesture. Instead, it has proved a valuable addition, enabling guests to learn from Native people themselves about indigenous culture in the years before the English arrived. For being "the closest thing to time travel that will ever be accomplished," as Deetz once put it, Plimouth Plantation received the prestigious Commonwealth Award for Creative Learning from the Massachusetts Cultural Council in 2011.

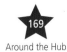

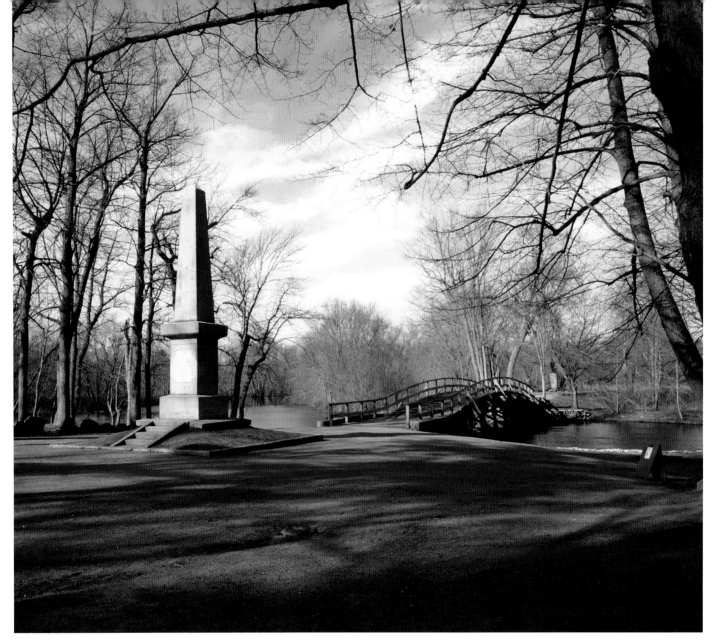

*Ralph Waldo Emerson coined the phrase "the shot heard 'round the world" to describe the significance of the brief battle which took place at the North Bridge.*

# Minute Man National Historical Park

✦✦✦✦✦✦✦✦✦✦✦✦✦✦✦✦✦✦✦✦✦✦✦✦✦✦✦✦✦✦✦✦✦✦✦✦✦✦✦✦✦✦✦✦✦✦✦✦✦✦✦✦✦✦✦✦

Since the famous "Shot Heard 'Round the World" in April of 1775, the history of Boston has been inextricably linked with that of two small villages in the Massachusetts countryside, Lexington and Concord. The British occupation of Boston in 1774 had scattered its population and forced Revolutionary leaders to find safe refuge in the colony's interior. Their presence helped rouse formerly apathetic farming communities that typically cared more about planting than politics. Concord, some twenty miles from Boston, soon became a major center of resistance, hosting

the patriots' Provincial Congress and stockpiling munitions for a possible war.

In the meantime, royal officials were pressuring General Thomas Gage, commander of British troops in Boston, to move decisively to break up the rebellion. He had already ordered raids against suspected stores of arms in Somerville and Salem, but more force was deemed necessary to scare the New Englanders into submission. Plans were accordingly made to seize the arms at Concord and perhaps capture two patriot leaders believed

to be in the area, John Hancock and Samuel Adams. But before the expeditionary force could assemble along the edge of Boston Common, Paul Revere and other messengers had begun warning the countryside that the Regulars, as British soldiers were commonly called, were appearing.

Among the towns where Revere sounded the alarm, before he was captured by a British patrol, was Lexington, which lay directly in the path of the British advance toward Concord. In the early hours of April 19, 1775, Lexington's militia mustered on the Common under the command of Captain John Parker, a forty-six-year-old farmer and veteran of the French and Indian War. Despite suffering from tuberculosis, Parker stood in the cool, windy weather with his men, waiting for the enemy to arrive. Conflicting reports about British movements prompted some to retire to nearby Buckman's Tavern, however, until the sounds of approaching soldiers sent them scurrying back onto the Common around 4:30 a.m.

Outnumbered nearly four to one, Parker told his men to stand

*The Minute Man sculpture was created by Henry H. Kitson to honor the citizen-soldier of 1775.*

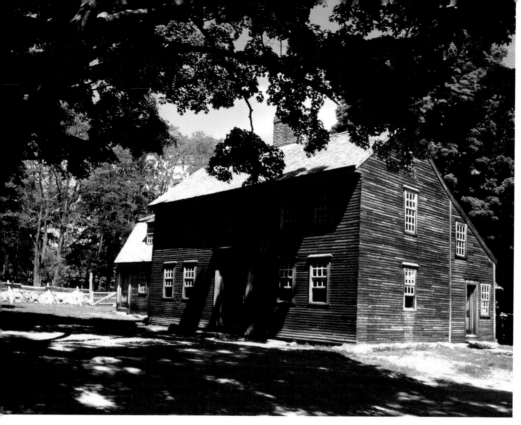

firm but not to fire as the Redcoats filed in around them. "[I]f they want to have a war let it begin here," he reportedly said. The words proved prophetic, for while British officers negotiated with Parker to end the standoff, a shot rang out. To this day, it is unclear who fired first, but in the confusion that followed seven militiamen were killed and nine others wounded. The Revolutionary War had begun.

Parker would gain his revenge later that day as the wearied British soldiers returned along "Battle Road" from a clash at Concord's North Bridge and marched right into an ambush by Lexington militia. To honor Parker and his men's heroic stand for American freedom, the town

*Hartwell Tavern—a 1733 building with later additions—was not only a typical country inn of the period, but is was also the scene of fighting along Battle Road.*

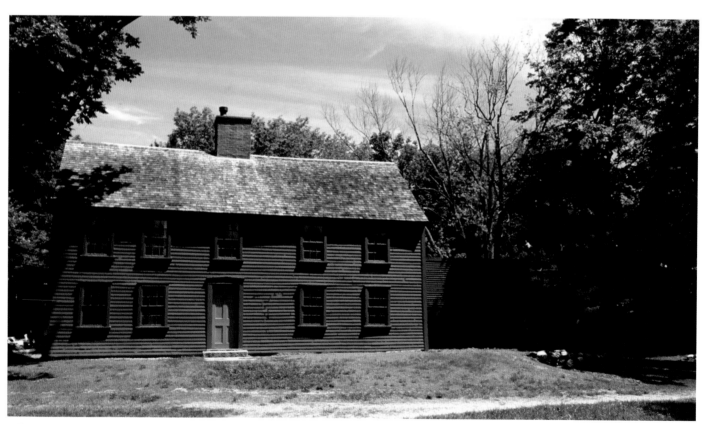

*John Meriam's House is one of the oldest in Concord, MA. The shots exchanged here between colonial militia and British troops began the fighting along the Battle Road that continued for 16 miles back to Boston after the skirmish at Concord's North Bridge.*

*Once the home of Samuel Whitney, muster master for the Concord Minute Men, The Wayside gained fame in the 19th century through three literary families. Louisa May Alcott's childhood here inspired her scenes in Little Women. Nathaniel Hawthorne named it The Wayside; Margaret Sidney, author of Five Little Peppers, preserved this "Home of "Authors."*

erected Henry H. Kitson's bronze statue of a militiaman in 1900. It stands defiantly atop an outcropping of boulders presumably taken from a stone wall used on the day of the battle. Facing east toward Boston, with the American flag at its back, the statue also marks the direction of the approaching British column. In 1965, the federal government made the flag on Lexington's Battle Green one of only a handful nationwide that is to be flown continuously. The state of Massachusetts commemorates the historic events at Lexington and Concord annually with Patriot's Day. The highlight of this April 19th holiday is a re-enactment of Parker's clash with the British, along with events such as the Boston Marathon and a Red Sox baseball game at Fenway Park.

*Meriam's Corner.*

# Salem Witch Trials Tercentenary Memorial

Though its name means "peace" in Hebrew, Salem has come to symbolize intolerance in the American cultural lexicon. What began as a strange affliction among a group of young girls ended with the execution of twenty people for the crime of witchcraft in the summer of 1692. Already convinced that Satan was tormenting their fair town, officials ignored denials of guilt and pleas for mercy from the accused.

Theories abound as to why witchcraft hysteria gripped Salem. Might resentful farm families have lodged false accusations against neighbors associated with the seaport's more prosperous commercial order? New England in the 1690s was also caught in the coils of a war that many Puritans saw as divine punishment for their sinful ways. Perhaps the anxiety and sense of impending doom caused a reactionary search for scapegoats within the community.

The Salem Witch Trials Tercentenary Memorial offers a dignified and solemn reminder of the awful consequences created by intolerance. Designed by architect Jim Cutler and artist Maggie Smith, the memorial was dedicated in 1992 as part of Salem's tercentenary commemoration of the witch trials. Its themes, according to Cutler, are deafness, silence, and memory, which are represented in several ways. The accused are allowed to speak for themselves through quotes etched in stone, yet the walls cut off their words before being completed, a symbol of society's indifference to their pleas. Twenty stone slabs bearing the names of the victims and their dates of execution jut out from granite walls, inviting visitors to sit for spell and contemplate their sad fate.

*"If it was the last moment I was to live, God knows I am innocent..."*

\- Elizabeth Howe, hanged July 19, 1692